PHOTOGRAPHS BY **David Yellen**

TEXT BY **Johanna Lenander**

Hair Wars

pH **powerHouse Books Brooklyn, NY**

Introduction

The Merriam-Webster dictionary lists the first definition of the word "fantasy" as "the creative power of the imagination." It's that creative power that we have attempted to document in this series of photographs of fantasy hair, which was taken at several Hair Wars shows around the country. In the business, fantasy hair is defined as a hairstyle that is so extravagant that no one would attempt to wear it in real life. In other words, these creations are imaginary hairdos worn in an imaginary world. The images capture that sense of playfulness and desire for an otherworldly glamour.

Fantasy hair can be described as a hobby of predominantly African-American professional hairstylists. The creations are exhibited in competitions at professional African-American hair trade shows, such as AHBAI's Proud Lady Beauty Show and the Bronner Bros. trade show. However, this project focuses on one event: Hump the Grinder's Hair Wars. Hair Wars was founded by David Humphries (aka Hump the Grinder), who first started throwing hair battle theme nights in Detroit nightclubs in the mid-1980s. Since then, Hair Wars has grown and evolved to become a touring national event that takes place four or five times a year. Hair Wars is not a formal competition. It's a "hair entertainment" show, meaning an evening where a group of talented professional hairstylists try to outdo each other by presenting extremely imaginative work in an extremely imaginative way. The only prize is the audience's adoration and the brief rush of a few minutes onstage.

The photographer, David Yellen, and I began our relationship with Hair Wars in 2004, when we attended a show at the Apollo Theater in Harlem. It was a particularly grand event with a stellar lineup of stylists from around the country. Seeing the lackluster backstage area slowly being transformed by dazzling costumes, sparkling makeup, and hairpieces that defied all laws of gravity and common sense was a breathtaking experience. There was Mr. Little putting the finishing touches on his famous Hairy-copter while his models strutted around in braided hair bikinis, Steven Noss setting up his own little version of *The Wizard of Oz* that featured a pair of identical twins playing good and bad witches, and the awesome 250-pound bodybuilder-cum-hairstylist Big Bad D engineering a hairdo that included a gigantic bowl with live Japanese fighting fish on top of his model's head. But perhaps the most striking sight was when Veronica Forbes ushered in a sparkling parade of a dozen glammed-out girls that resembled a crossbreed of butterflies, fireworks, and showgirls.

Since then we have attended several other Hair Wars events around the country. While David took portraits of the models I would interview some of the most prolific hairstylists. As a fashion writer, I was particularly struck by the originality and audacity of the work. While I realize it's not everyone's cup of tea—it's certainly possible to dismiss some of the fantasy 'dos as outlandish and ridiculous—I find this work incredibly exciting and beautiful. It's a different idea of fashion and glamour than what is shown in the world of runway shows and magazines. That world ends up looking bland and anemic in comparison. The fantasy hairstyles in this book are proudly loud and outrageous. They express a desire to surpass the ordinary, to make something better, bigger, more extreme, and more shockingly different than everybody else. To me, it's just as serious and creative as, for example, an haute couture show by John Galliano, with the exception that these designers constructed their creations in their kitchens, on shoestring budgets.

We have become fascinated with the stylists' dedication to their craft. Some Hair Wars participants travel across the country several times a year in cars stuffed with hair weaves, costumes, and models. It's a costly venture. The designs in this book vary in sophistication, size, and execution. But they are all extremely time-consuming and very expensive to make. In addition, working with fantasy hair is an impractical skill. It's an art you learn because you want to, not because you need to. Rarely is a hairdresser asked to create a fantasy 'do for a paying client. While some of the hairstylists featured in this book also show their work at the aforementioned industry events, where they have the chance of winning cash prizes, the monetary awards are few and far between and barely make up for the expenses. And yet, many stylists spend countless hours dreaming up new fantasy designs and crafting new pieces. Some have been doing it for decades.

Human hair is the only material used for fantasy hair pieces. The cheaper synthetic weaves have a different look and are not possible to manipulate as efficiently. In the process of sculpting the pieces, a lot of hair is destroyed and has to be discarded. There are certain basic techniques, some of them taught in classes and on DVDs by stylists featured in this book, but many of the methods of construction are improvised and invented through the stylists' own problem-solving skills. The challenge is part of the reward.

Big hair goes with big personalities. Part of the pleasure of working on this project has been getting to know the talented people that are part of this creative world. Fantasy hair seems to attract particular personality types; the larger-than-life characters, the dreamers, the perfectionists, the exhibitionists. It takes ambition and drive as well as a fearless attitude to create strange and complicated hairdos that have no real reason to exist. There are strong feelings behind much of the work. Most stylists will tell you that their work is fueled by passion.

The Hair Wars show is a platform for the stylist to be seen, admired, and applauded. It's the combination of no-holds barred creativity and the joy of performing that attracts most of the stylists. In traditional hair competitions, the stylist keeps a lower profile and only takes the stage when the presentation is over. In a Hair Wars show, the stylist spends as much time on stage as the models, either sculpting and styling the hair on the spot, or dancing, rapping, or acting out a story line. Some of the most elaborate presentations, such as Mr. Little's, include dancers and serious choreography, while other performers, like Ms. 'Color Me' Vic, write their own lyrics (usually about Hair Wars and their hair creations) and rap them to a mix of current hits. The level of enthusiasm for performing varies a lot among the stylists. Some of them revel in the spotlight and are hugely motivated by the audience's response. But others are less interested in the stage itself and more driven by the challenge of creating something outrageous and beautiful without boundaries.

In the process of attending and documenting the shows we discovered different subcategories of fantasy 'dos. There are tribute themes with hairdos dedicated to local sports teams or current events, such as post-9/11 patriotism or the Olympic Games. Seasonal designs like Christmas trees and Halloween witches pop up from time to time. Hi-tech styles that incorporate special effects like lights, smoke, and mechanized movement are popular. They often feature an element of surprise, such as a ponytail that suddenly spins or a built-in device that blows soap bubbles. Many stylists have a signature theme that they keep exploring, often humorously, such as zippers or rainbow colors. And like the rest of the beauty and fashion world, some hair designs are inspired by movies or music. Both *The Matrix* and *Memoirs of a Geisha* are represented on these pages.

Unlike trade show competitions, Hair Wars doesn't have rules and regulations regarding styling and presentation, but there are certain conventions that most stylists seem to follow. One-of-a-kind outfits that match the hairdos are standard practice. Most stylists design and custom-make the clothes themselves. Makeup is also an important part of the presentation, and while some stylists use a freelance makeup artist, their work must follow the theme and colors of the hairdo. For example, if a hairstyle is green, the lipstick better be green. In the most extravagant presentations, outfits and accessories are made of human hair and dyed in the same colors as the coiffure. Sometimes hair-pieces are sewn onto fabric and sometimes an entire garment is made of hair. In a few rare cases, hair and hair spray are the only materials that have been used for the construction of entire outfits. There is no glue, fabric, or even thread involved.

The mixture of sincerity and humor is one of the aspects that make this subject so interesting. While many of the designs are obviously funny, they are also meticulously crafted and presented with a level of serious intent. The models' attitude is never clownish or ironic. The woman wearing a guitar or a giant barbeque on her head still wants to look sexy and beautiful. This is partly what gives the event such style and panache. Overall, the models' efforts are often close to heroic. They sit through long hours of hairdressing and makeup, walk in anatomically antagonizing shoes and costumes, and must successfully balance several feet of hairdo. It's worthwhile to note that while a few of the models in this book are paid professionals, most are friends and family members.

The dream of fame is a large part of this story. Perhaps no one would venture into such a demanding extracurricular activity if there weren't some kind of promise of celebrity and glory involved. One of the cornerstones of Hump the Grinder's concept for Hair Wars is to launch the idea of the hairdresser as an entertainment celebrity. He envisions the hairstylist as a performing superstar, whose live appearances would draw huge crowds and attract sponsors, like athletes and rock stars. While that level of mainstream fame has yet to befall any Hair Wars stylist, some of them have certainly raised their professional profile by performing in the shows. There is often a slew of local media present, particularly if the event takes place in a city other than Detroit. Many stylists have been invited to appear on TV talk shows and reality shows, sometimes regularly. This kind of notoriety can lead to bigger clientele and ownership of a salon. The next step is to launch a line of hair products, which can be very profitable.

While working on this book we were struck by the open and friendly atmosphere at the shows. The event may be called Hair Wars, but there's nothing hostile about it. The backstage area is often hectic and the space is sometimes tight, but the hairstylists seem nothing but warm and friendly towards each other. While the stylists don't necessarily divulge all the little secret tricks of their trade, they often share basic information about products and techniques. Several stylists have told us about the encouragement and support they received from more seasoned colleagues when they started out, and it seems that experienced fantasy hair stylists often mentor younger talents to follow in their footsteps. However, there's still a wildly competitive spirit driving the event. It's a congregation of big egos. The response from the audience is reason enough. When a particularly wild fantasy 'do comes down the runway, the audience cheers, stomps, waves, and claps with abandon, while a tamer style only elicits lame applauds and bored glances.

We hope that the excitement and energy of Hump The Grinder's Hair Wars will translate from these pictures. It's an event that has inspired us on many levels, from the boundless creativity of the hairstyles to the passion and effort that the stylists invest in their work. The exhilaration of the audience is also a high point. It's wonderful to see so many people come together to celebrate the creativity of their community. And lastly, the proudly eccentric personalities that we have come across have definitely influenced my own thoughts on personal style. The stylists' head-to-toe looks show how seriously they take hair and fashion as a means of personal expression. It's a manifestation of self-respect and a desire to make an impact on the world. We hope that this book will help them achieve that goal. JOHANNA LENANDER

"Hairstylists are the superstars of tomorrow."

—Hump the Grinder

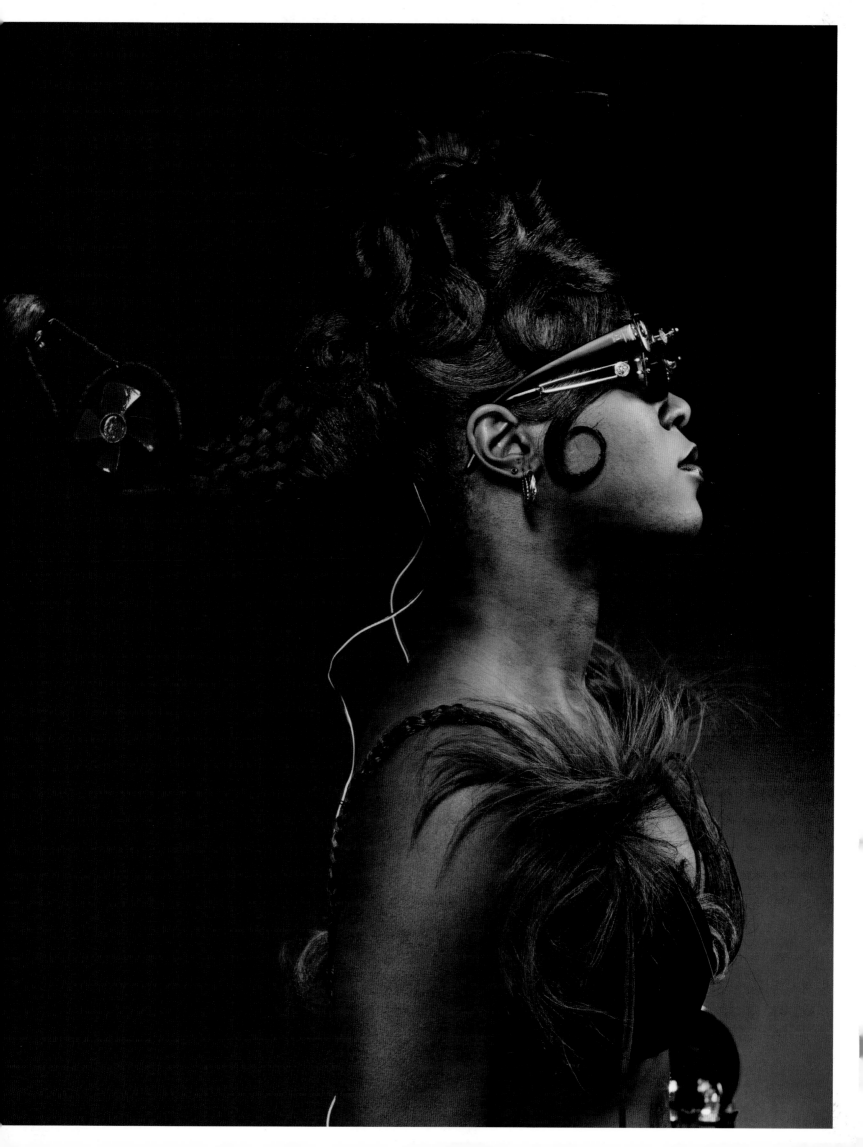

HUMP THE GRINDER

Every Hair Wars show starts promptly at 7:05 PM. It is a trademark of Hump the Grinder.

"I'll give you five minutes, but not more," he says, speaking to tardy hairdressers, fretting over last-minute details backstage. This somewhat idiosyncratic rule sums up Hump the Grinder's persona: professional, consistent, a little bit paternal, and deeply committed to his stable of talent. Hump the Grinder is the heart and soul of Hair Wars. He produces it, promotes it, and oversees practically every aspect of each and every event. On the afternoon before a show night, you'll find his soft-spoken yet authoritative figure in the center of the venue, directing lights, placing chairs, and testing DVD projectors, as well as patiently answering questions from arriving performers, press, and lost audience members.

Hair Wars has been Hump's main occupation for the past 20 years. It all started as a fun little side project in the mid-1980s when David Humphries was working as a copywriter for a Detroit advertising agency by day and promoting parties at night. "I was a DJ. That's how I got my name, Hump the Grinder," he explains. The parties often had themes. "I started doing gimmick parties in the clubs," he recalls. "Every week I'd do a different theme. And one of them was hair." Hump invited local hairdressers to show off their edgiest work on live models. The event turned out to be a huge success. "And then for the next four weeks, we decided that we would see how wild we could get with these hairstyling parties. So we said, 'Let's find out who can do the wildest hair.' We called it 'Wednesday Night Hair Connection.'" The hairdressers picked up the challenge and started pushing their creations to the max. "They loved it because they had no other platform to show their work," says Hump. "And it got kind of crazy, so more and more people who had heard about it came and said, 'Hey, I wanna sign up on this.' Those four weeks turned into three years." So what did the hairstyles look like back then? "The styles weren't as extreme as they are now, but they were getting there. It was something that just happened. These people, they have big egos, they were hams, they wanted to get on that stage and cut up. And they had a lot of talent too. Besides doing hair, they could also dance, and they would hire fashion designers to design their outfits. They wanted to show off, that was the main thing. It was like, 'Did you see my set at the club?' 'I'm gonna kill it when I get up there,' and 'I'm gonna kick your ass!'" Hump stresses that it was always a friendly competition. "We never really did it for prizes or money, we did it for bragging rights."

Bringing Detroit hairstylists together for the events created a unique sense of community. "Maybe hairstylists in other cities didn't have that unity, because nobody put them together. But for us it worked. I'm not a hairstylist, I'm not trying to take anybody's customers, I just wanted them to put it out there and have some fun with it." Several hairstylists from those early days, including Mr. Little, Little Willie, and Raphael, still perform with Hair Wars. They have all become celebrities of a subculture of the hair world. Since performing with Hair Wars, they have segued into giving classes at hair conventions, selling instructional tapes, and producing their own lines of hair products. "Many of the people who were with us from the start are still active because it's still making them money. When we go out in the world, they're establishing their markets. They like the fact that we promote them. I'm like a hair agent to a lot of these people." When Hair Wars began, Hump would find the talent for the shows, approaching people whose style he admired and asking them to perform. He helped many of the stylists hone their images and select stage names. "I give a lot of people their names. Because if I see that you have a love and a passion for hair and performing, and you want to be a star and you're serious about it, I can help you develop the skills to market your talent."

As Hair Wars' popularity grew, so did Hump's ambitions. He began to envision the "entertainer-hairstylist" as a new kind of star, much the way fashion

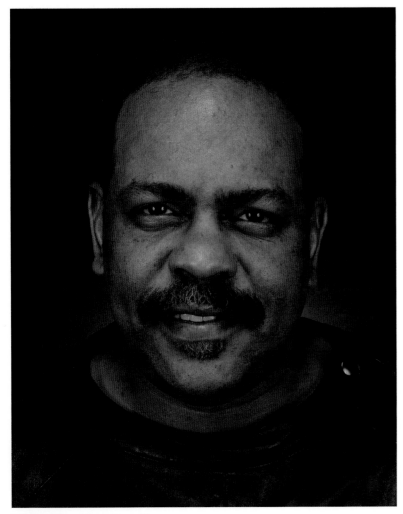

HUMP THE GRINDER AKA DAVID HUMPHRIES

designers are now celebrities. "There are all these 'celebrity hairstylists' doing styles for other celebrities. My thing is: 'You're the celebrity. These people are stars.'" At the same time, the show had outgrown its home in the clubs. "We got to the point where it got so big that I needed a ballroom. I started thinking, well, maybe this could get even bigger." In 1994, Hair Wars started traveling across the country, drawing crowds by word of mouth. Los Angeles and Miami were popular stops. The touring made Hump think of his past experiences working on a tour for New York rappers in 1984. He figured that Hair Wars had a similar potential to go from underground to mainstream. "Back then people didn't understand rap because they didn't know the history of it in New York. I remember everyone kept saying that it was just a fad and that 'It's gonna blow over.' It's the same thing with this hair thing. Nobody had ever heard of it until we started going on the road."

Not only did touring expose Detroit hairdressers to a different market, it exposed other hairdressers to Hair Wars. Today, stylists travel from all over the country to perform in the shows. "Now they come to me. It's not hard to find new talent. When we go to a new city to connect with new people, somebody will find out about it and they pretty much know what we do and want to be a part of it. They want to get promoted." Hump looks for several traits in new talent: "Personality is good, but there are some people that are low-key, like Kevin Carter, who's a laid-back kind of guy, but whose work speaks for itself. So all of them don't have to be hot shots who are trying to get attention." And in the case of a botched performance, there are consequences. "If the work is kind of ragged around the edges, or if they're not showing up on time, I can put them on what I call 'Hair Wars probation,' where it's like, 'You gotta get your stuff together. When you get your stuff together, come back and see me.' I can do some things for some people but you've gotta do things for yourself."

Hump is fond of saying that hairstylists are the superstars of tomorrow. However, tomorrow has taken a long time coming. "Even though we've been

on the road for 12 years it's still underground for the most part," he says. "It's never crossed over to the mainstream." While Hair Wars gets consistent media exposure and some of the stars have been heavily promoted on TV shows like *The Tyra Banks Show, America's Next Top Model,* and *The Ricki Lake Show*, it's still hard to find outside sponsorship. "Advertisers don't understand it—they don't really know what it is," says Hump, yet he still believes that the hair entertainment business has enormous cash potential. "If they're trying to raise the black dollar, we have a big clientele. Nobody's really tapped into this. The hair care industry is the biggest industry in America for blacks. It's the biggest in moneymaking entrepreneurship. It is so big that it's unreal that nobody's tried to tap into this game." In spite of this, Hump's faith in the potential mainstream success of his project isn't shaken. "You take chances in any kind of business. The potential is still there, I haven't given up on the potential. But when it happens, it's gonna happen fast."

RAPHAEL

To say that Raphael Isho was born to be a hairstylist is probably not an exaggeration. As an enterprising young boy, he started charging for haircuts in his native Iraq. His first customers were his brothers and sisters, then his business expanded to include cousins and neighbors. By the age of 14, he had made enough money to buy his first salon.

"I was looking for six months until I found a salon for sale," he says. "The owners thought I was joking. The lady asked, 'Do you have money?' and I said, 'Yes, I have money.' We finally agreed on a price, but she still wasn't sure if I was joking or not. But I was very serious about it. The salon was small with three stations. I had an assistant that was older than me; she was 19. Everybody thought she was the boss and that I was just a little cleaning boy. I stayed in that salon for almost eight months, then I got so busy that I needed a bigger salon, so I purchased another one. That one had about eight stations, three shampoo stalls, and six driers, and I hired three or four guys. Still, no one knew I was the boss. I kept that salon for a couple of years, and when I was 17 I opened an even bigger salon. I was very famous at that point, all the singers and musicians, movie stars, all the popular people in the country came to me. So that's how I started."

In the 1980s, Raphael decided to leave Iraq and move to Detroit after visiting a brother who had settled there. "People called Detroit the Motor City, he says. "I thought that was strange. Why did they call it the Motor City when there was so much high fashion here? I thought we should make it the Hair Fashion City! He bought a salon and started working. Raphael had already experimented with avant-garde hairstyles back in Iraq. "Every time I saw something interesting in the European styling books, I tried to stretch it a little bit further. I started creating basket weaves, doing a lot of braiding and weaves. At that time we just blended some hairpieces with the natural hair, just to make it a little different than normal hairdos. It wasn't very, very extreme but the ideas were there." But he took his experimental styles to a new level when he started participating in Hair Wars shows. Raphael quickly became known for his beautifully executed fantasy hair-styles. Using no other materials than natural hair and gel, he sculpted hairpieces to look like exotic flowers, sparkling fireworks, or extravagant evening hats. "When I create my work, every piece has a little story behind it. You can kind of read it when you look at it. You see that there's an idea in there, not just a lot of bulk all over in a jumble that you don't know where it ends."

A Raphael hairstyle is polished, delicate, and perfectly balanced. His technique is impeccable. "My work is very clean," he says. "You can't even see that it's hair, people think it looks like chiffon. Hair is the only material I use, because I do hair fantasy, not some other kind of fantasy. Other stylists use tree branches or whatever they can get their hands on, but my technique is just hair. It's the perfectionism that makes it a fine art."

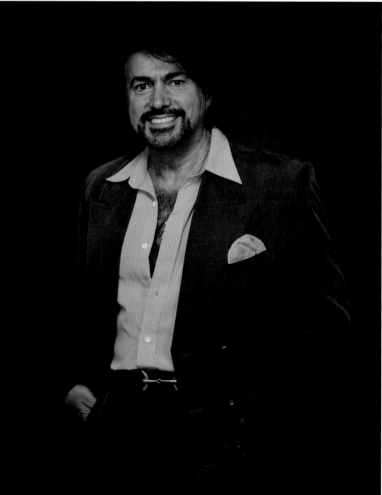

He also makes amazingly elaborate dresses out of hair. "It's very tricky to make them," he says. "When you look at the dresses, you'd think they were made of silk but it's just hair. I use braiding and basket weaving to attach the pieces to each other and then I glue them together with hair gel and extra-strong hair spray." When Raphael performs in the hair shows he doesn't dance or sing. "The work speaks for itself," he says. When he shows his creations on stage, he often saves the final touches for last, whipping them together in front of the audience. "The model comes out with one piece in her hair, and people think it's finished, then I put another piece in and they say 'Wow!' and then more and more is coming. It's like you're building sculpture."

Raphael is also an accomplished teacher. "People say I'm the number one teacher of fantasy hair in this country. It makes me feel good when I see my students' work. I have a lot of students that enter competitions. The first thing they do when they win the trophy is to call me, screaming on the phone. That's a great feeling. I scream with them from the other side of the phone." Although he no longer holds live classes, he sells six instructional tapes that feature the techniques that he has developed over the years. The tapes are very popular among fantasy hair beginners. There's a tremendous amount of respect for him in the business. Other hairstylists seem humbled at the very mention of his name: "Oh, Ra-pha-el. He's *good*."

Raphael himself seems to believe in natural talent. "To do fantasy hair you have to have a strong, creative mind, a strong vision. Not everybody can do it. Some people lose their idea before they've finished. Patience is very important, because working with hair is very delicate. If you don't polish it the way it's supposed to be polished and you don't have the basic skills to do it, it's very hard to finish. You have to have a good artistic mind and artistic hands. It's creative, that's what I like. It's a different kind of art."

RAPHAEL

Big Bad D

Hair Wars has no shortage of colorful personalities, but no one has perfected the art of projecting a larger-than-life persona quite like Detroit's legendary Big Bad D. Standing 6'4" and weighing in at 250 rock-solid pounds, Big D would probably attract attention even without his flamboyant, self-designed costumes and knee-length dreadlocks. But it's this inimitable style, paired with a good-natured sense of humor and a sharp business mind, which have made him a legend. "No one dares to do Big Bad D," he says when asked if he has many imitators. "You have to be extremely confident to do this look." "This look" is an absolutely unique fashion statement that includes elaborate one-piece suits in leather or snakeskin and brightly colored outfits complete with winged shoulders, harem pants, and deep necklines exposing his impressive pectoral cleavage, all accessorized with oversized custom jewelry and huge hats or head wraps.

Big Bad D was an icon in the hair industry long before he started performing at Hair Wars. He has had his own very successful line of BBD hair products, popular with music celebs like Alicia Keyes, Brandy, Ciara, and Diddy, for 15 years and is a regular at the podiums of hair conventions around the country. Surprisingly enough, he didn't start styling fantasy hair until 2000. "I had been going to Hair Wars forever," he says, "and I got tired of getting write-ups about my look. I wanted people to write about my hair creations."

Not surprisingly, Big Bad D's first fantasy 'do outsized the competition. "It was a peacock with feathers that measured four feet side to side. It must have weighed forty pounds," he recalls. He followed it up with other super-sized designs like a giant motorcycle, a waterfall of cascading weaves framing a fish-bowl (with water and live fish), and a tiered creation with a toy train that ran through a hair landscape scattered with smoking volcanoes and landed in a pool of water. Hairstyles that size are particularly fragile and were difficult to show more than once. "They didn't last long," laments Big Bad D. So what motivates him to go through weeks of hard work to put together a creation that might just last for one Hair Wars show? "It's the competition. Even if it's technically not a competition, it is in reality. Everyone wants to be the greatest and get the best response from the audience." However, through meticulous research, Big Bad D has now found his secret weapon. "I'm not going to give away all my secrets, but I finally found a way to make super big hair that lasts. It's a product that the Air Force uses."

Like a number of other young men in Detroit, Big Bad D got his start in the hair business when he lost his job at a car company 25 years ago. "Originally I wanted to be a barber, but they had cut the barber programs at the beauty school so then I got into hairstyling," he says. The hair business suited his personality. "Getting into hair was a reason for me to be different and flamboyant. I always loved attention and knew that I wanted to be different."

Being different paid off. After a few years Big Bad D had his own salon, which he eventually converted to a factory when his products started taking off. His creativity goes well beyond hairdressing. He also paints, sculpts, takes photographs, and makes all his own extravagant clothing and jewelry, notably his trademark gigantic (of course) gold and diamond scissor ring, which is worth $50,000. Since Big D wears a new outfit to every hair event he attends, he has accumulated quite a clothing collection. "I have seven closets and each one of them is full," he says.

Big Bad D also employs some of the most colorful Hair Wars personalities to represent his hairstyling products in their hometowns and appear with him in his booth at trade shows. "I found Ms. 'Color Me' Vic, Headsnap, Ridiculous, and some other people there. Everyone who works for me has to have a nickname and be dressed in character." Has he helped people out with their image? "Oh yes! I give them a name and a character. For example I have this guy Tommy, and there's something in the way he moves that reminds me of Zorro, so now that's his name and he dresses in a cape and mask and has a sword."

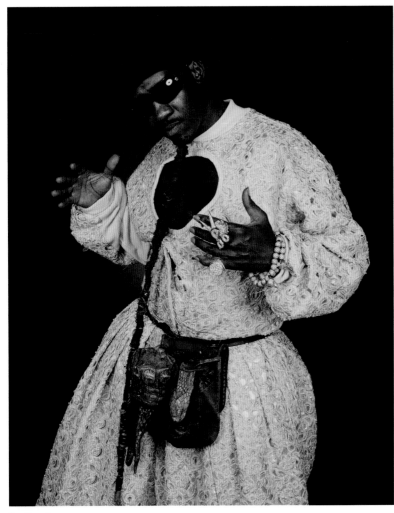

Big Bad D

Big Bad D might be about to reap the ultimate eccentric's reward. He's developing a potential reality TV show with VH1. "They just want to make sure that I'm really like this," he says. "They want me to be sexy and they want me to be funny." That shouldn't be a problem. One of the most appealing things about Big Bad D is his disarming humor and self-aware irony. He seems genuinely amused by his own image and sometimes accompanies his Hair Wars performances with a rambling soundtrack of intentionally ridiculous Big Bad D boasts. Where did he get his sense of humor? "From my father. He was always joking and clowning. He named everybody too. He had a grocery store and it was always like a stand-up comedy show in there. I'm basically a carbon copy of him. He was my hero."

Steven Noss

Steven Noss, aka "tha baddest whyte boy in tha hair business," is one of the most dedicated stylists on the fantasy hair scene. Although he lives in Pittsburgh, he shows up to nearly all four or five Hair Wars show a year with new creations and unbridled enthusiasm. Each of his performances is topped off with his famous booty shake, which never fails to bring the house down. But it took him a long time to get there. "I attended Hair Wars for six years before I went on stage," he recalls. So what made him keep coming back? "After I saw the first show I was addicted. I was so excited to see the hairdressers go on stage, because they were not only doing hair, they were really entertaining the crowd, you know?"

Steven Noss was also taken with the creativity of the work. "There were a lot of fantasy hair designs, a lot of big hair, a lot of street- and hardcore—it was cutting edge." After years of faithful attendance, Steven became a recognizable fixture. "Because of course I stood out. I was always driving up to Detroit by myself and I was always the only white guy in the audience. Always. And every-one was wondering who I was." Finally he started performing. "One day I just

decided to do it. I said to myself, 'I can do this. In fact, I bet I could turn this place out.'" And he did. "I did my first fantasy hair in March of 2000. It was three three-foot-tall hairdos with lettering that said 'Hair,' 'Wars,' and 'Detroit.' Then I snapped all the pieces off and underneath there were regular hairstyles. Then we did a dance routine. We won best stage presentation and a trip to Miami. When doing that first show, I was nervous and excited at the same time. But I got a really good response. And that's what really what got me. That just gave me the drive."

Since then, Steven has built a huge repertoire of fantasy hairstyles. He has become one of the most visible Hair Wars performers and has made frequent TV appearances on *The Ricki Lake Show, America's Next Top Model*, and *The Tyra Banks Show*. Not surprisingly, his fame has brought him more business. "My clients follow my career, they love it!" he says. "I once got a call from a rich, eccentric lady in Pittsburgh who had seen me interviewed in the paper. She wanted me to make her a hairdo for an animal rights fundraising gala. I made a poodle for her and it ended up in the paper."

Steven's creations are always elaborate and theme-based. His inspirations include varied sources such as the Pittsburgh Steelers football team, Bob Mackie-designed Barbie dolls, and *The Wizard of Oz*. "Sometimes I'll go with what's going on in the world. When 9/11 happened, I was like 'You know what? This would be a great time to do something patriotic,' so I made a flag hair design that went into flames, and put the piece together on stage to a soundtrack of Whitney Houston singing the Star Spangled Banner." He also creates hair outfits to match every style. "It's a lot of work, but I love it. The thing about fantasy hair is, it's creative, it's artsy. And the creativity and the performing go hand in hand for me. I love working with the hair, but to present it in an entertaining way is what makes it really enjoyable, especially with the response I get!"

INFAMOUS LISA B

The Bay Area's Infamous Lisa B is currently one of the brightest stars among the Hair Wars stylists. Her creations are grand and imaginative, using tremendous volumes of hair to sculpt halo-like styles that are integrated with majestic costumes, constructed from hair into extravagant shapes. Like many other prolific Hair Wars stylists, Lisa B was first introduced to the show as an audience member. "I saw my first Hair Wars show in 2001," she recalls. "I had never seen fantasy hair like that before and I thought it was real artistic and challenging, so I felt inspired to do it myself." What happened next is a good example of the generous spirit among the Hair Wars crowd: "Basically, I just got a concept, bought some hair, and asked Steven Noss what he used to make the hair hard. He told me and I went from there."

Although Lisa B's fantasy styles have a coherent aesthetic, her sources of inspiration vary. "I get ideas by looking at a picture of something," she says. "I want to try to mimic something I've seen, like an animal, or I'll look at a hair color and just get an idea, something like that." Her main motivation is to compete with herself. "I constantly push myself to be better. Each time I have to improve, I don't want to do the same things over and over. That's the challenge and the reward, to know that I can make all these creations out of hair." A successfully completed hairstyle is her greatest reward. "That and the response you get from people is the best thing about it. And also seeing it in print in the paper or on television, wherever it ends up, that's quite rewarding as well."

She's had a lot of media attention lately. Besides being written up in several magazines and papers, she was featured on *America's Next Top Model* and *The Tyra Banks Show* along with Steven Noss and Mr. Little. "People are still excited about that—months later, they're still talking about it," she says. However, she won't

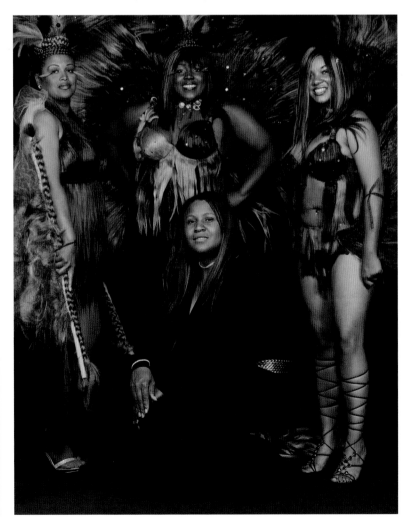

STEVEN NOSS

INFAMOUS LISA B

replicate her famous-from-TV 'dos for her regular salon clients. "I have had requests for fantasy hair, but it's just too costly for the average person. I tell them it's really expensive and it's not really something you can wear, because it's highly flammable and it doesn't really hold up to cold weather. For the money that they would pay to get that hair, it's not worth it."

Unlike a lot of her Hair Wars peers, Lisa B is not overly fond of performing. "It's not that interesting to me. I would really like to just send my models out and walk out later and then I'm done," she asserts. No one who has ever seen her confidently strut down the catwalk would ever be able to tell that she prefers staying backstage. "Over the years I guess I've overcome the fear of it, but it's not one of my better parts. I don't really like the stage, cameras and lights and that stuff. I just really like displaying my work."

Her work is certainly worth displaying. The hairstyles are often integrated with the outfits, creating an incredibly striking effect. For the annual Hair Wars show in Los Angeles, Lisa B created a trio of earth goddesses who represented the sun, a rainbow, and fire, respectively. With their bodies covered in artfully draped masses of vibrant gold, red, and orange tresses, the girls looked like otherworldly creatures with glowing gowns and wings. When creating a stunning display like that, Lisa B surprises even herself. "When I'm completely done, I'm just really pleased and excited. Sometimes, the colors and sizes and results I come up with are amazing to me."

LITTLE WILLIE

Detroit-based hairstylist Little Willie is an innovator whose best creations are born of intuition, dreams, and accidents. For example, he invented the popular "quick weave" hairstyle (a weave that is glued on a cap) during a London hair convention when his daughter caught him off-guard on stage, taking off her hat to reveal a surprise dye job that had to be quickly covered up. His outrageous zipped hairdos are legendary on the fantasy hair scene and have earned him the name "The Zipper Master." True to form, the zipper 'do came to him in a flash of inspiration. "I came up with it one day when I was working in my salon, " he recalls. "At that time French rolls were in style, and something came to me and told me to put something different in that French roll, something like a zipper. So I took a regular coat zipper with gold teeth and a black cloth, and I cut the cloth and then made a French roll and put the zipper between the rolls. When I showed it at a Hair Wars show, people went *crazy* over the hairstyle, I'm telling you. So the next time I did it, I made it so you could zip it up and zip it down. And once I did that, it was over!"

From there, he expanded the idea to include surprising objects hidden inside the roll. "One of these hair shows I did, I put a live bird in there. And another time I put a camera. I've also had a champagne bottle with two champagne glasses in there. And a change of outfits, a TV, a bible, and a purse—you name it, I've had it in a French roll. But the most famous one is when I put a four-foot-long python snake inside. A lot of people really, really liked that one. "

Willie's toned-down versions of the zipper 'do are popular among his salon clients. "I also do the zipper on regular haircuts. I put a zipper on regular fade haircuts and on "real" styles that people wear out. As a matter of fact, there's a young lady who used to take a plane all the way from California to Detroit, just to get a zipper for her hairdo. Before 9/11, the airport security wasn't as bad as it is now, so she could get away with it. She used to go through the metal detector and the metal detector would go off, and they'd look at her and pay no attention. But now, oooh, they'd probably take it out of her hair now."

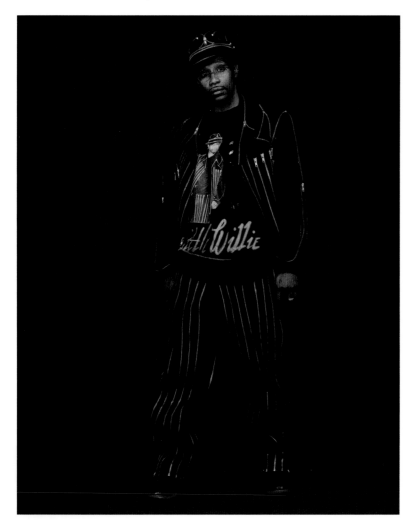

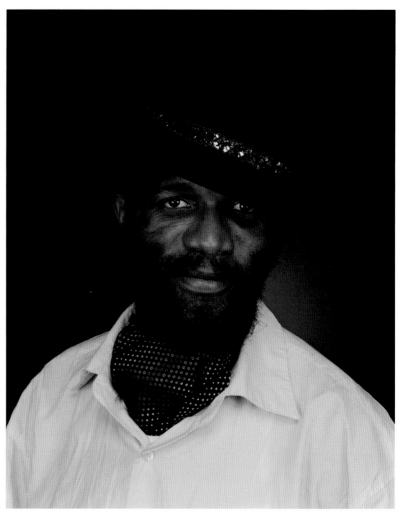

LITTLE WILLIE DAVE RAY

Although not all of Little Willie's hairstyles revolve around zippers, they share certain similarities. His creations are never abstract; they always have a clear motif. "I have different themes," he explains. "You wanna have a theme, because you don't want to create just anything. I have a style that I created with a guitar out of hair, and what I was trying to do was: America loves rock and roll. That's what I wanted to show. And I have another one that I'm working on right now. America loves choppers, motorcycles, so that's what I wanna do next. I wanna put a Harley on the head, a Harley Davidson, and make a total look with the outfit and everything, in hair. I think that'll be unique." Many of Willie's best ideas have come to him while he was sleeping: "I dream about hairstyles," he says. "I go to bed at night and have a dream and when I get up that morning I put it on paper and then I put it together in my mind. And once I've put it together in my mind, then I take it from my mind and put it to practical use. I did a Hummer out of hair, and it came to me in a dream—that's how I thought of a person with a Hummer on their head."

He also continues to dream up more versions of his famous zipped 'dos. "That's my signature. That makes it different. There's no other fantasy hairdo like Little Willie's because I use the zipper. It's what I created."

DAVE RAY

The dapper New York-based hairstylist Dave Ray sometimes goes by the name "The Beauty Surgeon." Perhaps it's because he has such a sharp and precise eye when he creates his hairstyles. "It's a total package of balance, symmetry, creativity, and clean technique," he says. "The fantasy piece has to be clean and completely integrated into the model's hair. You shouldn't be able to tell where the real hair begins and ends. Some people just plop a piece on somebody's head and then they wonder why they never place in competitions." However, as meticulous as he is, Dave spends a lot less time working on his pieces than most fantasy hairstylists. "A lot of my colleagues start many weeks in advance before a show. I don't like to plan, I usually start just a few days before," he says, "The stress excites me." Considering he also designs and makes his models' outfits, it's a good thing he enjoys the adrenaline rush.

Dave has been creating fantasy hairstyles for the past 12 years, but not always regularly. "Sometimes I've been very consistent, but sometimes I need regrouping," he says. He tends to look at his creations with an architectural eye; it's the structure itself that seems to fascinate him. One of his fantasy hairstyles replicates the landmark design of the Brooklyn Bridge, and one of his earliest pieces was an elegant triangular 'do that was inspired by the symmetry of a hanger. He won his first fantasy hair competition, the prestigious Bronner Bros. show, in 1996 with a sophisticated Olympic-themed creation. The hairstyle features five Olympic rings made of braided hair wrapped around Styrofoam, and a matching hair torch. "I was watching ads for the games on TV and I saw that symbol and thought, 'How can I bring that to life?'" he says. The circle part turned out to be easy, but getting the rings attached to the head was trickier. In order to find a solution, Dave went back to his Antiguan roots. "I'm from the islands," he says, "and we do lots of carnivals. So I looked into finding someone who could make me a base for a headpiece." He found a craftsman who created a subtle, custom-made metal wire crown that the circles could attach to. He then braided his model's long hair and wrapped it around the base. The finished style came out perfectly sleek and clean, with the metal base completely disguised by hair. Although he was happy to get first prize for his 'do, he says winning was not the most important part. "Creativity is my passion. It's about doing the best you can do. I want to be able to look at my work and say, 'Oooh, that's good.'" Dave also likes to be challenged by his peers. "One of the best things you can get is constructive criticism. Accolades don't help you grow. But when someone says, 'I like this, but have you thought about improving this and that?' you tend to listen. I don't want to be good, I want to be great."

MR. LITTLE

The sleek, lithe, and slightly aloof Mr. Little is one of Detroit's best-known stylists. He is often introduced at the Hair Wars shows as "the hardest-working man in the hair business." "I believe they call me that because of the amount of energy that I put into the hair field," he explains. "I put 100 percent into all the hair shows that I do. I probably bring the most crowds to the show, and then I'm also in the show, dancing, performing, doing hair, and pumping up the show, so there's no stopping."

A Mr. Little performance is a mini-Hollywood production, complete with dancers, elaborate costumes, special effects, and spinning, smoking, blinking hair. But the focal point is always Mr. Little himself and his quick, agile styling technique, which he integrates into complicated dance routines. One of his most famous acts is called "The Matrix," a gravity-defying number where his models are spun upside down and Mr. Little hangs suspended from their bodies while transforming their hair styles with different weaves. "I get really deep into the whole scene of what we're gonna do," he says. "I do most of the choreography and I do most of the clothing. I also put the skit together and I run the rehearsals and then I do all the styling of the hair. That's what makes it different: the combination of all those things put together."

It's the sense of competition itself that drives him the most. He was fresh out of beauty school when he first started performing with Hair Wars. "I started in 1989, 1990," he recalls. "And the reason I got into fantasy hairstyles was because we were always in competition. We always tried to come up with different styles, different ideas, and different creativity in order to win over the audience." Mr. Little's first breakthrough style was a detachable ponytail, which eventually evolved into a reversible ponytail that could be turned on the head and become two different looks. Eventually he found his own unique niche,

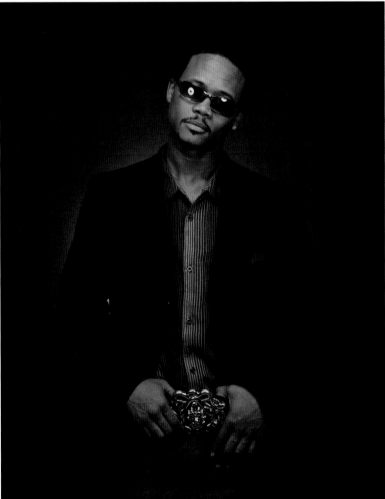

MR. LITTLE

science fiction-inspired hairdos that incorporate special effects. "My signature style is hair in motion," he says, meaning hairdos that incorporate mechanisms that make them move by themselves. How did he come up with it? "Well, I wanted to make something completely different than what everyone else had. So I took a motor and wrapped hair and lights around and it connected it to a battery. When I put it in the model's hair, it made it spin. It was a real sight." Another of his most famous creations is the Hairy-copter, a helicopter-shaped hairpiece that is neatly integrated into the model's hair, with a revolving back propeller that sticks out like a ponytail. Again, the idea was born out of Mr. Little's competitive spirit, his desire to outdo all other hairdos, rather than an abstract flash of inspiration. "I'm not afraid to do the crazy things because I know that's what makes the people go wild," he says. "That's what I'm looking for. I'm looking for the energy of the audience."

Mr. Little is one of the most visible Hair Wars performers in the media. He's been on *The Ricki Lake Show* four times, as well as *Ripley's Believe It or Not*. But it was his appearance on *America's Next Top Model* that brought him the most notoriety. "I got a *lot* of attention from that show," he says. "That was real nice. I realized how many people were actually watching it here in Detroit. Most of the shows I get on, people call me up afterwards, but this particular show it was like everywhere I went: 'Hey, I've seen you on the show, I've seen you on the show.'" Mr. Little has his own salon on Detroit's east side called Better Fashion Hair Designs and his own line of products called One Time Hair Products. "Customers come to me because of my name," he explains. "The shows really put you on the map and get people to look at you as a celebrity. And that makes them want to talk to you and want to be around you."

MS. 'COLOR ME' VIC

Ms. 'Color Me' Vic's greatest creation is herself. Her entire figure is rendered in primary colors, from her hair to her eyelashes to her custom-made suits. Her nails are like sculptures, long, with swirly, abstract color patterns reminiscent of 19th-century spatter glass. Her look is not a stage costume—she is deeply committed to it and wears it every day. "This is my image," she says. "I've been like this for 20 years. The rainbow inspires me because spiritually it means positive energy and each color has a meaning. They're very friendly. Colors make you happy, and when other people see me I make them happy. So that makes me happy, to know that I make other people happy when they see my rainbow."

She was a young single mother in the early 1990s when she decided that she was tired of making seven dollars an hour as a shop clerk, and enrolled in beauty school. Shortly after graduating, she met Hump the Grinder, who liked her look and invited her to perform with Hair Wars. "I said, 'I want to be a movie star. Can you make me a movie star?' And he said, 'Yeah, I can make you a movie star,'" she recalls. Ms. 'Color Me' Vic is the perfect embodiment of Hump's vision of the hairstylist as entertainer. Not only does she sculpt spectacular rainbow hair creations, she also dances and raps on stage. "At that time, I was just called Miss Vic and David said, 'You need a name.' So we were up for like two days trying to come up with a name. Then all of a sudden we came up with Ms. 'Color Me' Vic. Well, it took me six months to remember my name, but then I started really feeling Ms. 'Color Me' Vic. When you have a name and you feel it, you can act out your name. That's what I've been able to do. I'm representing who I am".

Over the years she has become a celebrity of sorts in Columbus, Ohio where she lives and operates her salon, Ms. Vic's Hollywood's Expressions. "I've been on Ricki Lake, Jenny Jones, Sinbad, *Extra,* and *Ripley's Believe it or Not*," she says. "People say, "Hi, Miss Colors, I've seen you in a magazine!' and I have to ask them, 'Oh, which one?' because I'm in so many of them. Everywhere I go I capture attention." Once you've laid eyes on her you'll never forget her. She is instantly

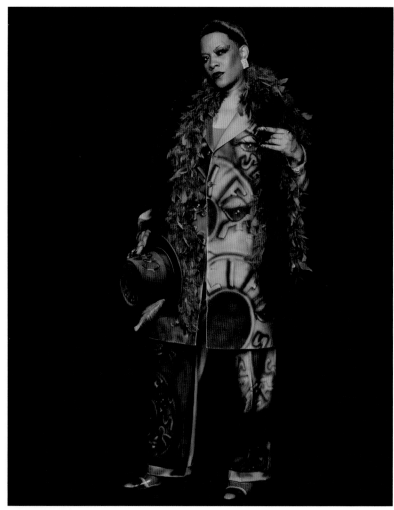

recognizable but never looks the same. "I change my hair every three weeks. I can do it in five minutes. I take colors and mix whatever I'm feeling. I don't know what I'm going to do beforehand. It's whatever comes to mind." She meticulously matches every aspect of her outfit. "I wear my makeup according to my hair color; my lipstick has to match my hair. I like to be coordinated."

She acknowledges that keeping up her appearance takes a lot of work, but says that it's all worth it. "The love and the hair have brought me so far. I would never change it. I would never change it."

CELESTE TOOMER

Most fantasy hairstylists find their inspiration in continually creating bigger, bolder, and more original hairdos. San Diego-based Celeste Toomer's drive is a little bit different. Rather than focusing on the hair and letting clothes and makeup play second fiddle, Celeste is interested in the whole picture. Her little ensemble of show models is carefully composed like a painting, each girl complementing the others. The entire look has been styled and created as a whole, and each detail is an equally important component. "I start by drawing out my ideas on paper," she explains. "I sketch everything out, exactly how I'm going to put the makeup on, make the outfits, everything. I take my time and I really do things. I think about the theme of the show, what I'm gonna do, what I wanna do different. I ask myself what I can do to distinguish my work, Celeste's work, from everyone else's." The balanced composition and coherent execution is what sets her work apart. "There's always a theme," she says. "I find it by listening to different music or looking at colors." She is particularly partial to blue. "Blue is a special color for me. It's beautiful. It's so calm and refreshing but at the same time it's electrifying. It comes out hot."

She started performing with Hair Wars in 2000 and it's still the only hair show she participates in. "It's the funnest show!" she exclaims. "There's no competition, you just do you. I love that, I love the energy, it's not catty. It's good

energy all the time and it's fun." What's the best part for her? "It's fun to do the fantasy hair because you really get to take your creativity where you want to take it. And to see the reaction, to see people's faces and get the compliments. To see what you can do with some hair!" While she doesn't perform any complicated dance routines, she always gets up on stage with her models, asserting her presence with a confident swagger. "I like performing. I like the catwalk. Its fun to be up there and it makes my girls feel comfortable. I'm just all around—hair, outfits, makeup, performing! I love it, it's a rush!"

WISHBONE

The Detroit-based stylist Wishbone's fantasy hair creations are not confined to the head. He is mostly known for his extravagant hair outfits. Some he makes for himself, such as a suit covered in luxuriously shaggy black hair that resembles some kind of exotic animal skin. For his models, however, he creates sweeping and elaborate bustiers, skirts, and dresses that incorporate braiding and colorful feathers. "I'll throw them on my models and then we'll hit the clubs," he says. "It's a great promotional tool." Wishbone's hair couture appears regularly on cable TV shows and in hair magazines. His very first outfit, an all-orange getup that he created for a 2004 Hair Wars show at the Apollo Theater in New York, made it to the front page of the *New York Post*. But Wishbone's head-based hair creations have received a lot of attention too. His first ever fantasy hairstyles, a giant hawk with four-foot-wide wings perched on a model's head and a rainbow-colored mohawk, made their debut on a special Easter hair show on Detroit's Channel 2 in 2006. "Nobody knew I was doing them," he says. "It was a surprise for everyone. People kept calling my house, clapping and screaming, they were so excited."

Wishbone works at fantasy hair champion Little Willie's salon. He says that being around such an abundantly creative stylist definitely has rubbed off on him. But Willie isn't Wishbone's only influence. "I saw Raphael perform at a Hair Wars show years ago", he effuses, "and it's just unexplainable how fabulous he is." He also admires the creativity and polish of the renowned Detroit hairstylist Kevin Carter. However, his flamboyant styles have their own distinct flavor. "I get my ideas from the Lord above," he says. "They come to me in my sleep. Or I can just look at someone and see something special, or I look at nature and trees. I like to look at how things are put together." Figuring out how "things are put together" is a big part of Wishbone's creative process. "Nobody has taught me how to do this, I just think about it and then I start to make something," he says. "It really brings out my skills, that's what makes it interesting." Although he dreams of one day creating hair costumes for movies like *Austin Powers*, he currently gets his greatest thrill from competing and performing at hair shows. "That's what really inspires me," he says, "to take something I see and make it my own. You want to be the best."

VERONICA FORBES

Few people have developed fantasy hair as distinct as that of New York hairstylist Veronica Forbes. Her always recognizable, yet ever-evolving creations have the vibrancy of fireworks and delicacy of spun sugar. Unlike most fantasy hairstylists, Veronica has one source of inspiration that continues to feed most of her designs. "There is a crystal place in Jersey that I go to," she says, referring to the fine china and glassware store Mikasa. "I love to look at the crystal there—the shapes of the leaves and the dishes, and I just picture it on someone's head."

Veronica has always been fascinated by hairdressing and beauty. When she was a little girl she would tell her mother that her hairdresser appointments

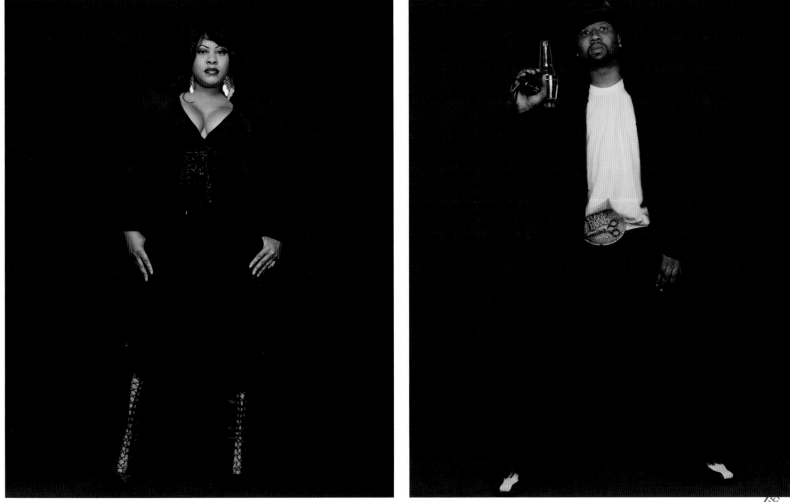

CELESTE TOOMER WISHBONE

were earlier than they actually were, just so she could spend extra time at the beauty parlor. She always knew she wanted to be a hairstylist and what kind of hair she wanted to do. "When I started in this business I didn't want to be just another hairdresser. What I liked was the glitz and the glamour," she says.

Veronica has lived up to her dreams. Besides creating some of the most beautiful fantasy hair in the business, she cuts an utterly glamorous figure herself. She is always perfectly coordinated in purple outfits, purple hair, and sparkling purple eyelashes. "I call myself the purple diva," she says. "It's a regal color." She is a stylist who is not necessarily motivated by stage performance or competition. Her main impetus is the beauty of the work itself. "Fantasy pieces give you an opportunity to create," she says.

Her salon in Harlem, Veronica's Beautyrama, is full of dusty trophies she has won at hair shows. She spends a lot of her spare time working on new fantasy creations. "When I get an idea I don't make drawing of it," she says. "I see it in my mind and then I go to work. I mold a piece of hair on cardboard to put the basic shape in and once I do that I put it on a mannequin to see where I can make changes. I might mess up a lot at first, but I improve from there, and after I perfect the piece I put my stones and my glitter on it." One of her signatures is her use of rich, vivid color. "I don't like dead colors. Today you can buy any color that you want in any hairdressing shop: purple, pink, green—you name it." However, her hobby isn't cheap. "It's expensive, you mess up a lot of hair, but when you have a passion for something, the reward comes from that. It's just something I love doing, so I'm going to spend that money if I have to spend it."

ALI D'SHUA

Ali D'Shua is a relatively new fantasy hairstylist, but he's not new to the scene. While working at Little Willie's salon, Ali watched Willie create his famous 'dos for years before daring to try himself. "I was scared of doing fantasy hair," he says. "When I was working for Willie I watched him doing fantasy, and I would say, 'I want to do it, I want to do it,' and he said, 'Do it!' But I was intimidated—the hairstyles were so big and intense." However, last year he worked up his nerve to try. "I said to myself, I'm gonna have to tackle this thing, because fantasy hair is the future." His first effort was an impressive Hair Wars performance that involved two angels with giant hair wings and lots of Christmas lights. "I wanted it to be a battle between good and evil," says Ali. "We had an angel with black wings who represented evil and a good angel in white who had her hair wings lined with lights. The story line was that the good overcomes the bad, so we lit up the blond angel's wings on stage so she overwhelmed the black angel." To pull off his tech production, Ali got help from his cousin who works as an electrician. "I like to have an element of surprise, you need something with that edge," he says. His second Hair Wars show also involved theatrics and special effects. "The idea was to stage a family reunion," he says. "I thought it would be nice to have a picnic, so I built a grill made out of hair, and we actually cooked hot dogs and I fed them to the girls onstage." Performing with Hair Wars has helped Ali evolve as both a stylist and a person. "Hump inspired me to promote myself," he says. He also thinks the show plays an important social role. "It's good for the community. It's exciting and it breaks up the daily grind. It's gives people something positive to do." Coming from this perspective means that he takes his own message seriously. He likes to stage a real narrative, with a beginning, middle, and end. "I like happy story lines because I come from a happy family and grew up going to church," he says. "I wanted to use my venue to express something good. We've all had our ups and downs, and when you look at the whole spectrum of life you've got to be thinking, we have so many things out there that are negative, so much drama. When you do something positive, you stand out, and you can inspire others too."

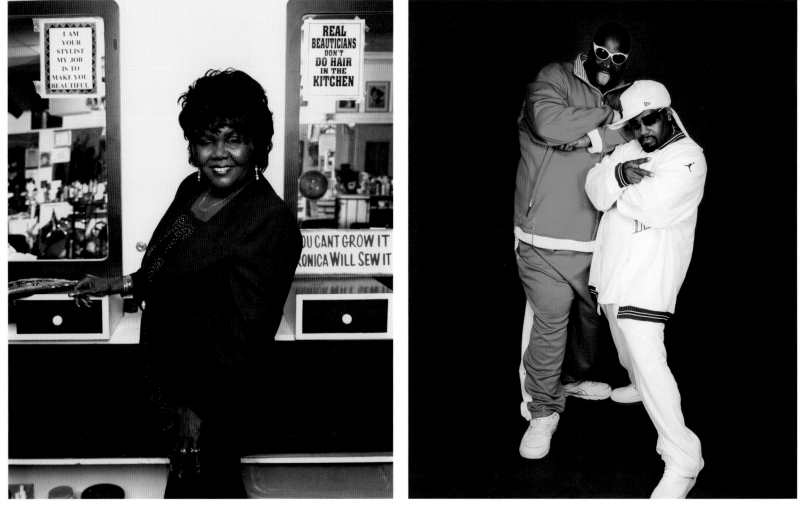

VERONICA FORBES

BIG DICKIE AND ALI D'SHUA

THIS BOOK IS DEDICATED TO THE MEMORY OF MR. LITTLE
1964–2007

"I dream abc

ut hairstyles."

—Little Willie

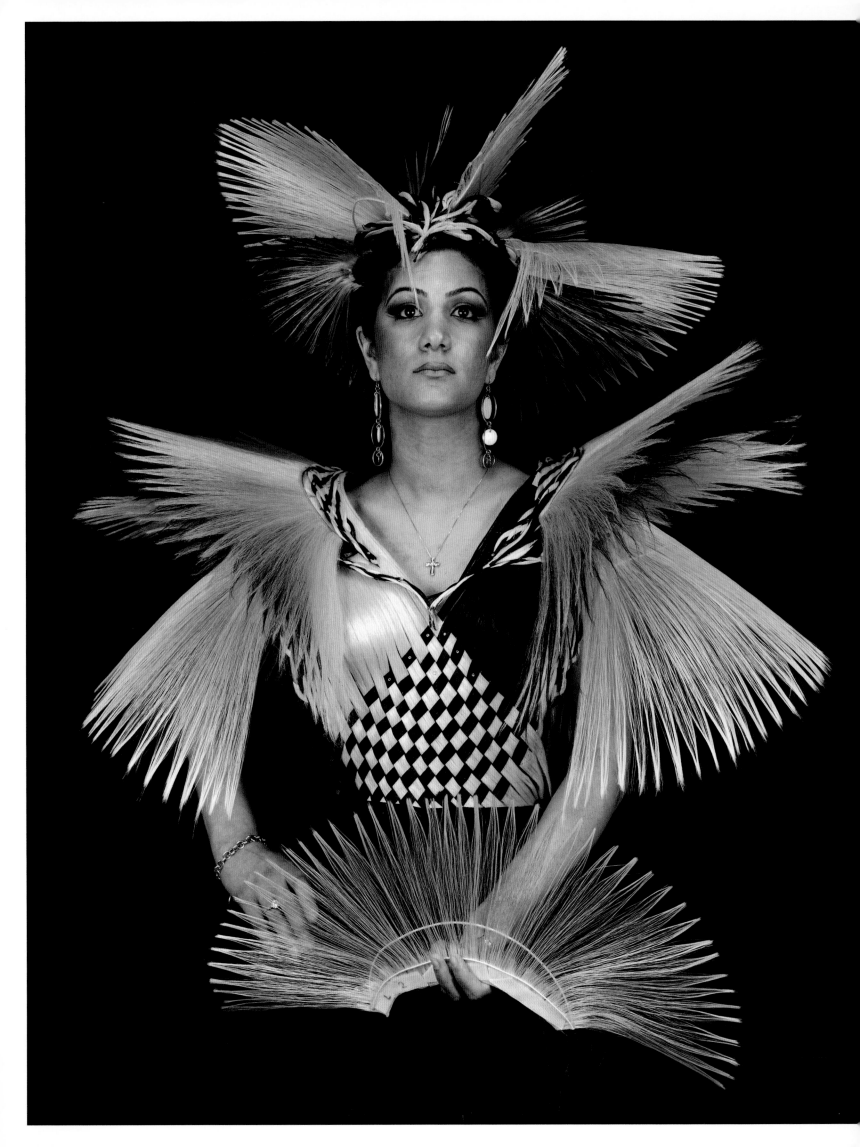

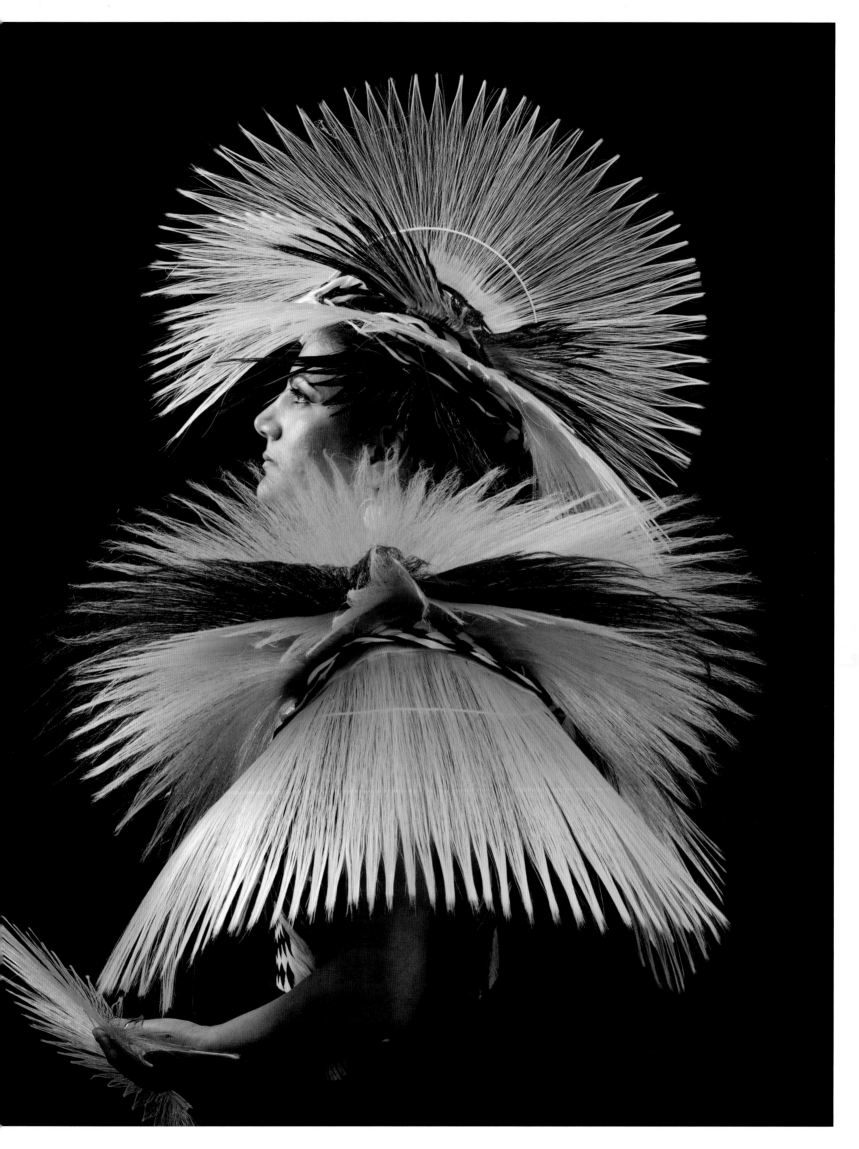

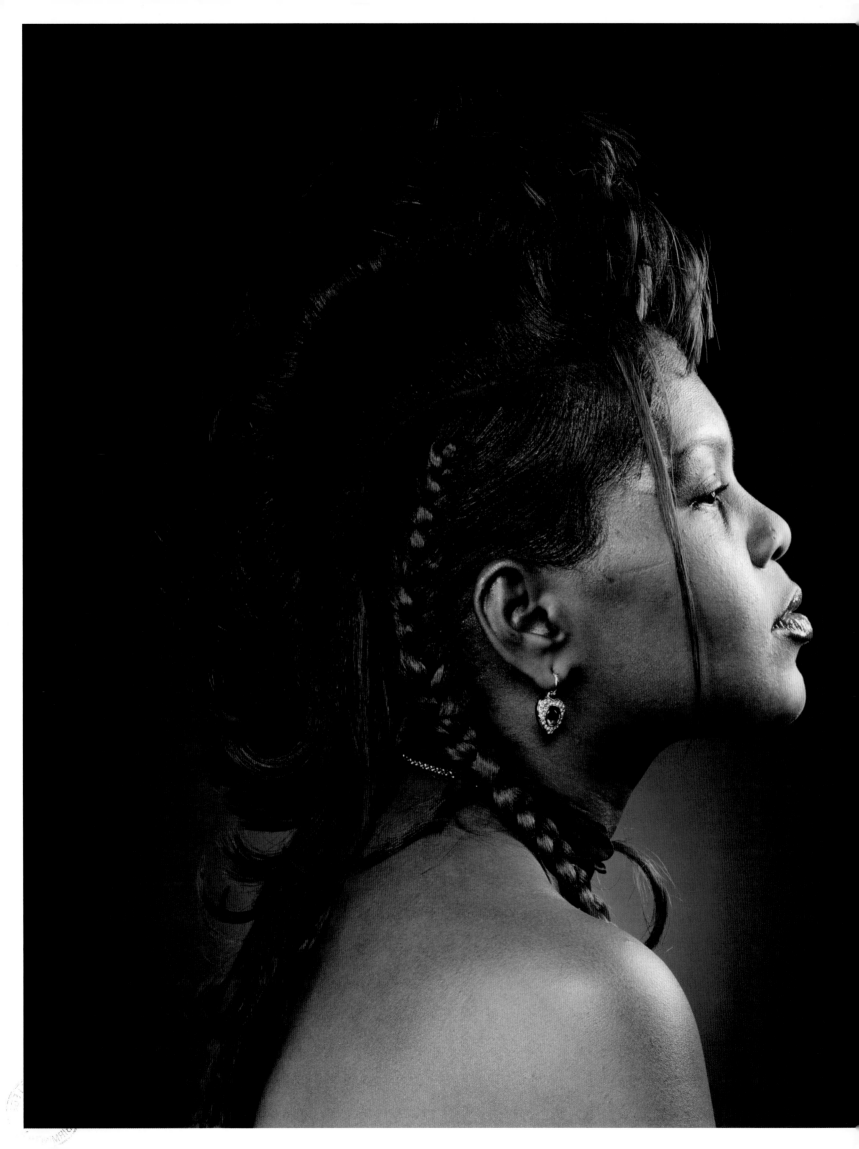

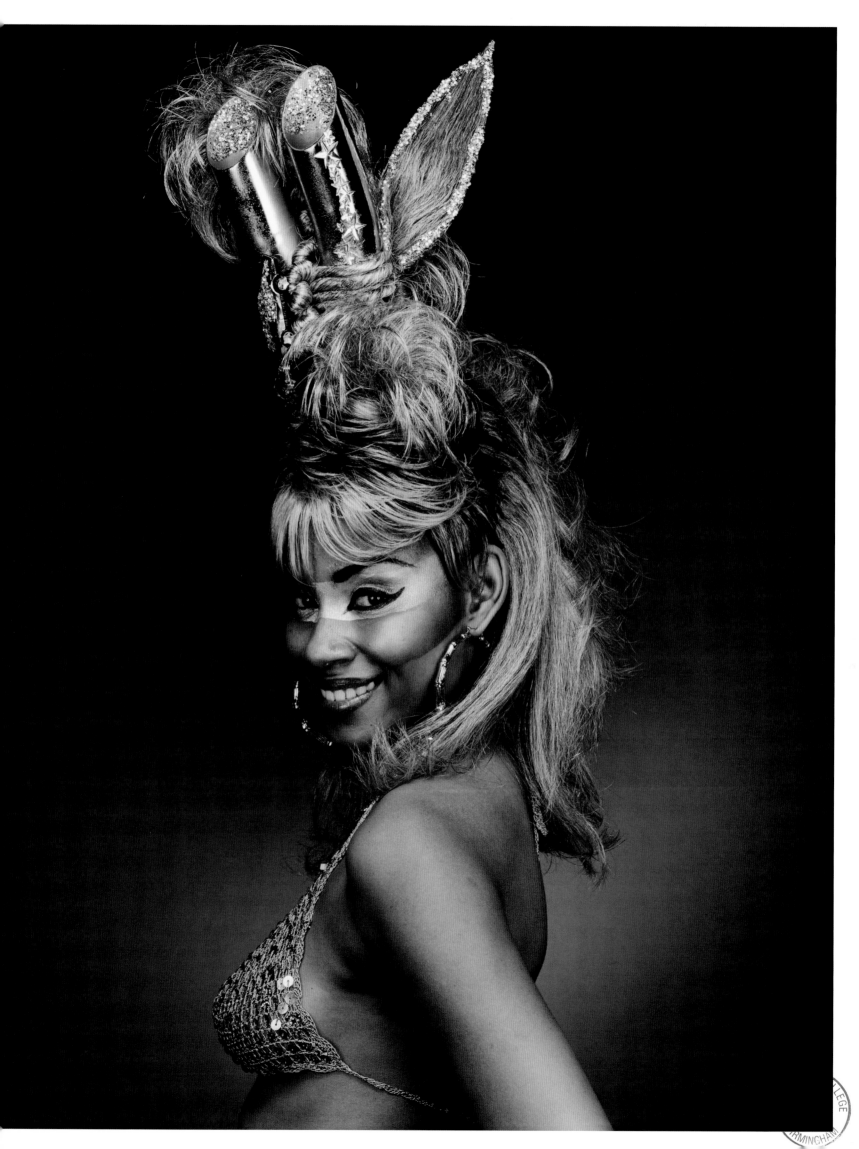

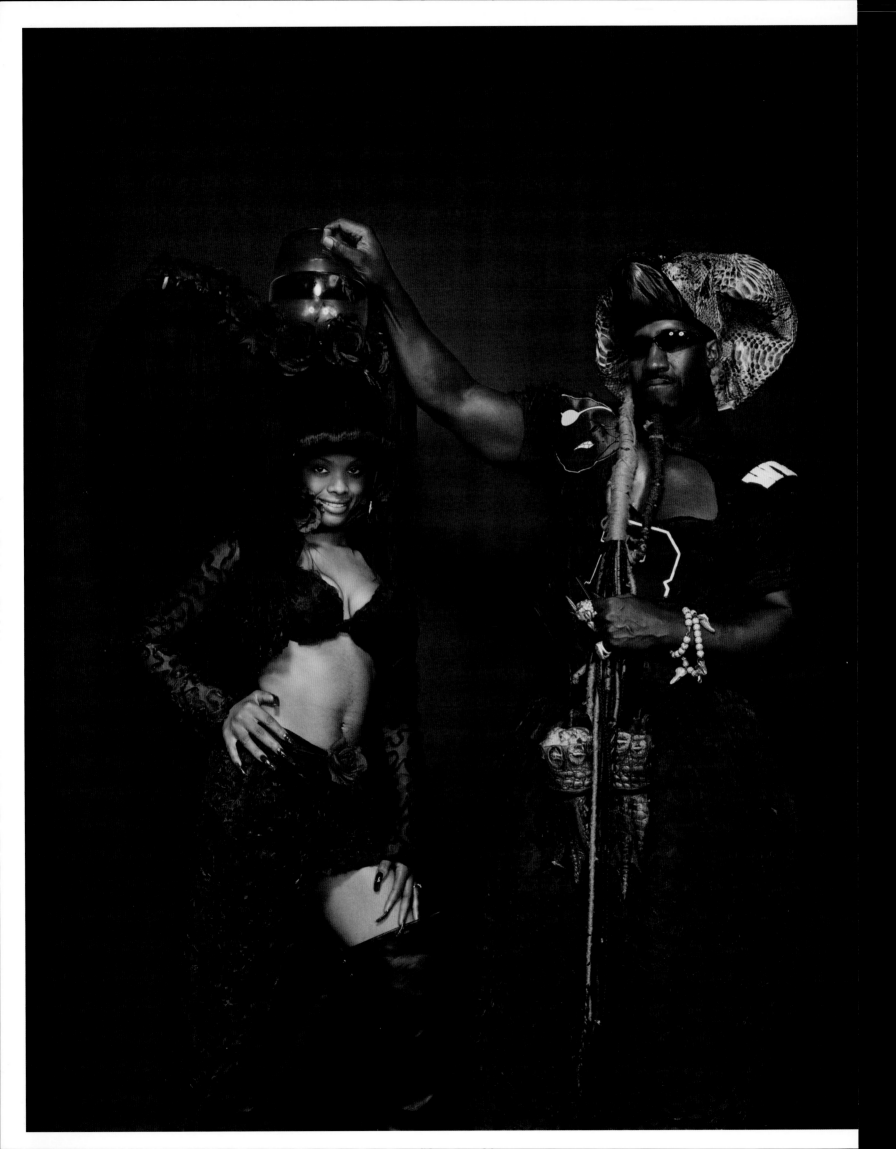

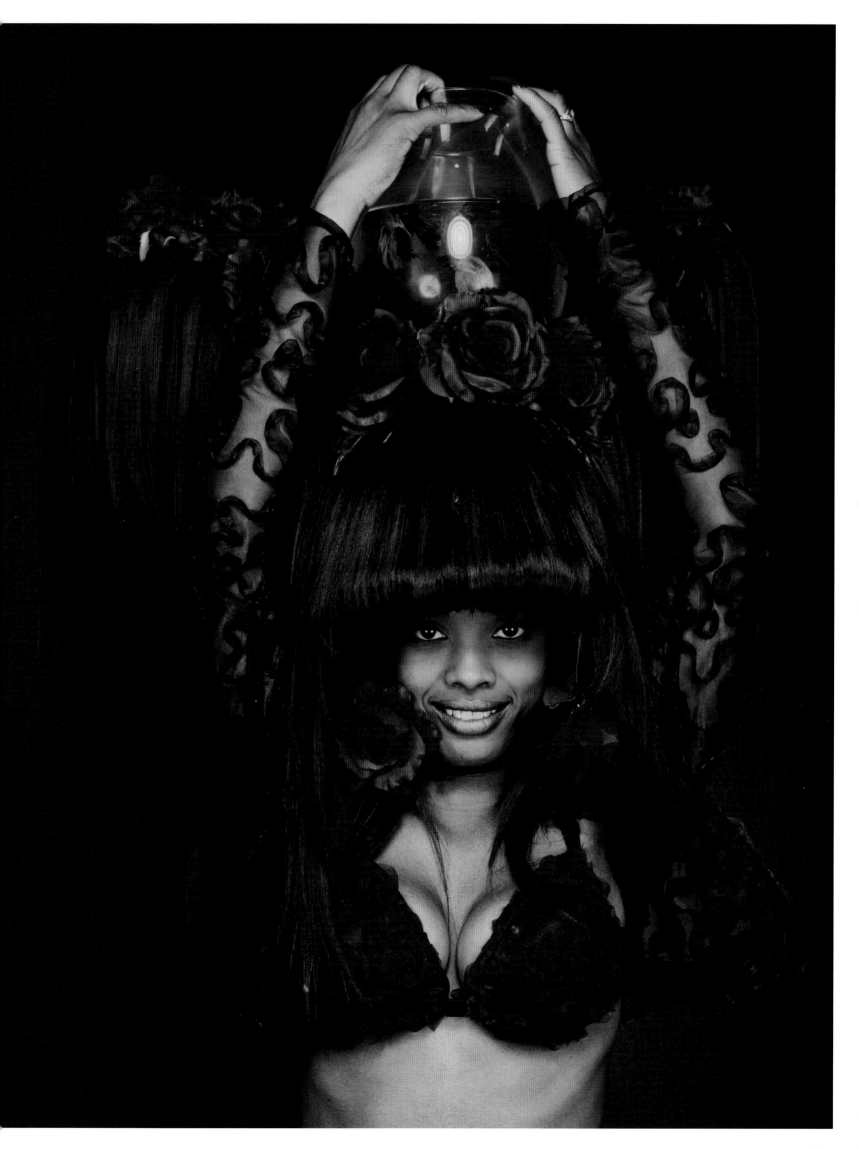

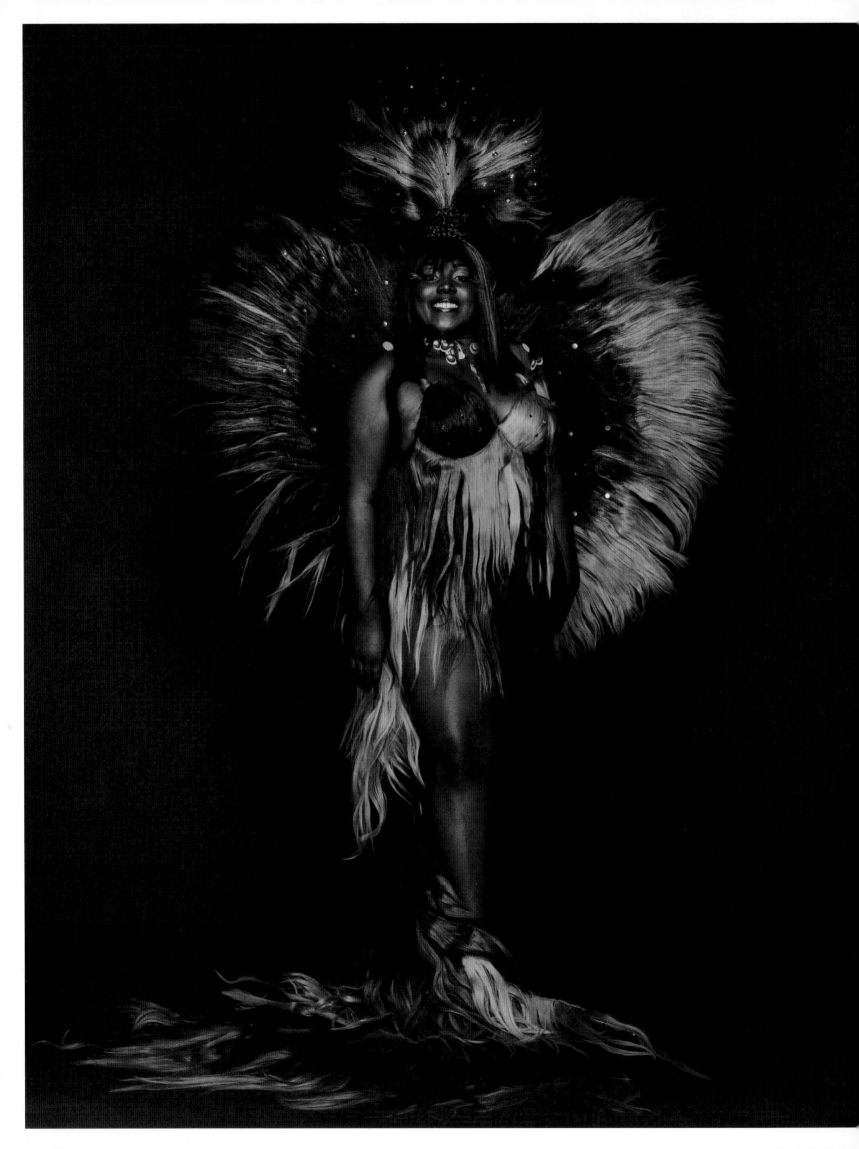

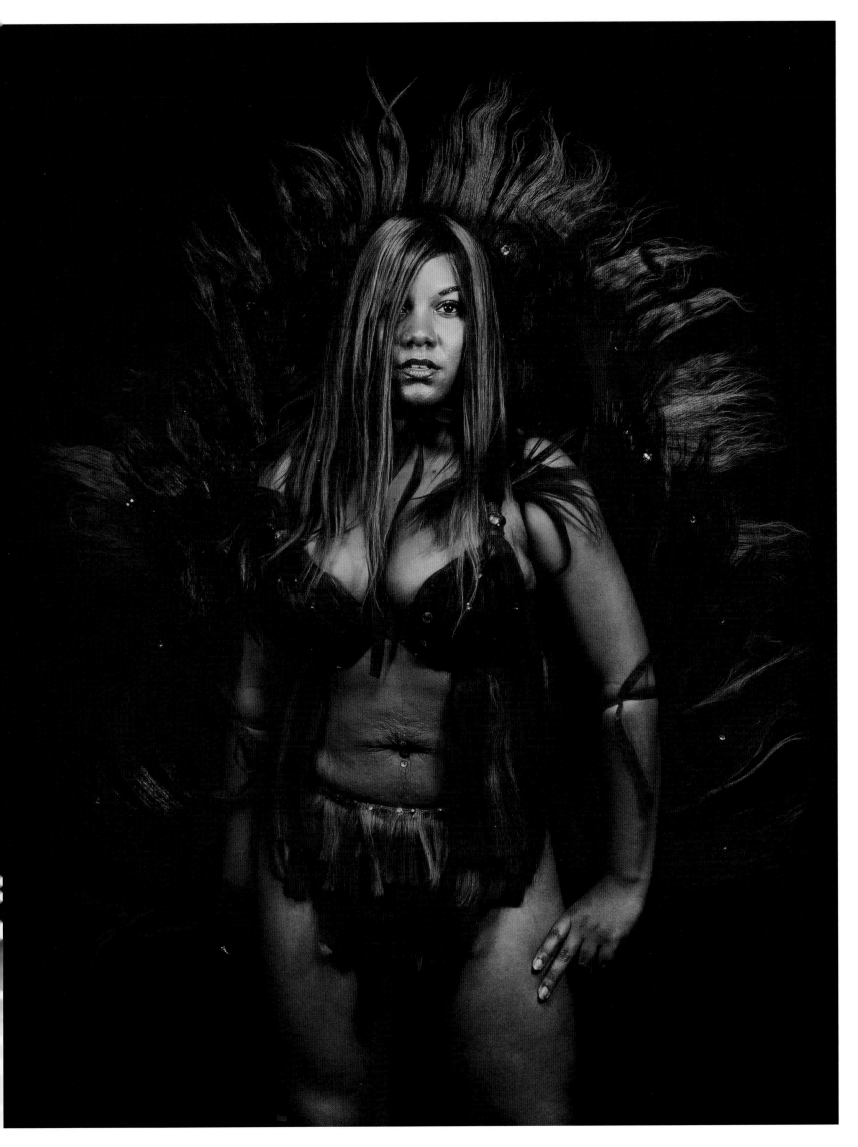

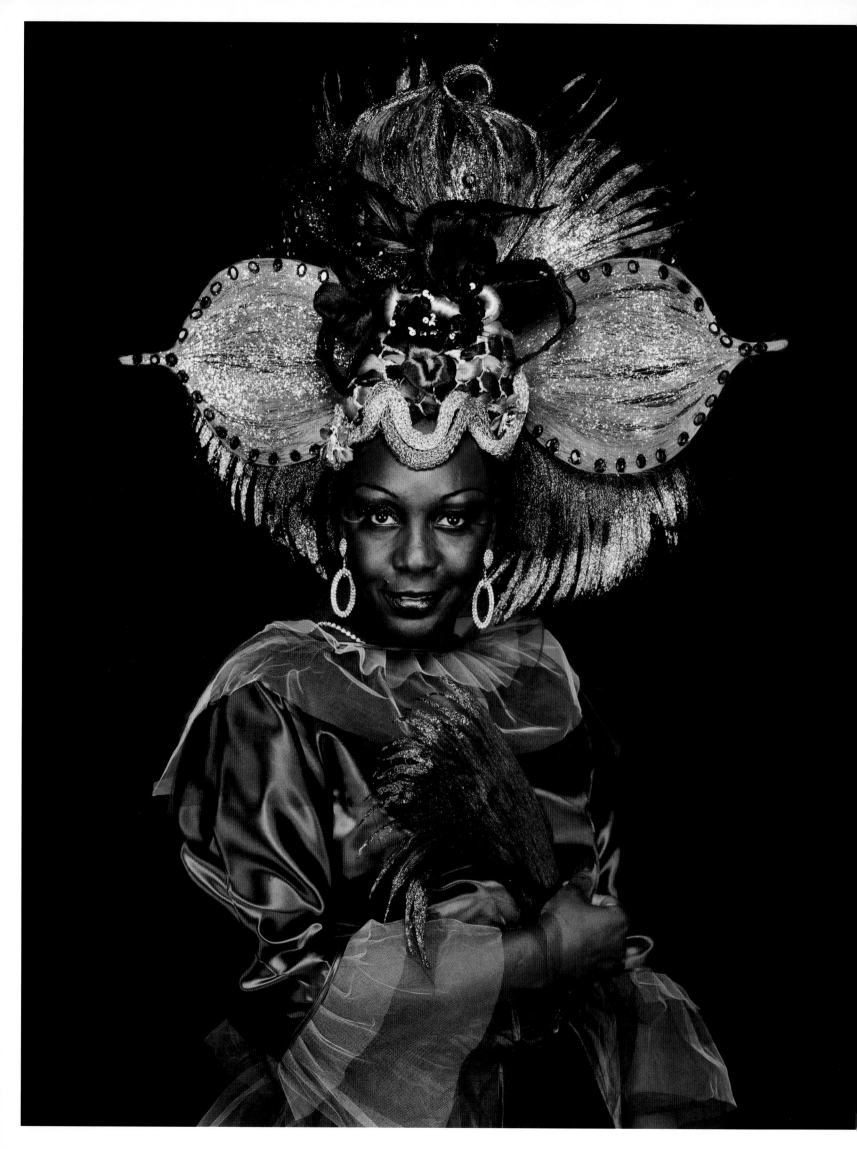

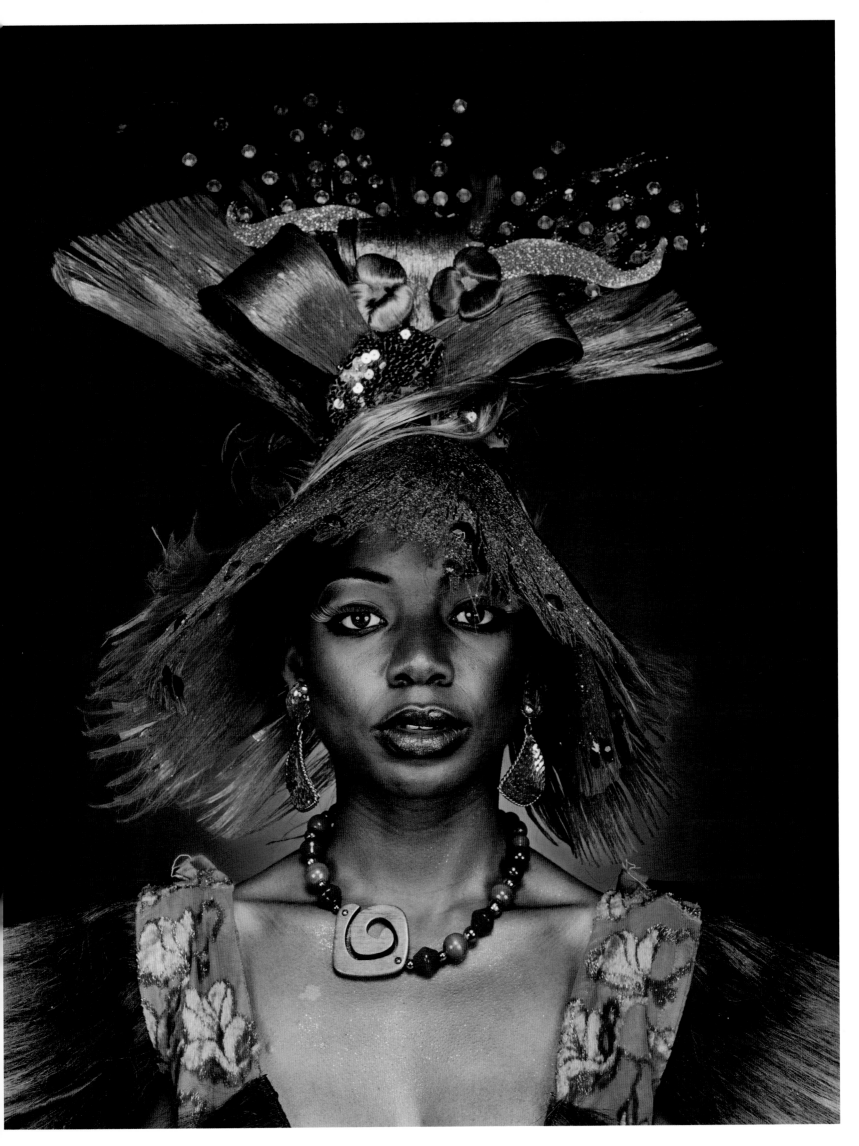

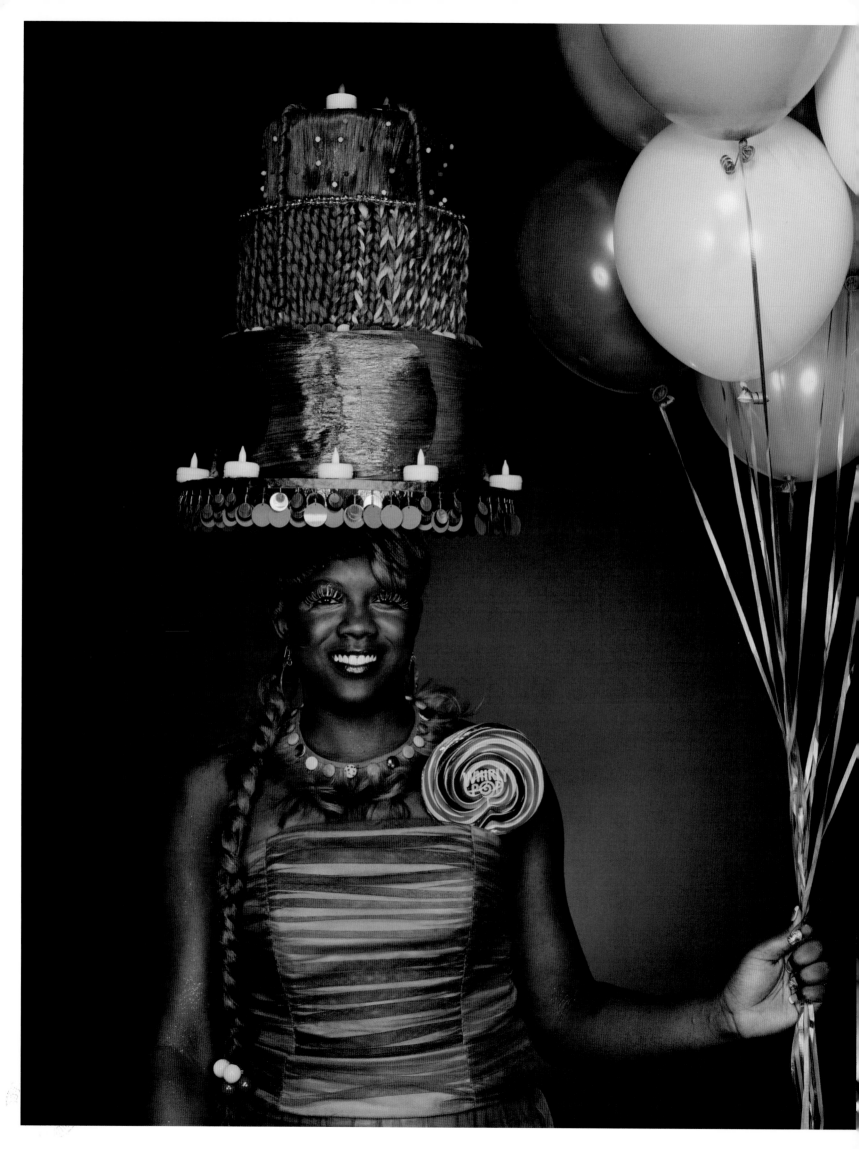

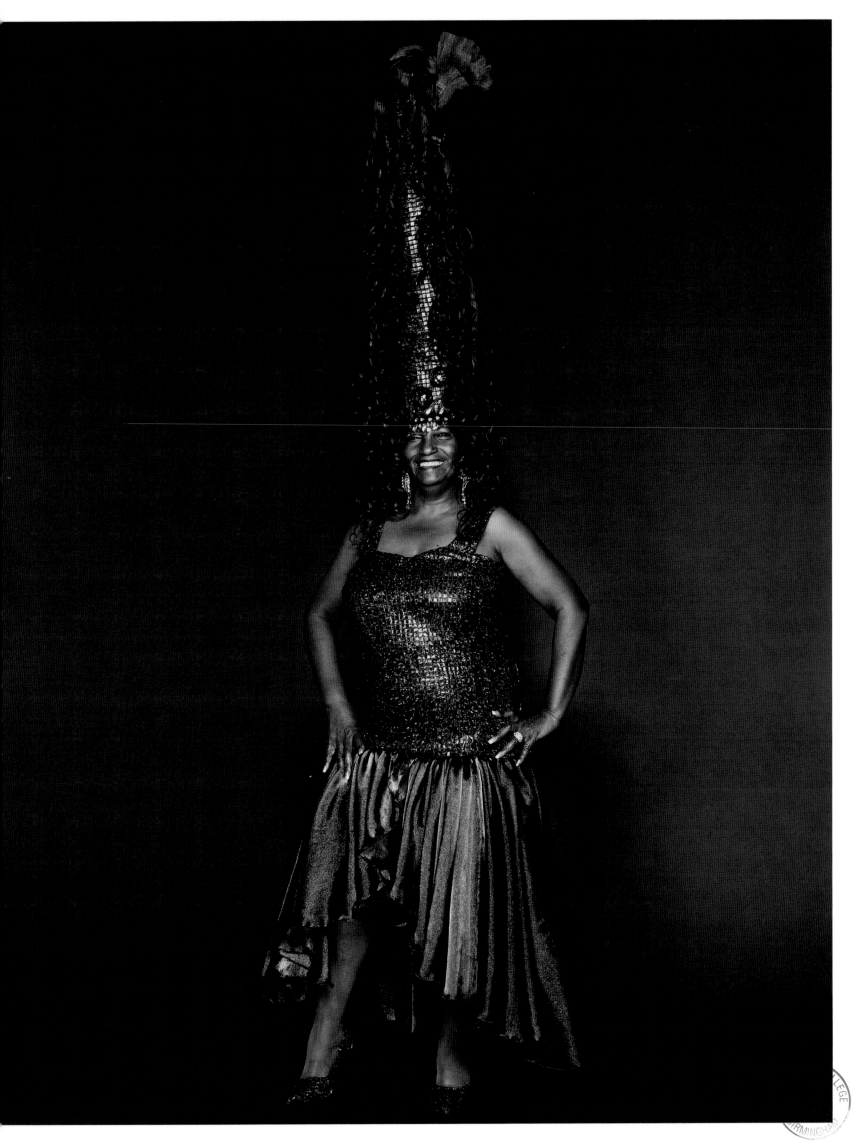

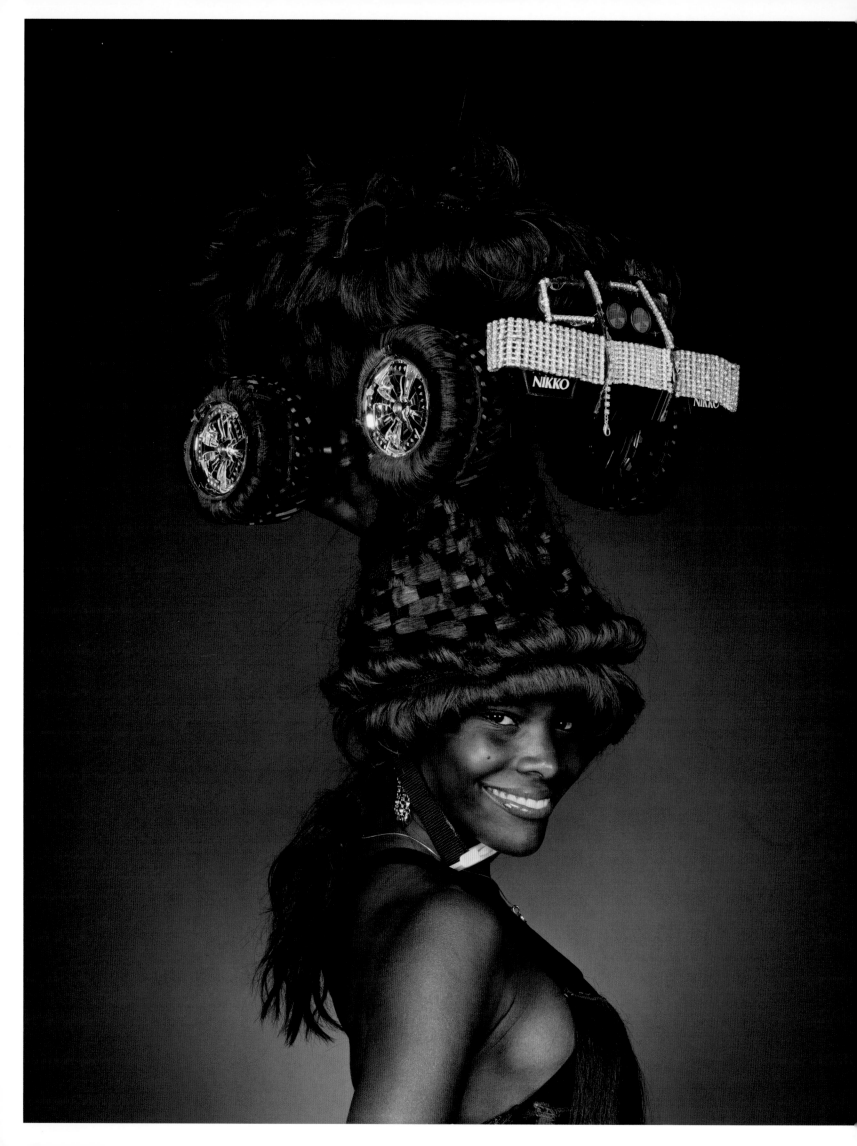

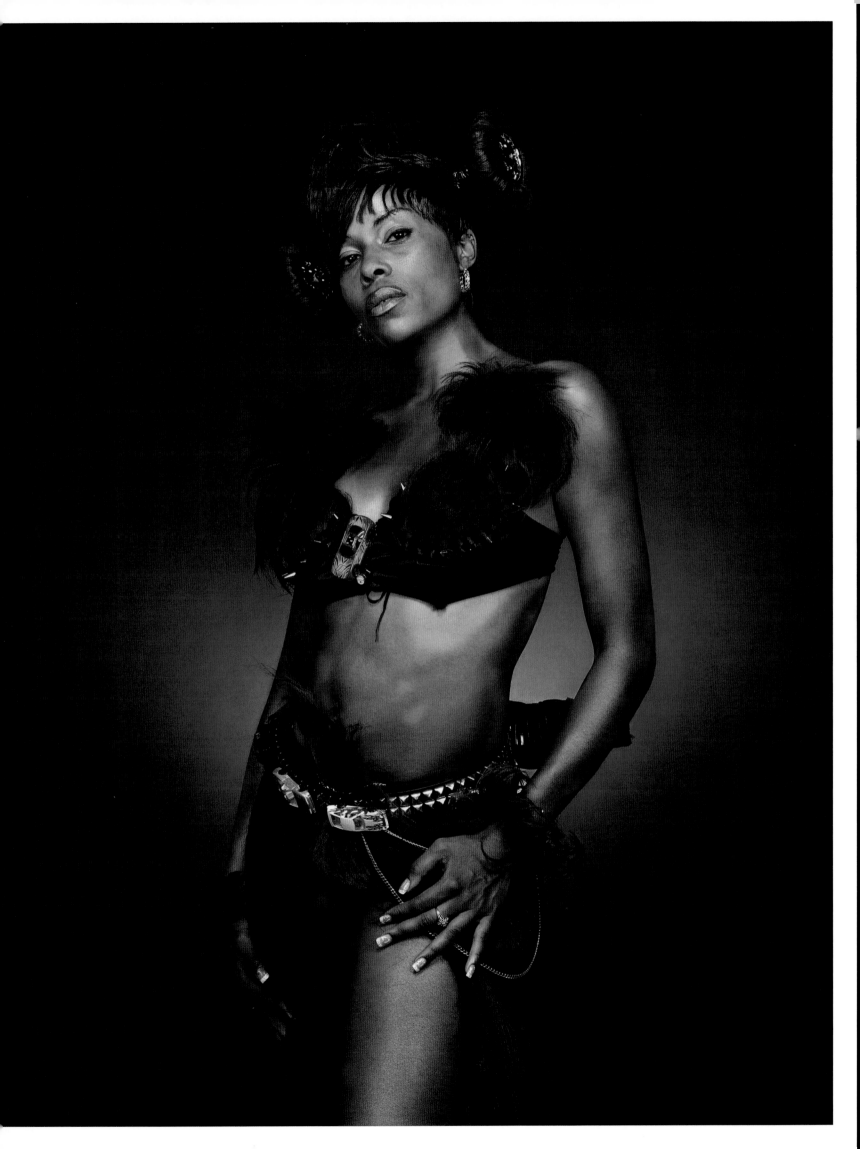

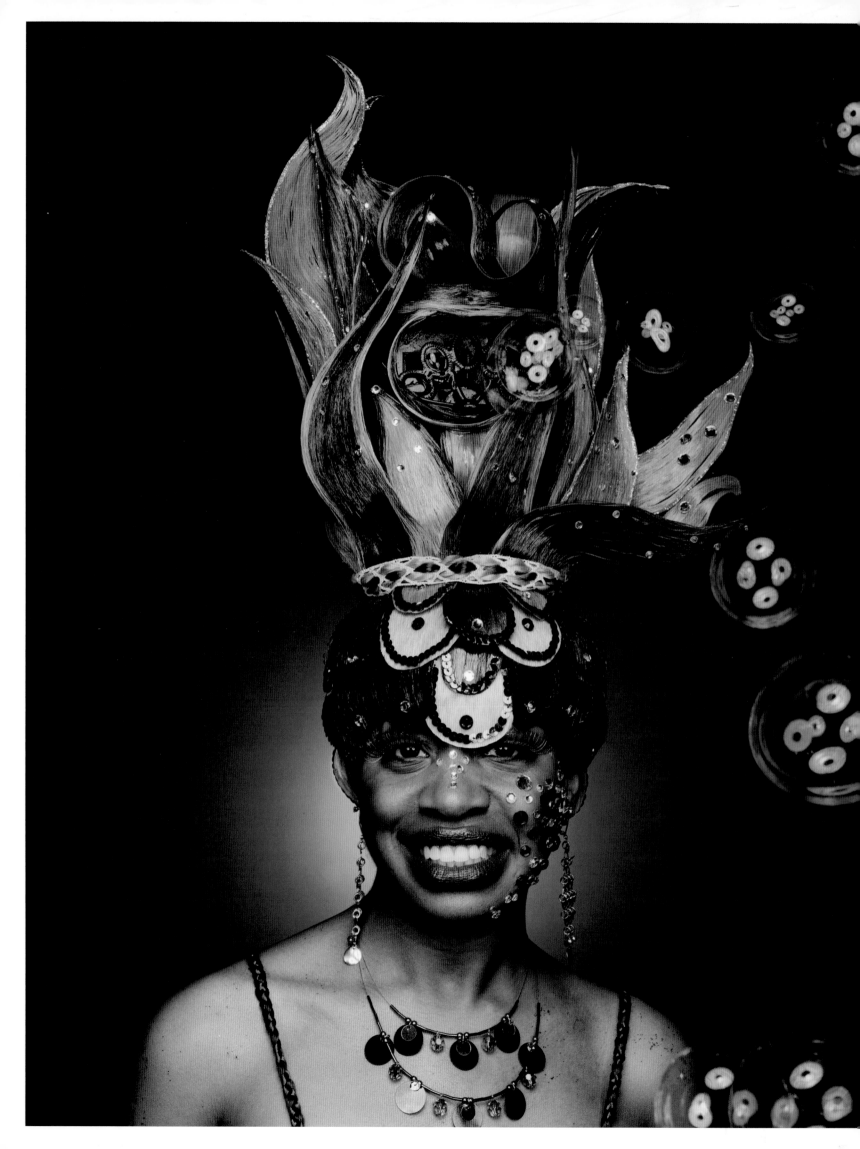

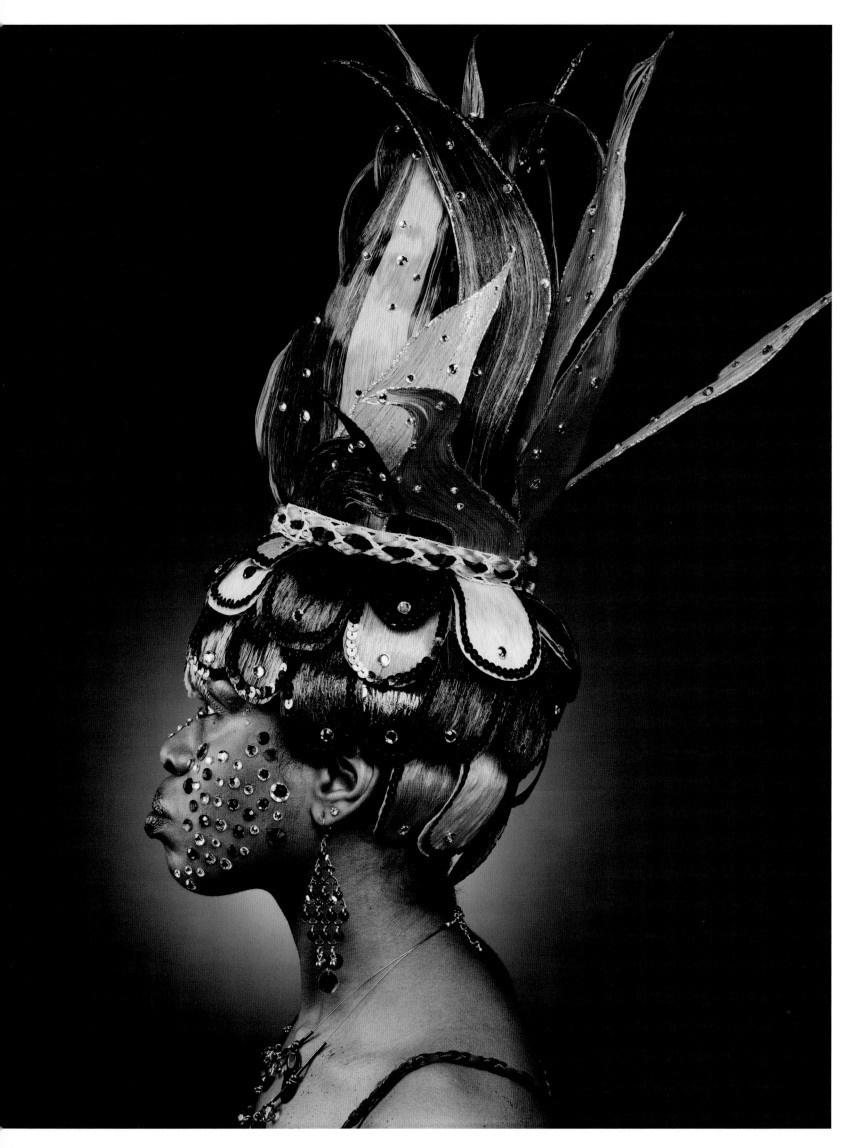

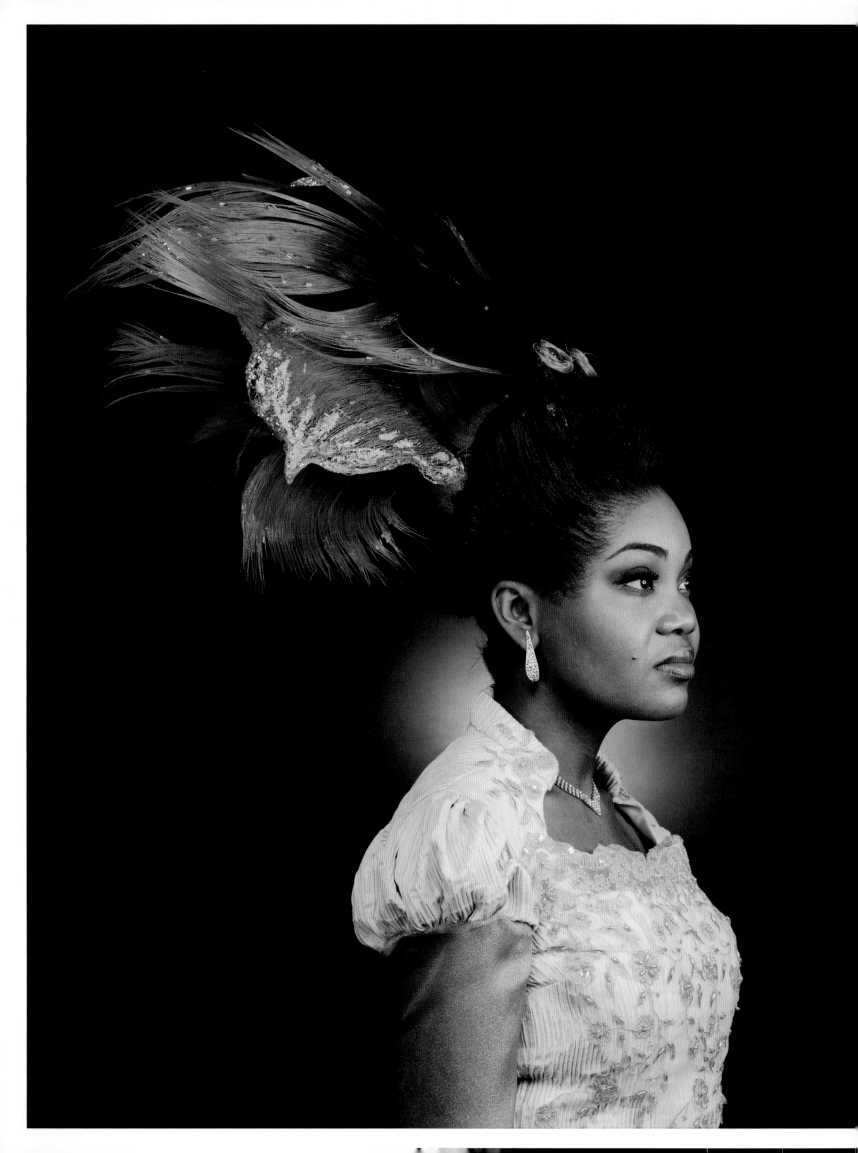

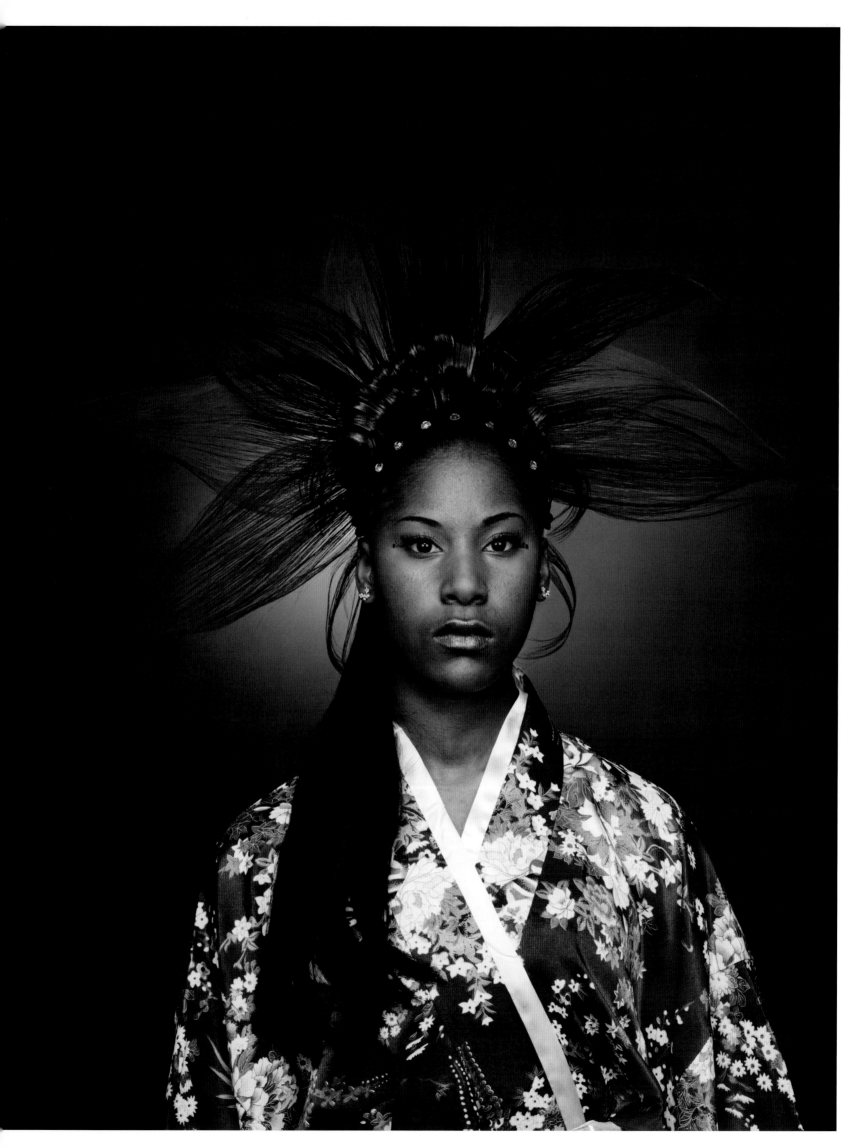

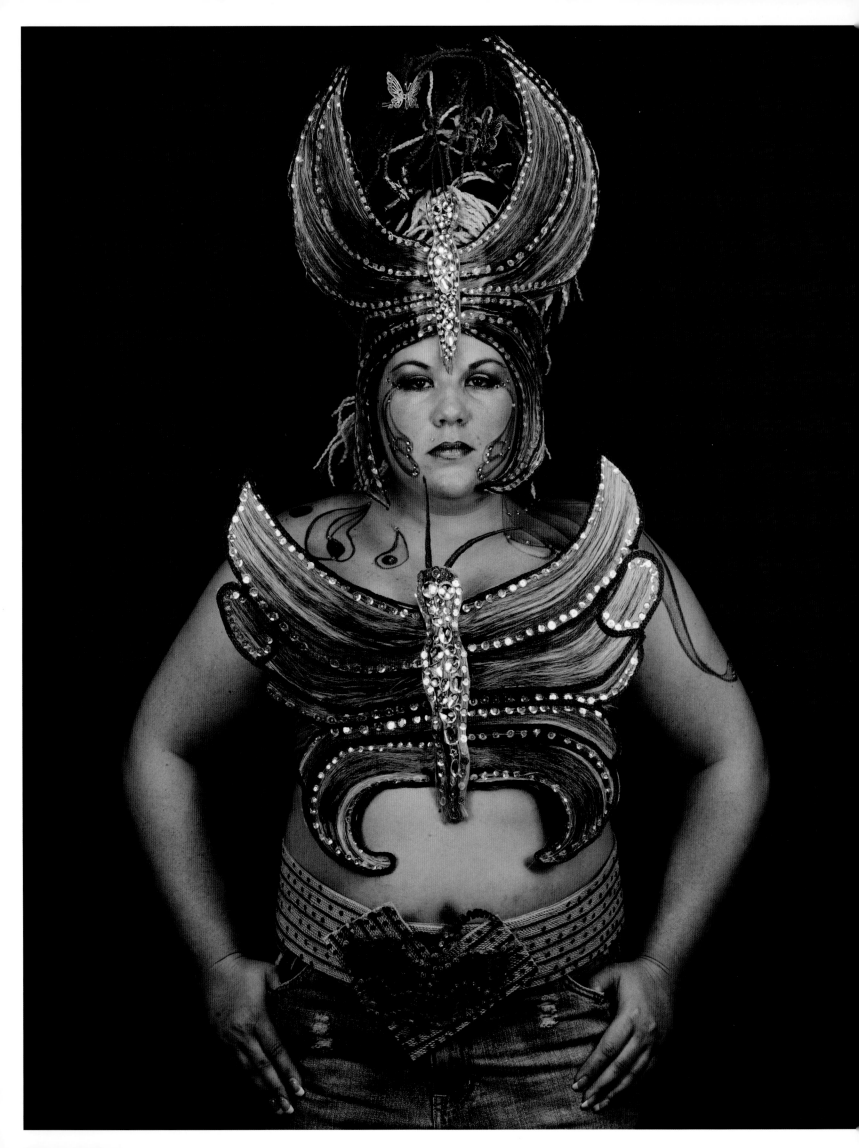

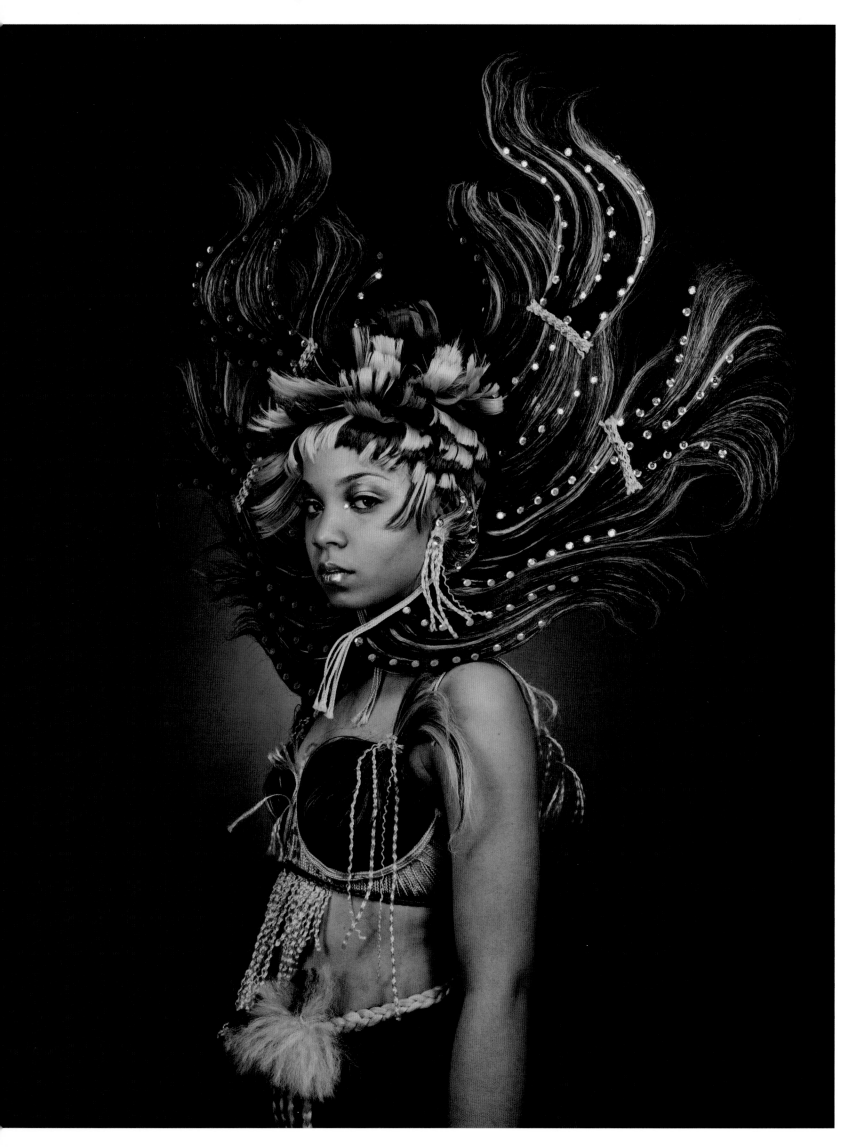

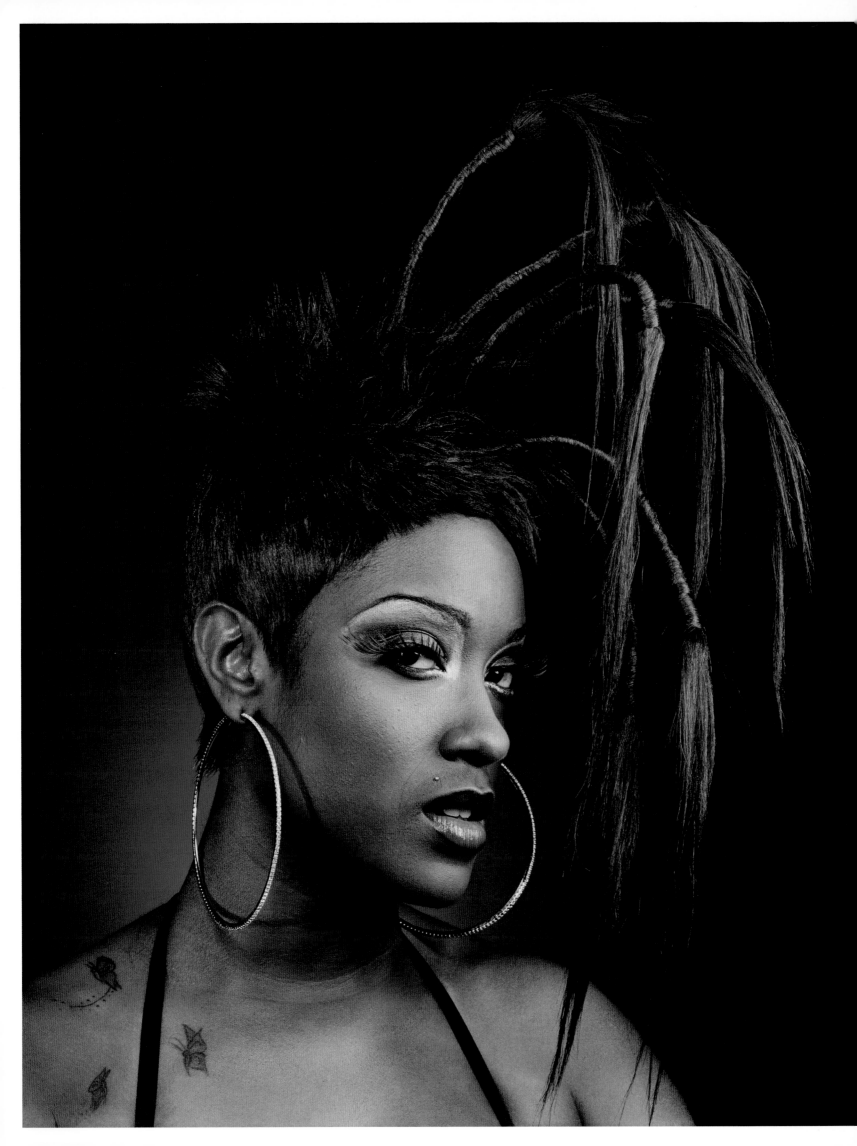

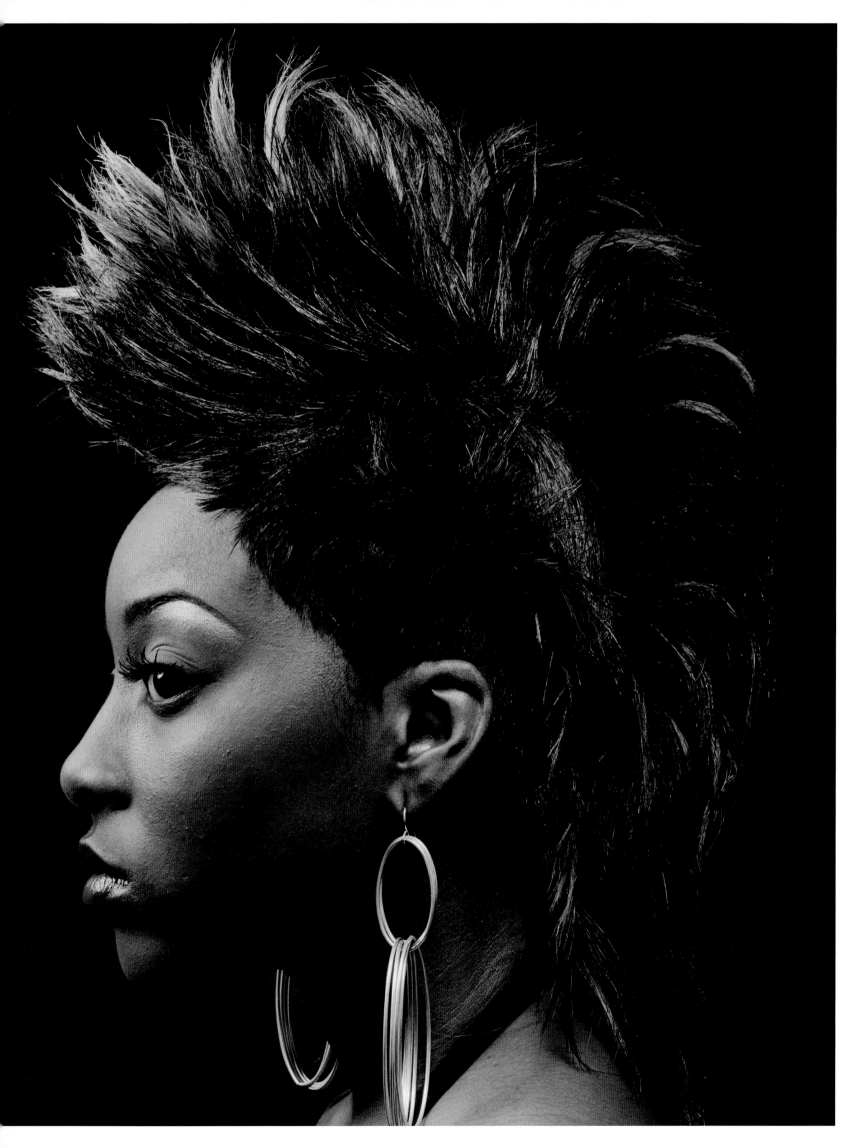

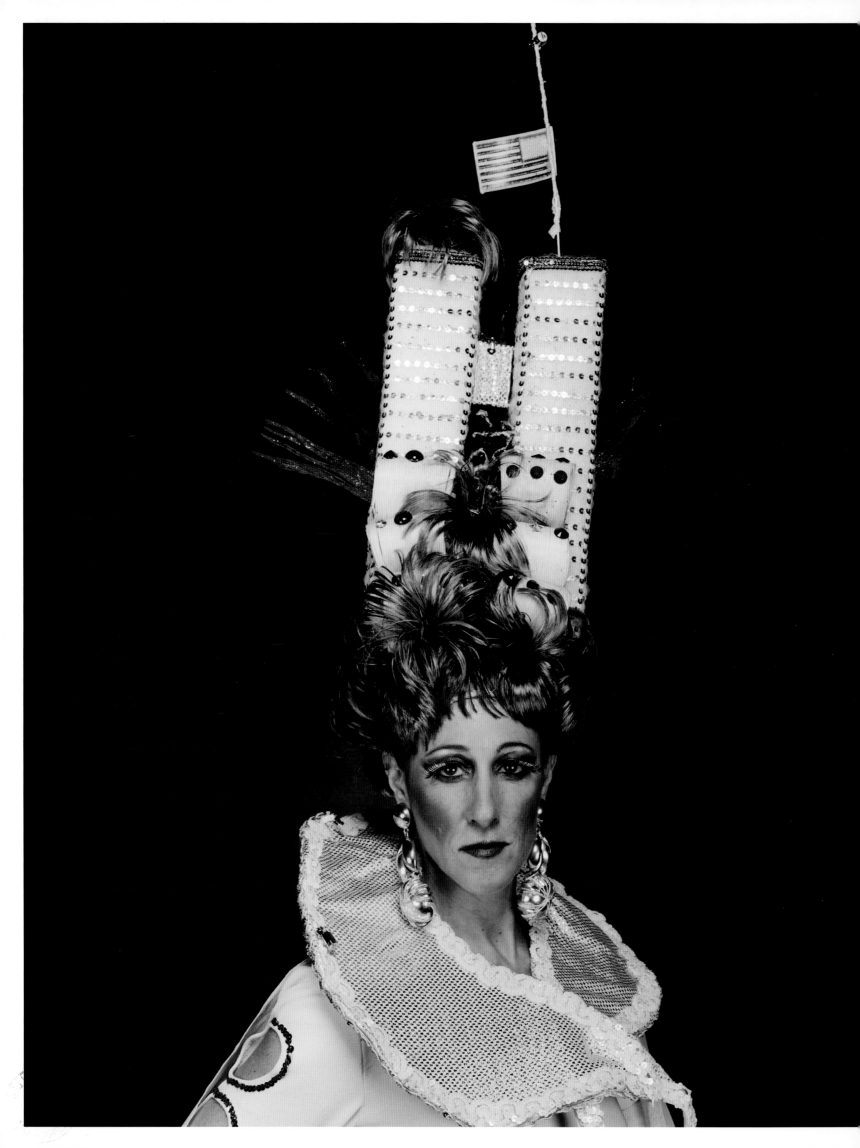

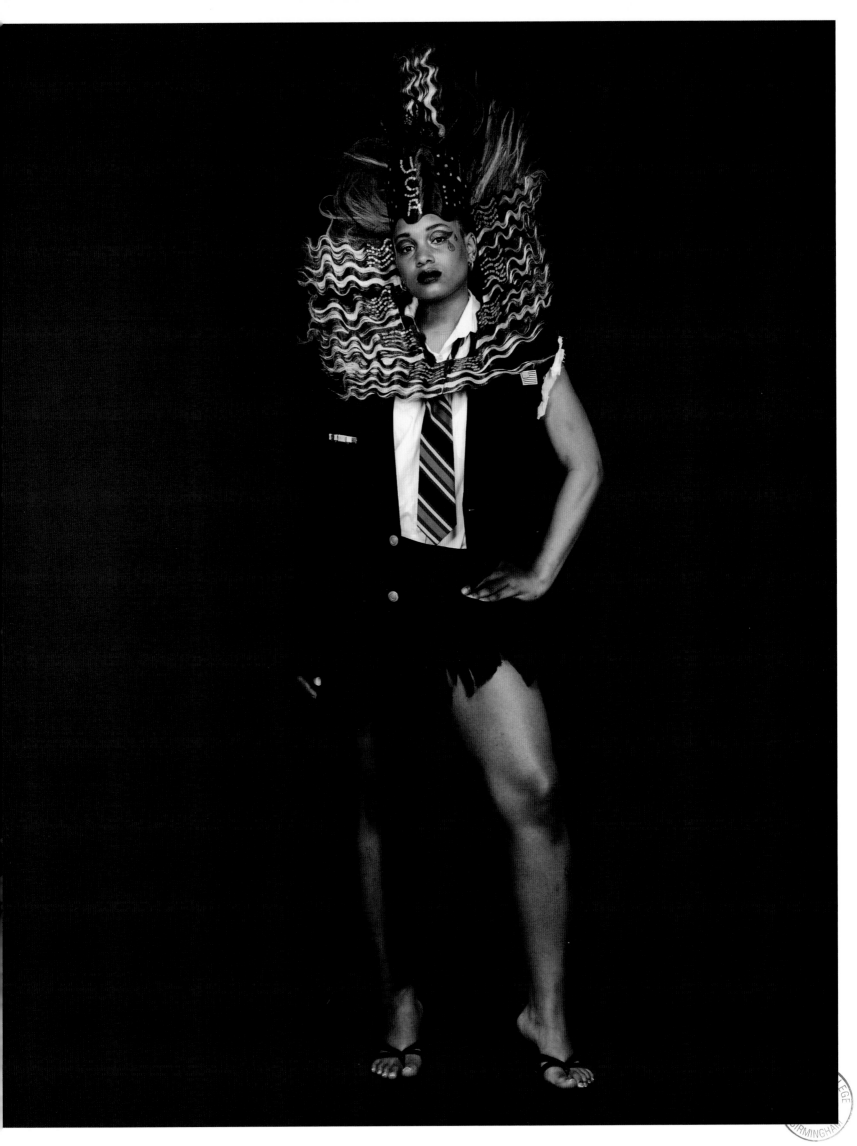

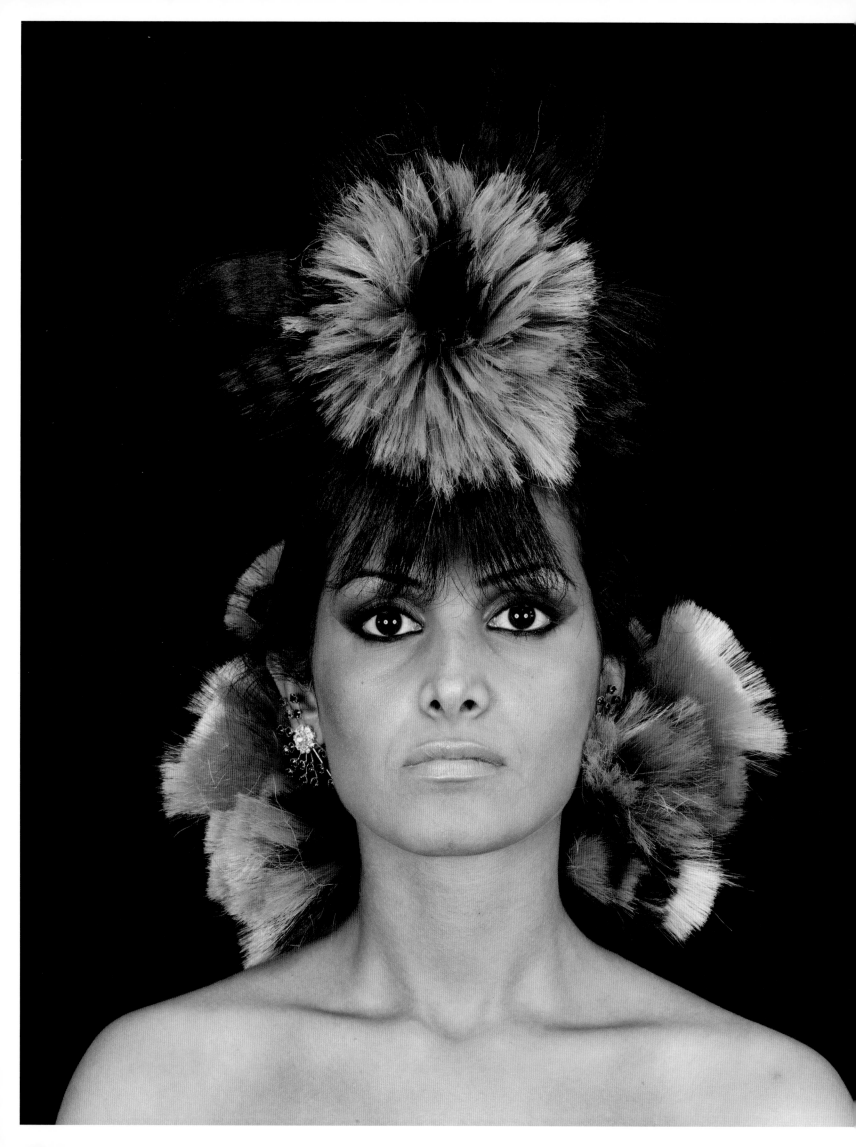

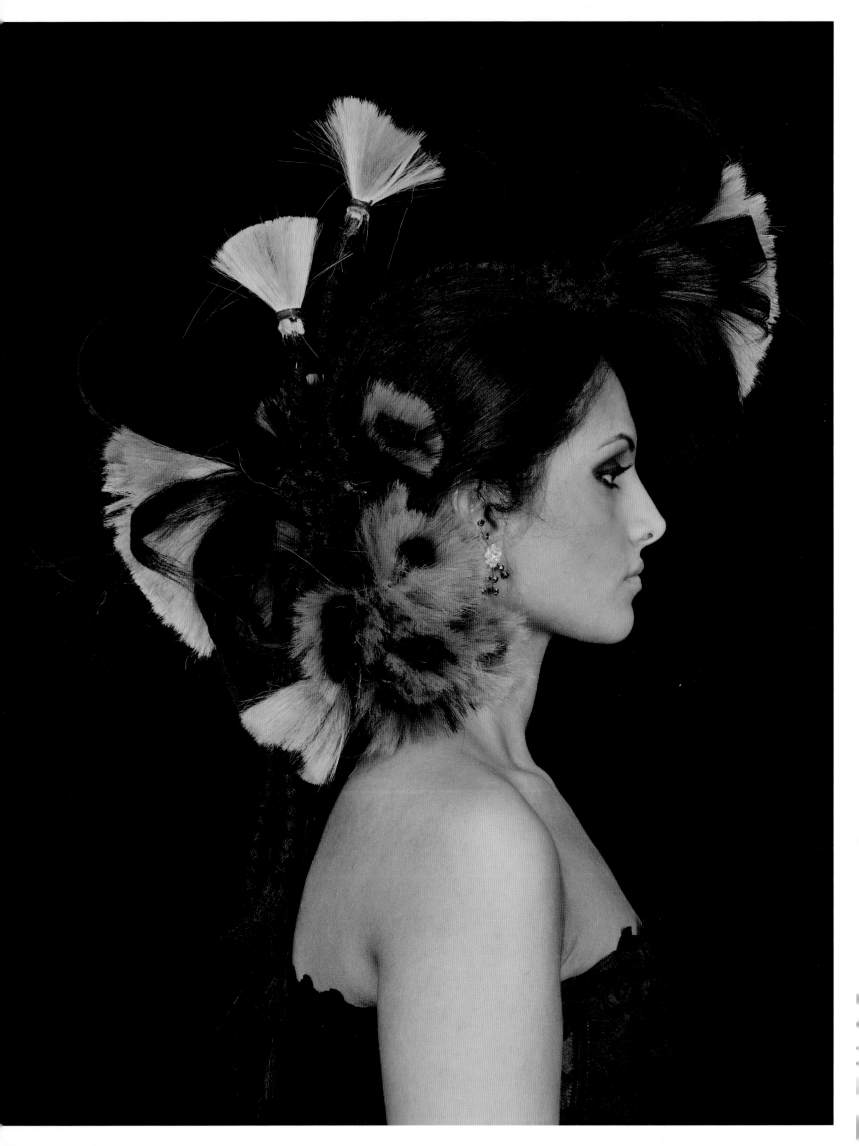

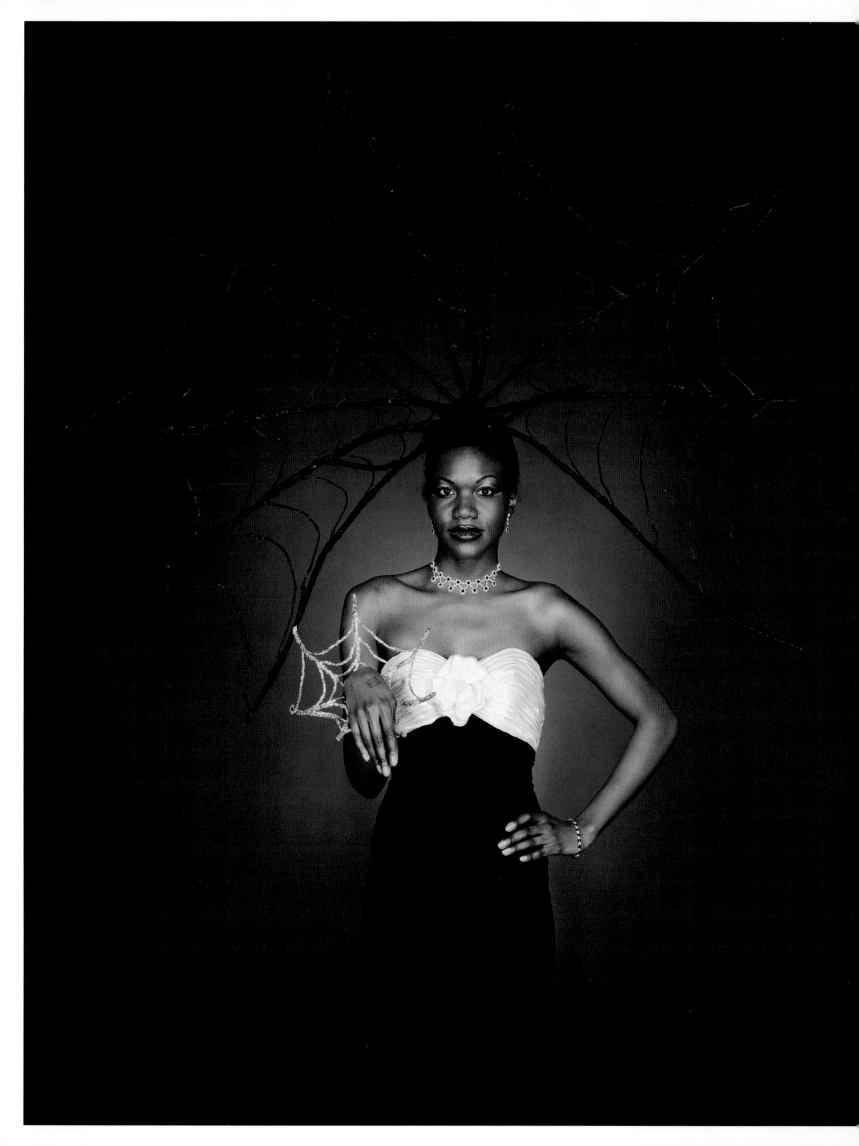

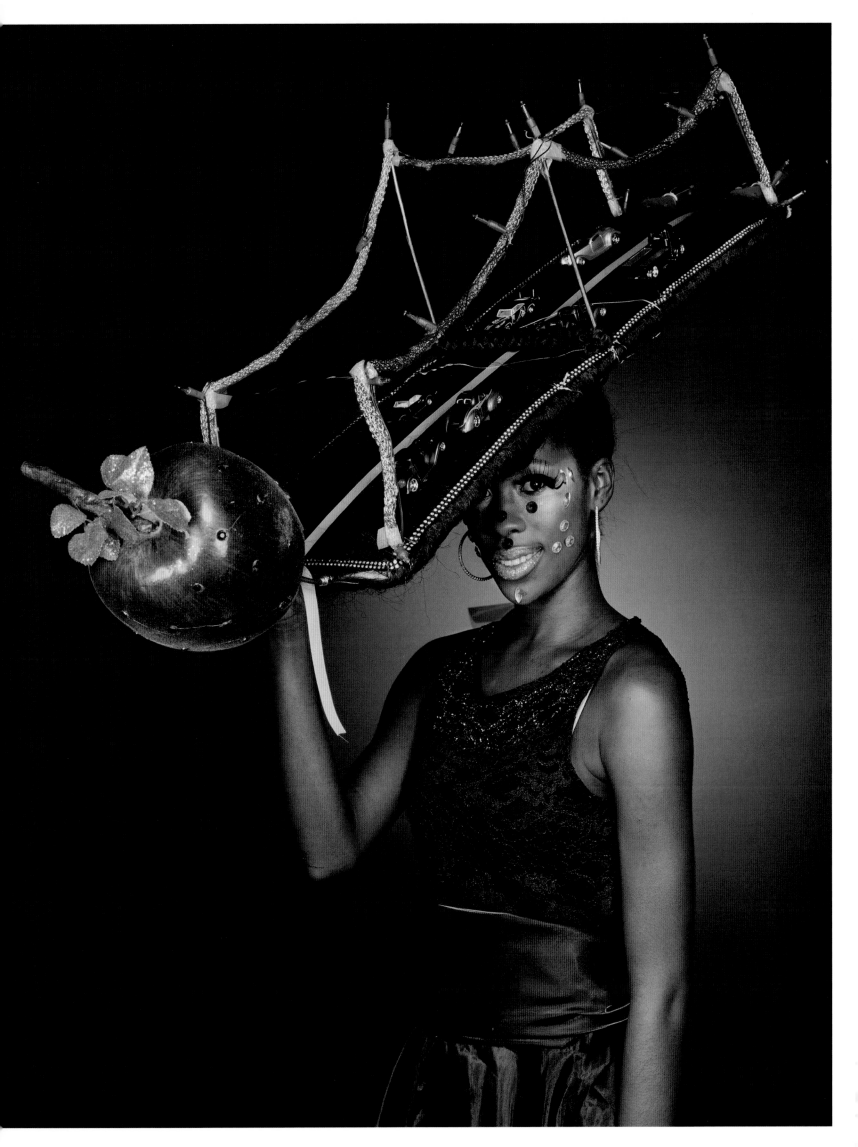

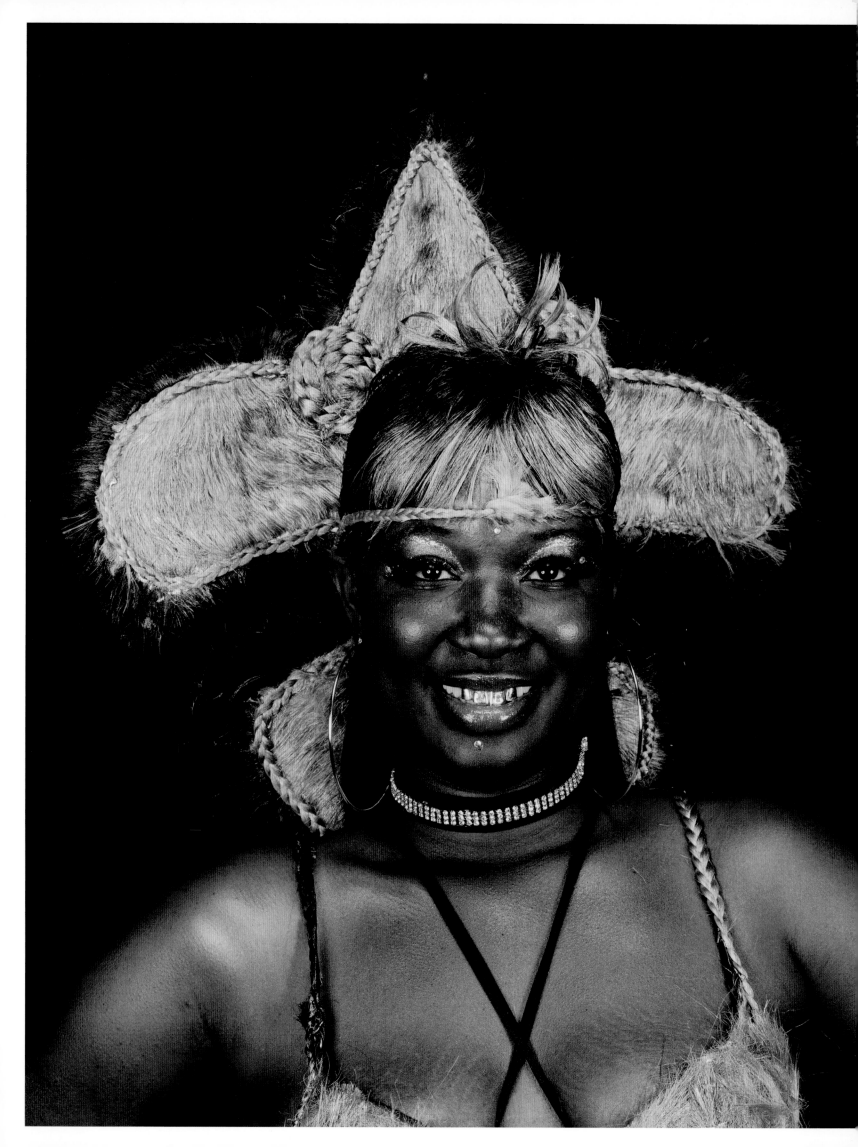

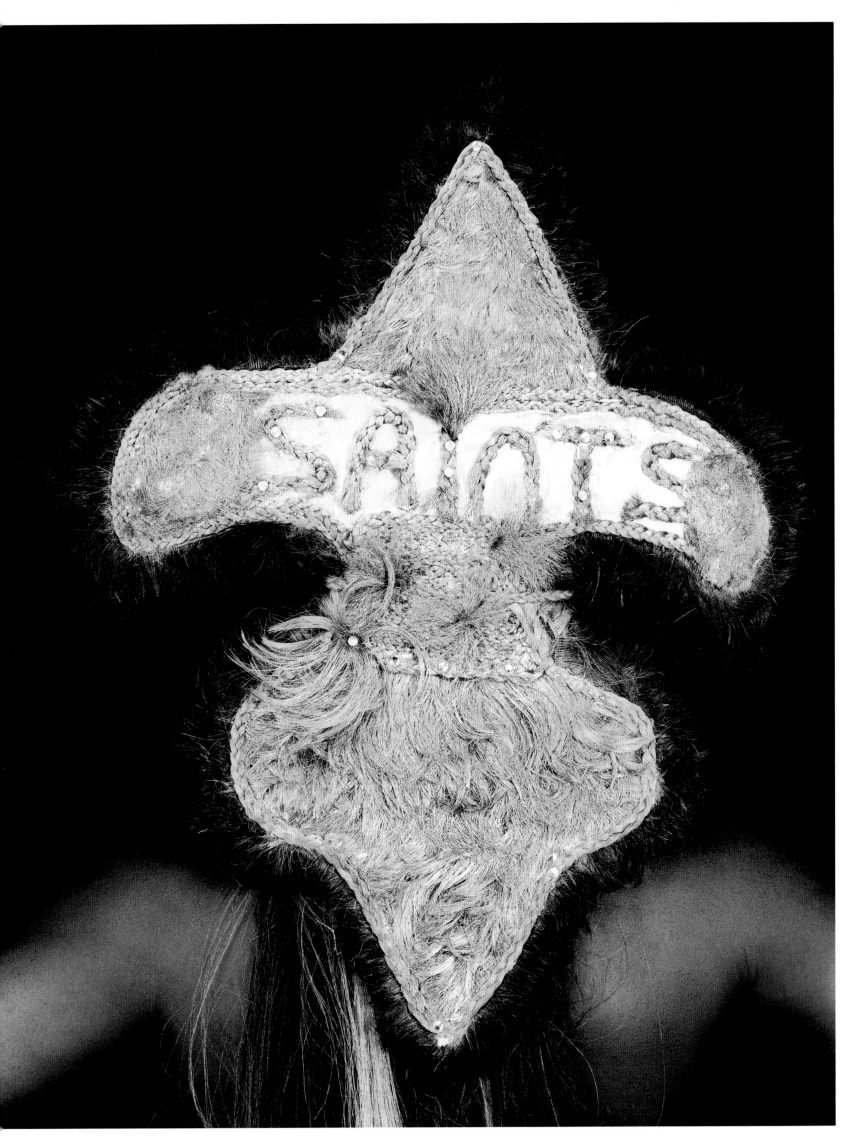

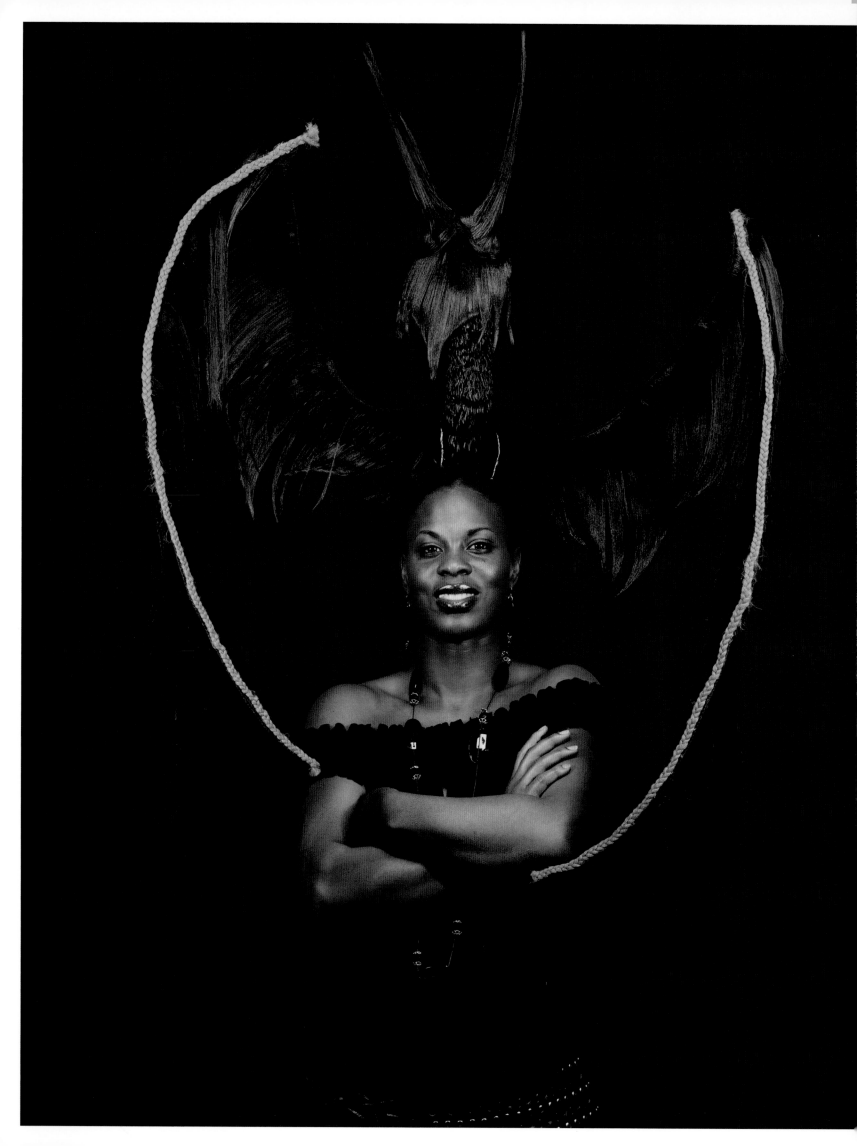

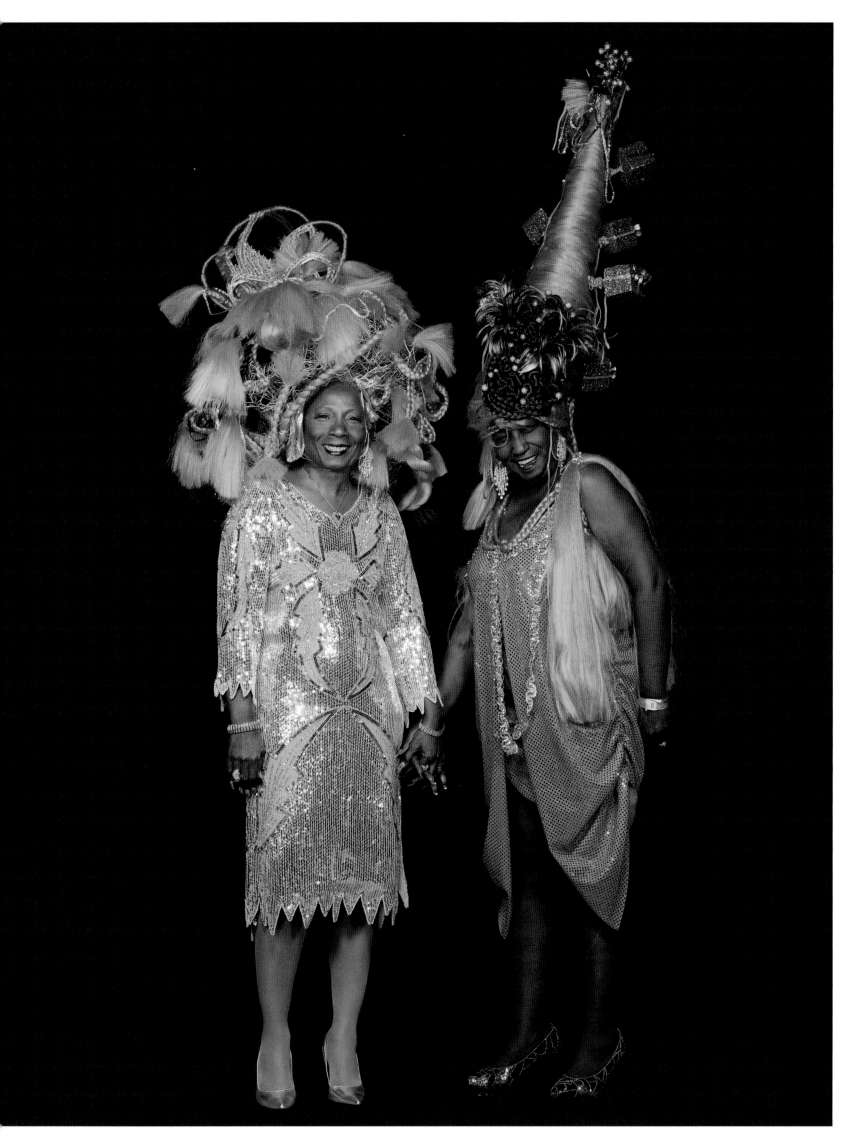

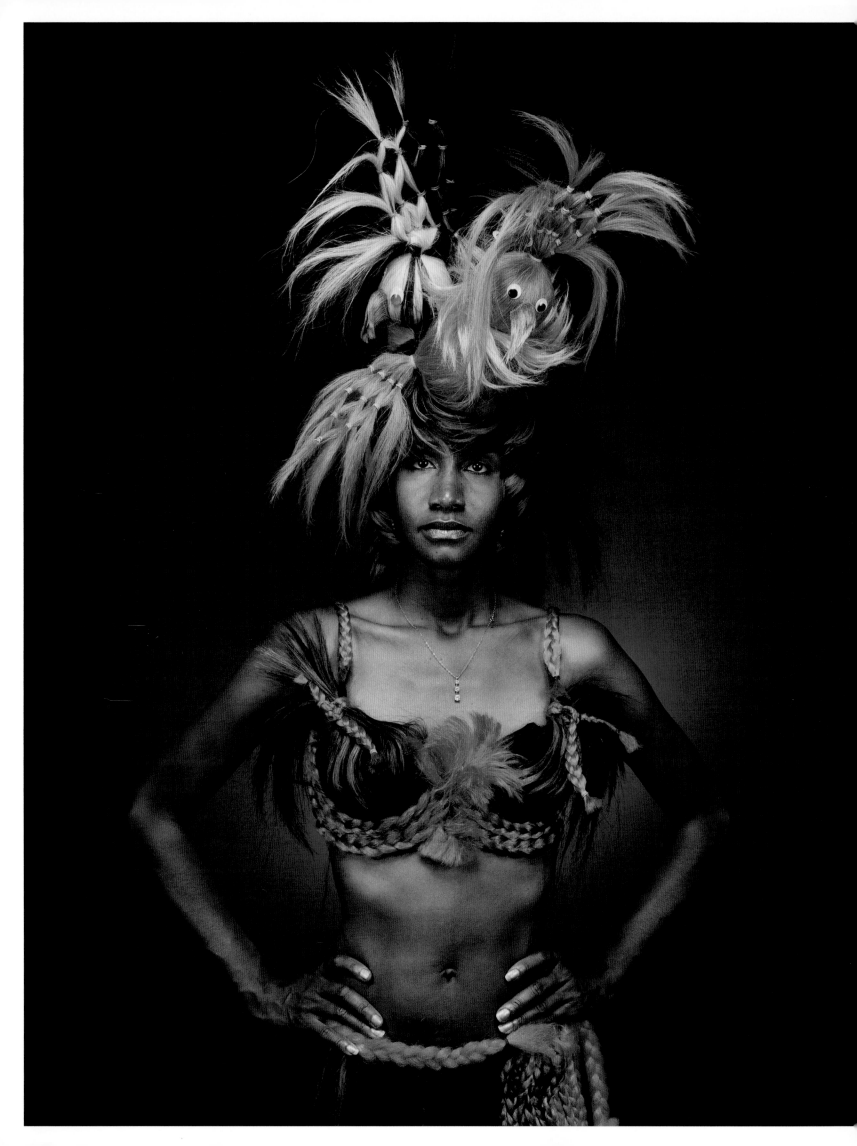

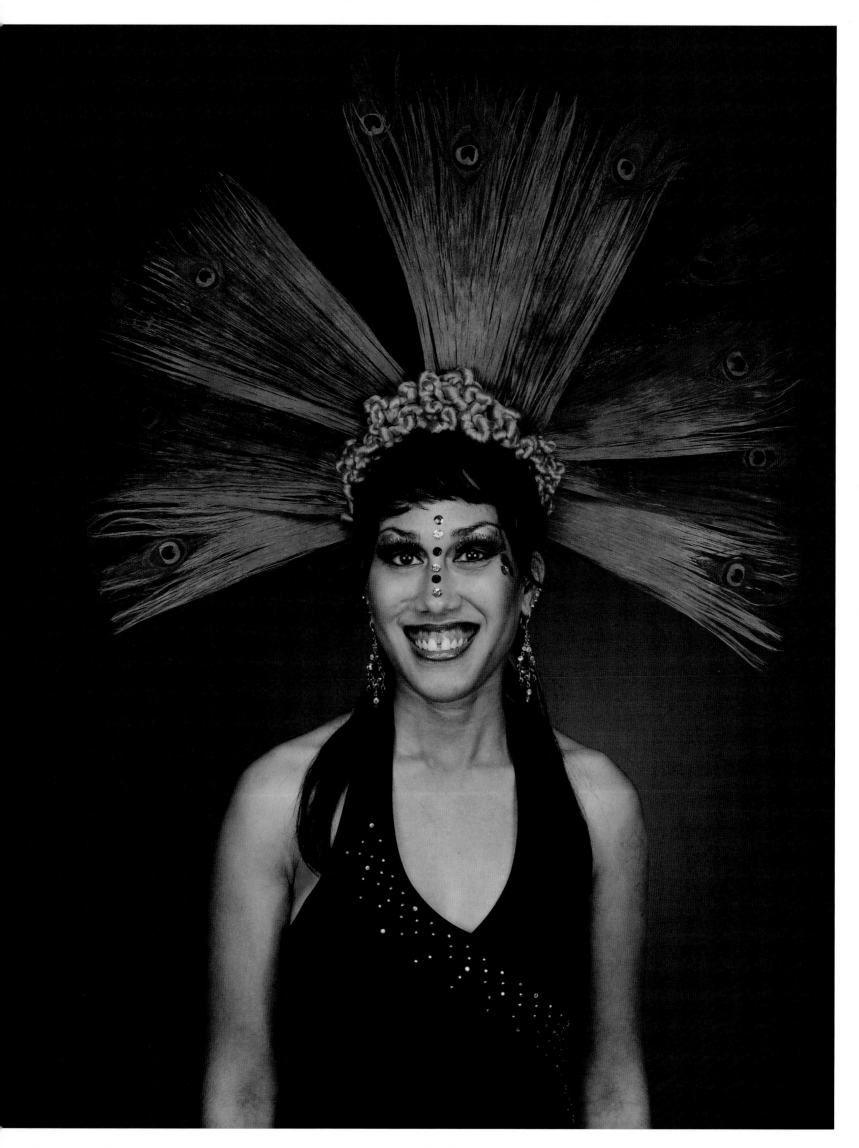

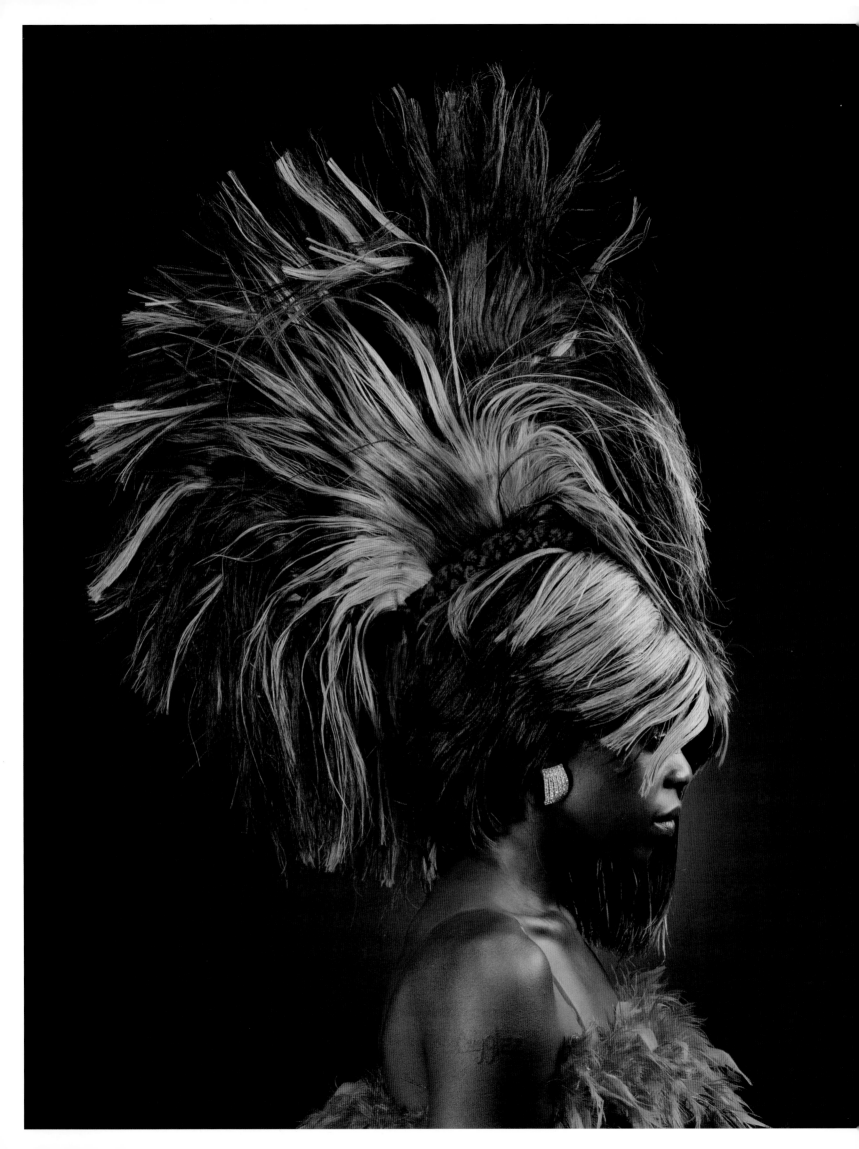

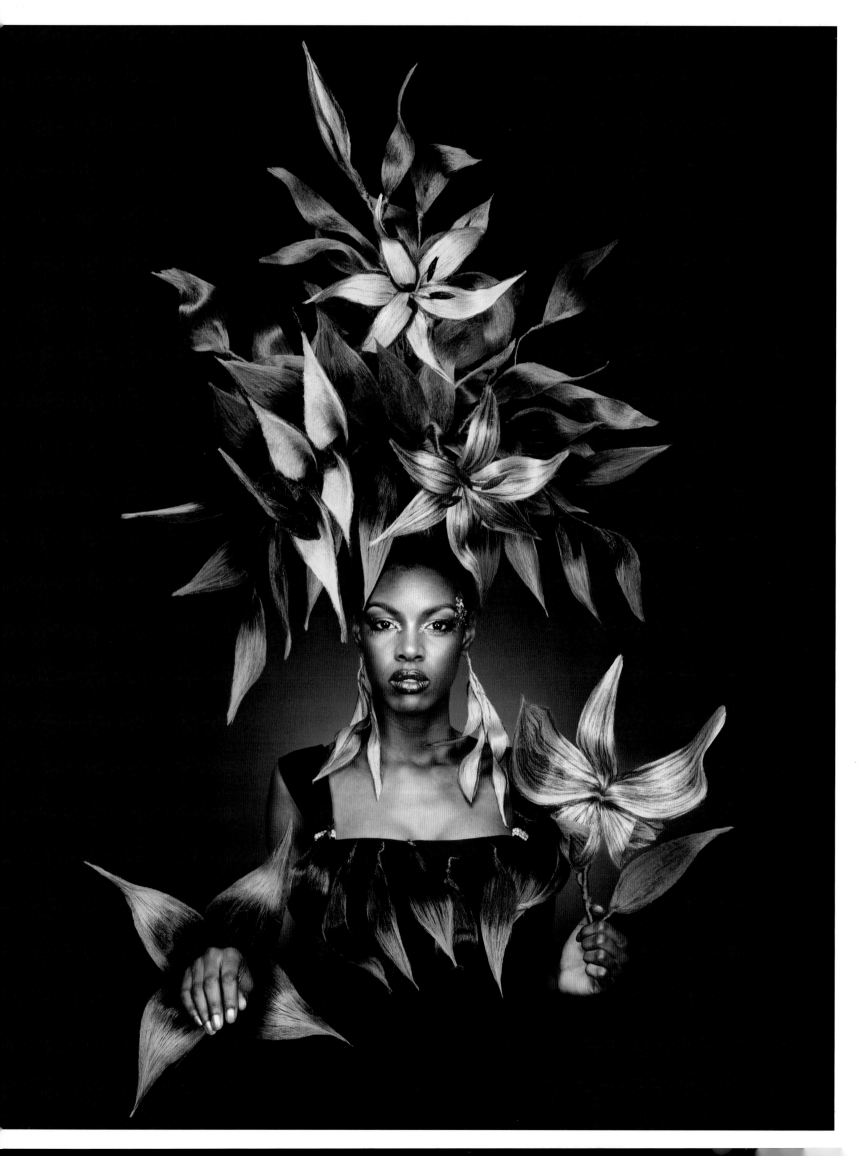

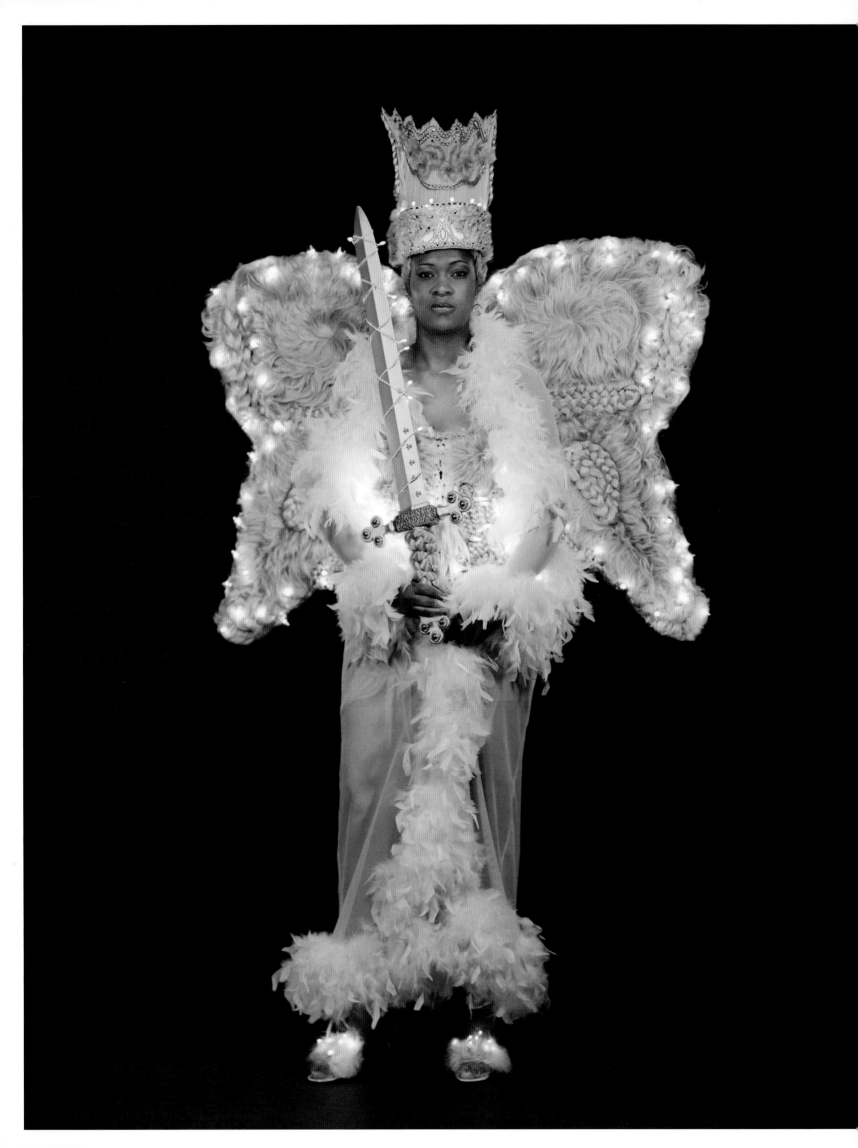

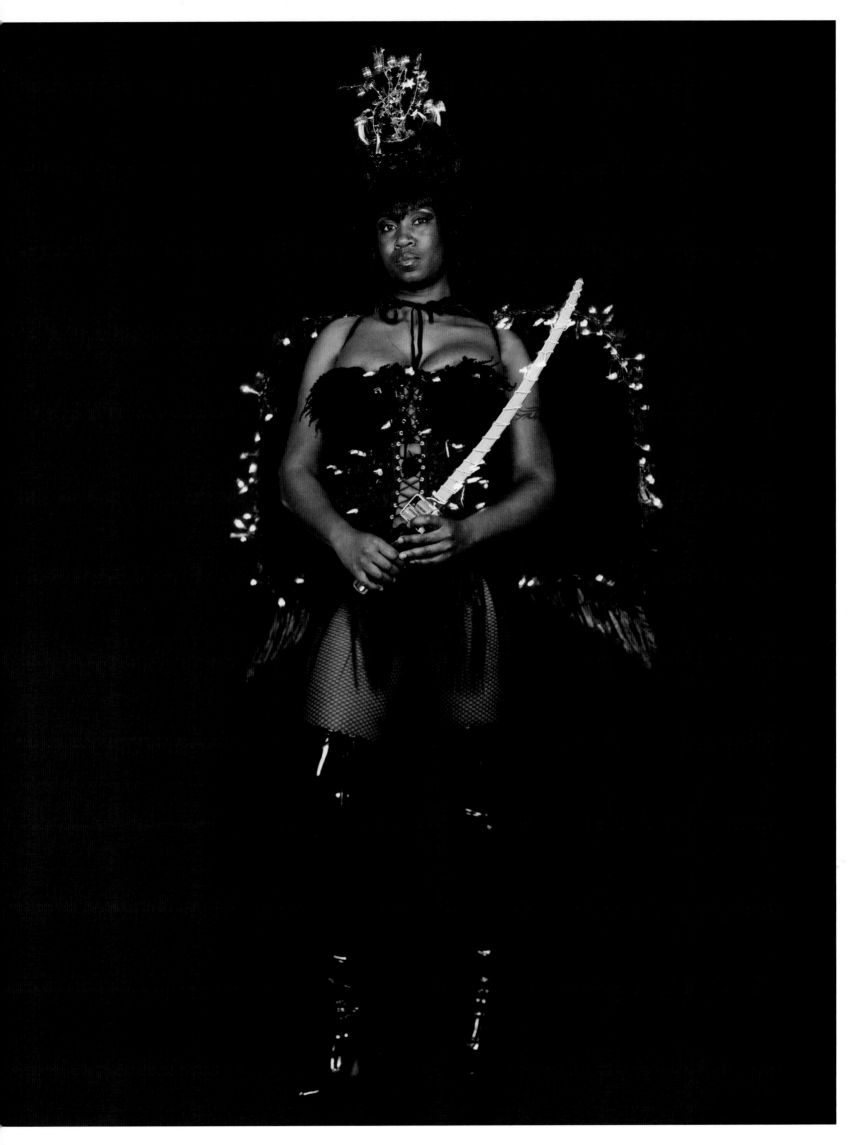

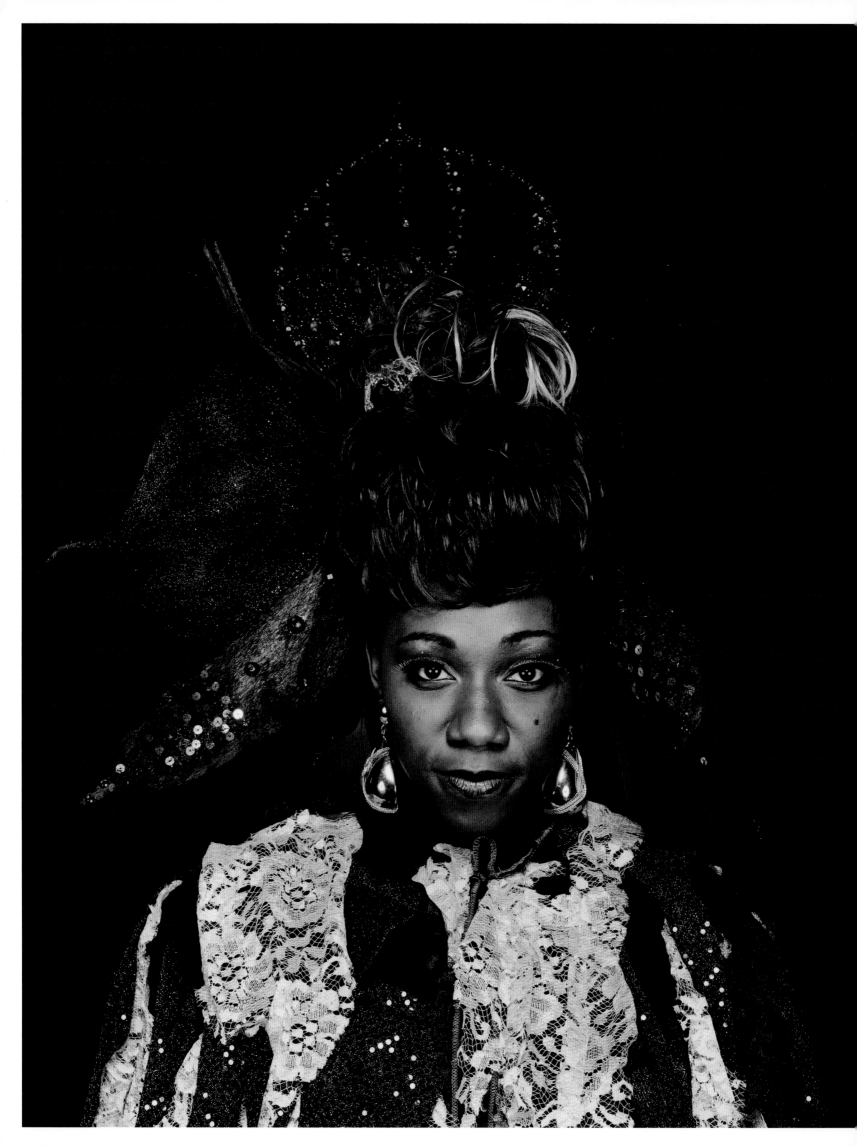

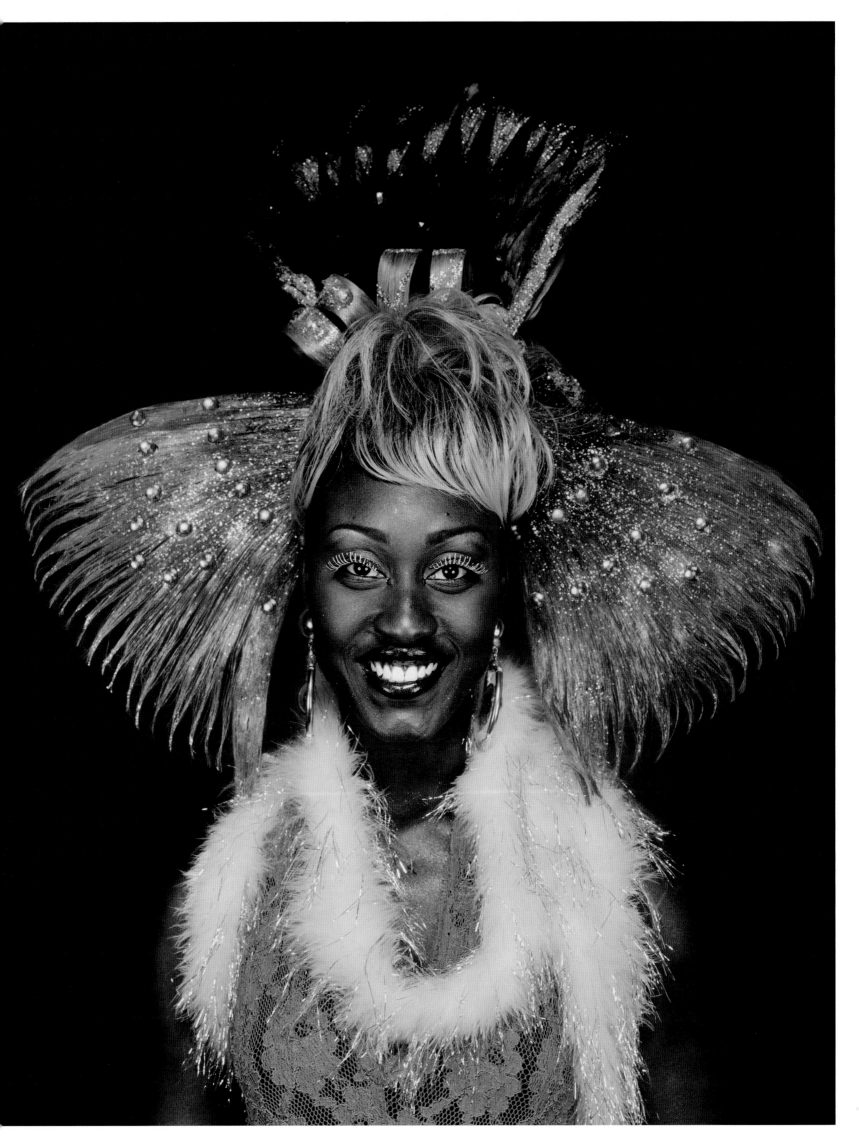

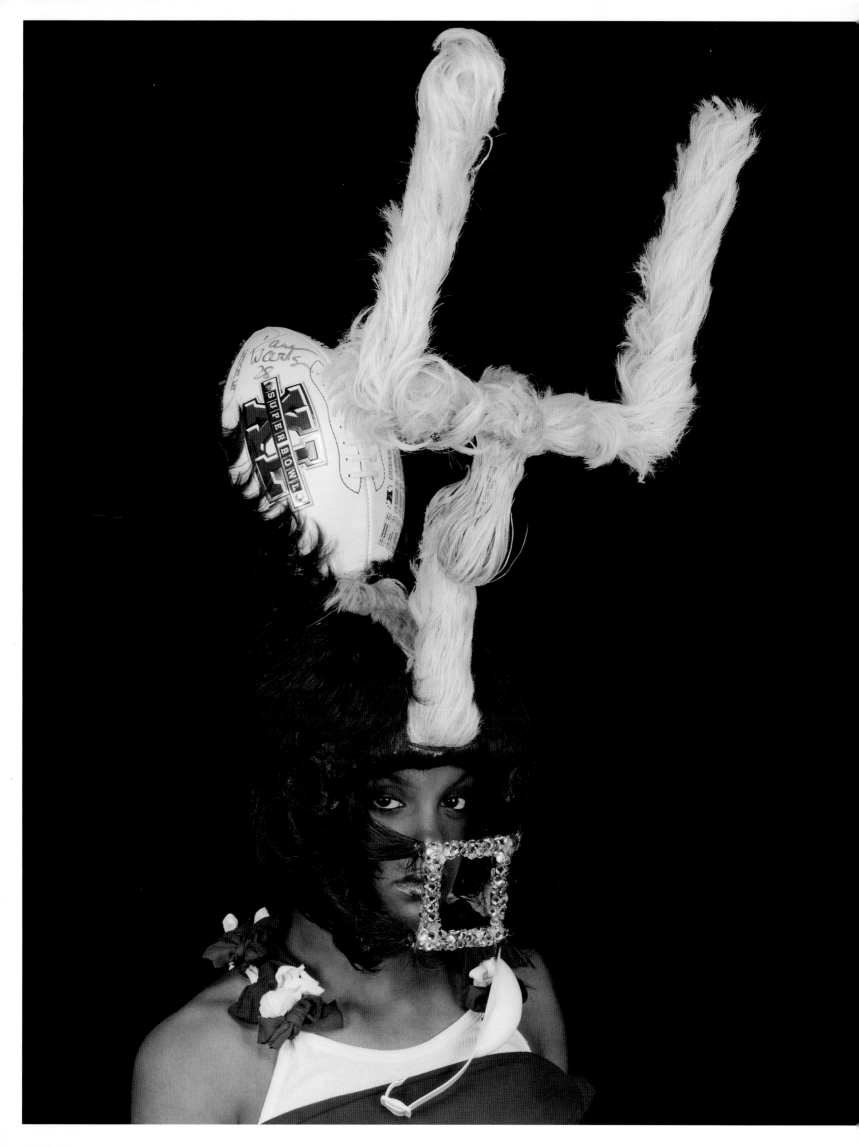

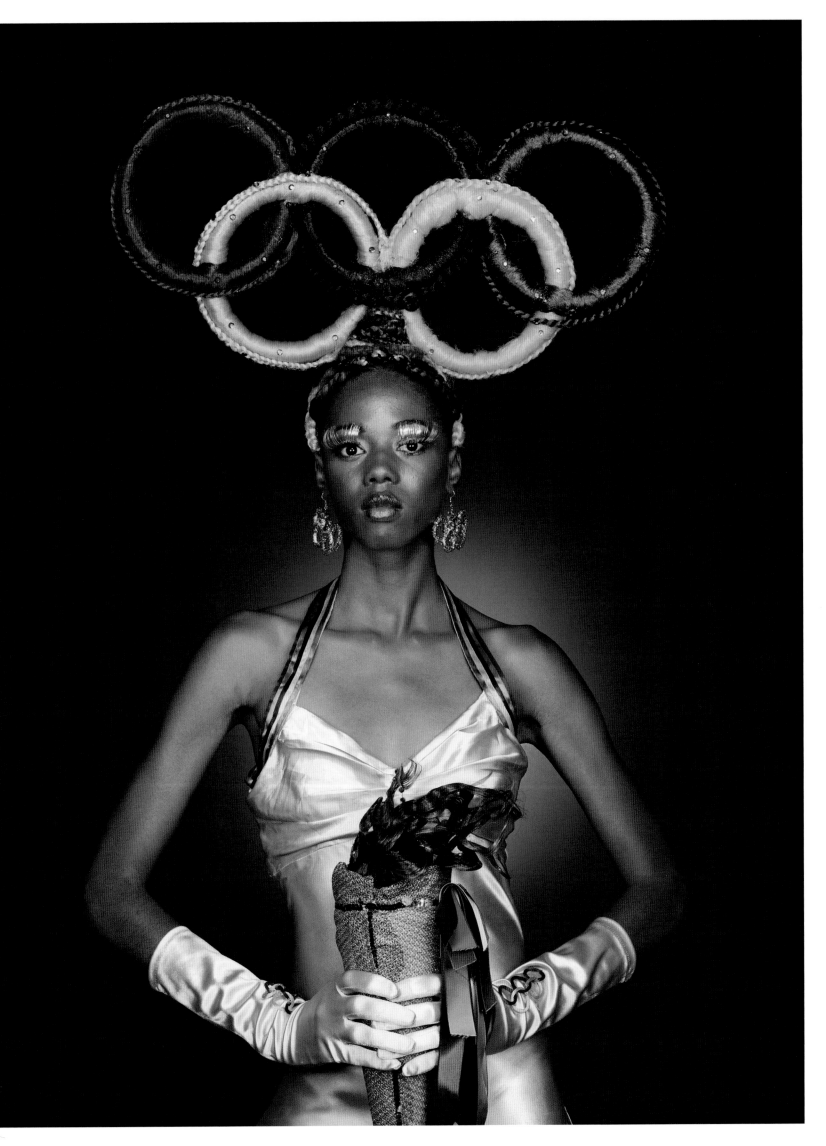

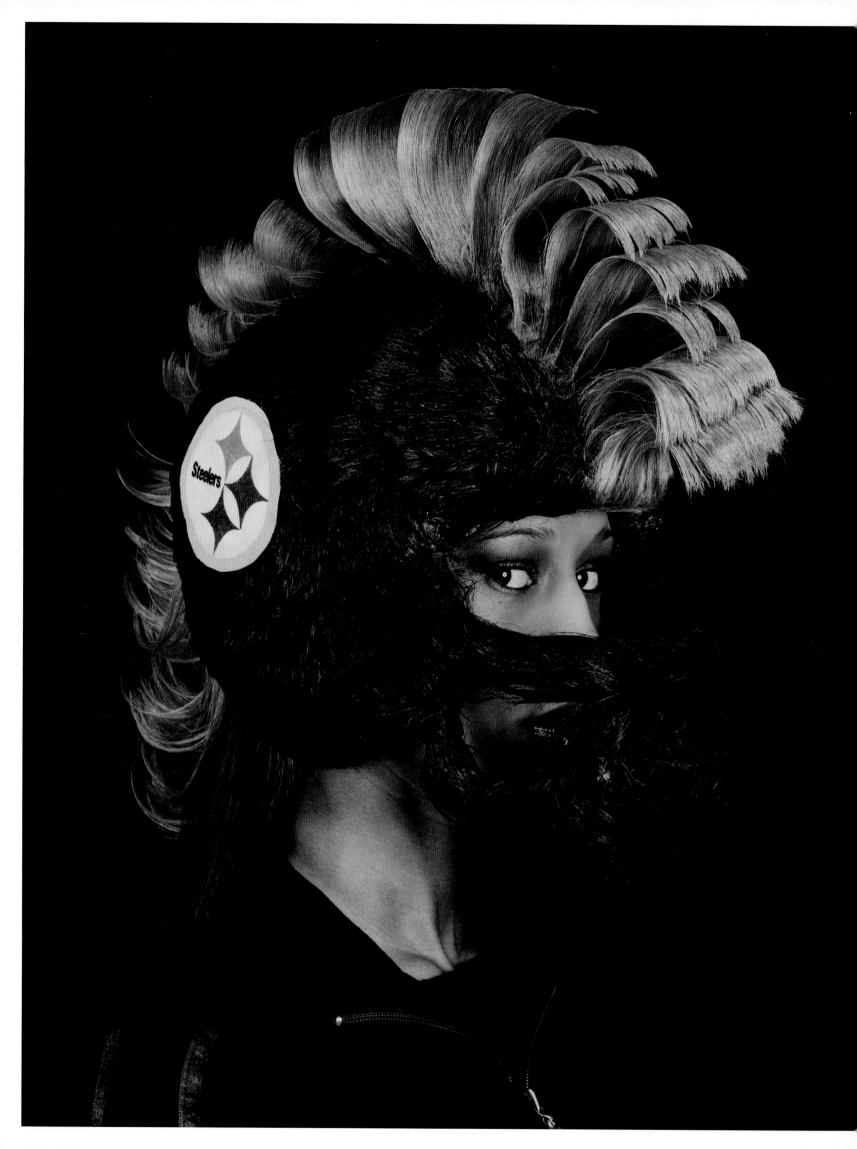

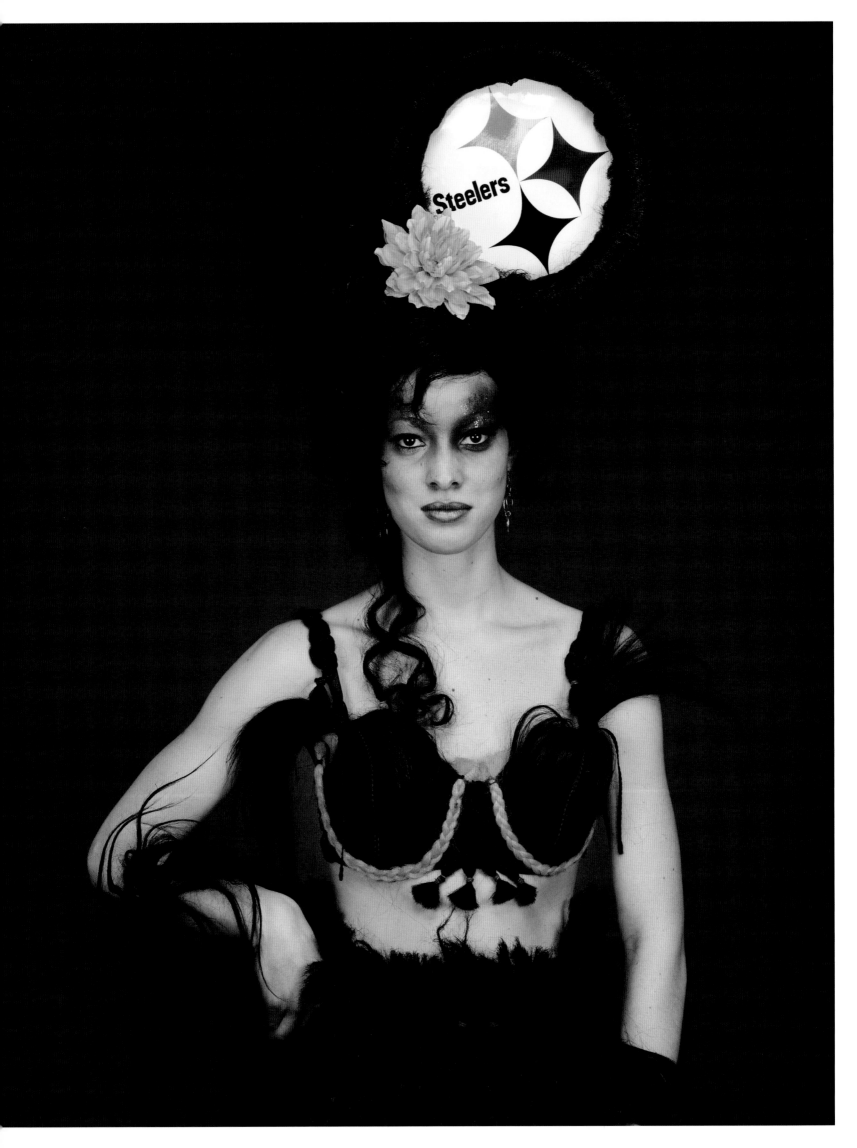

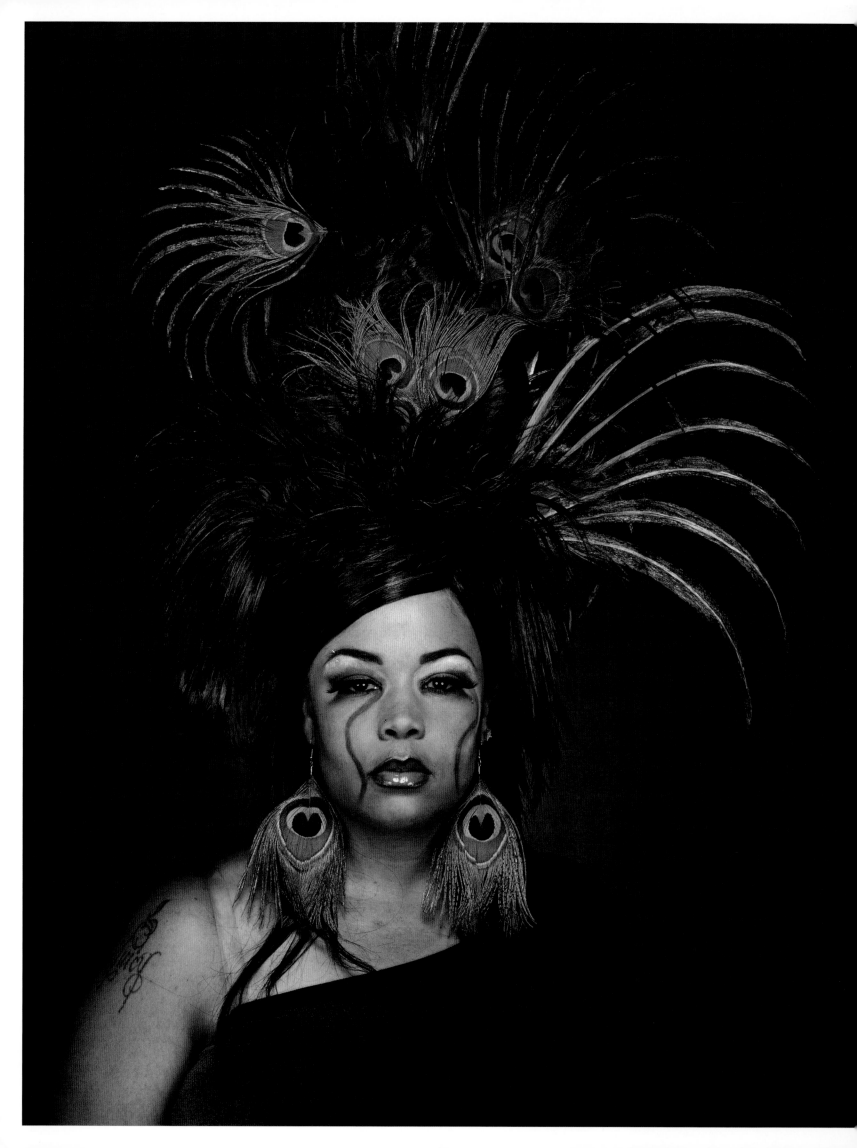

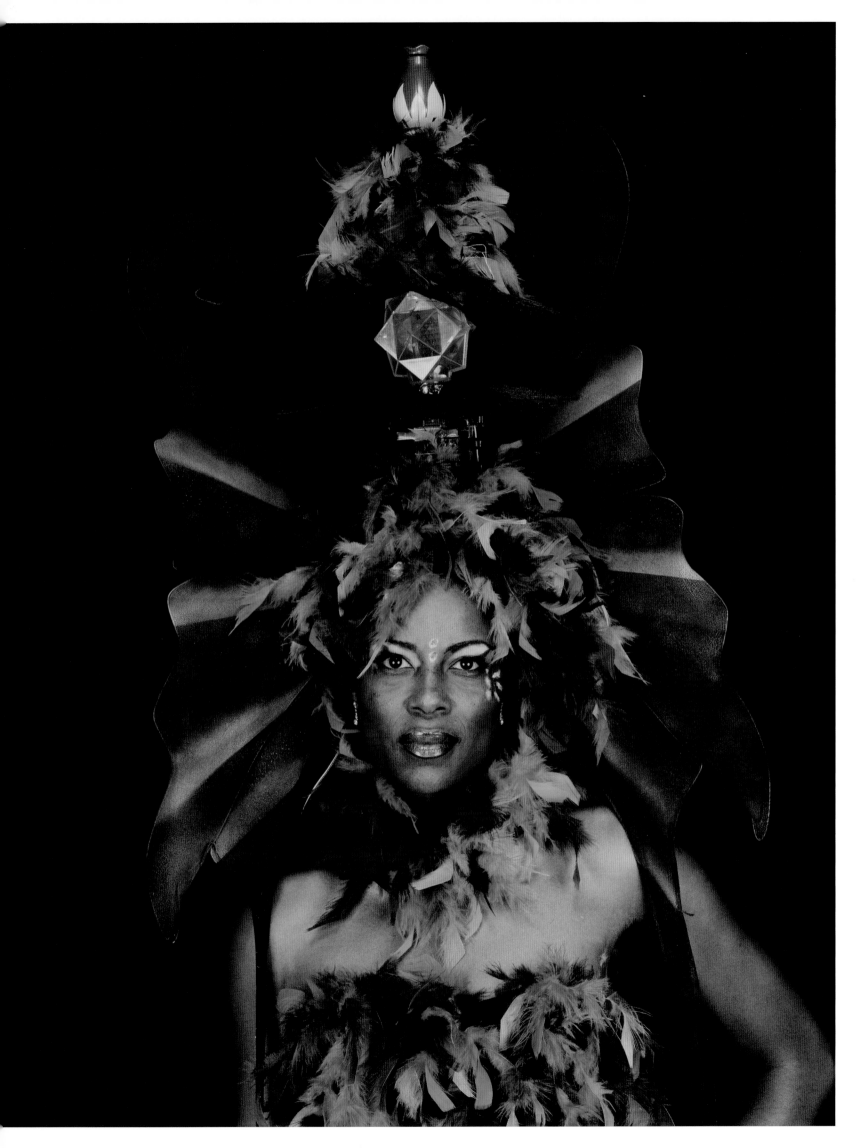

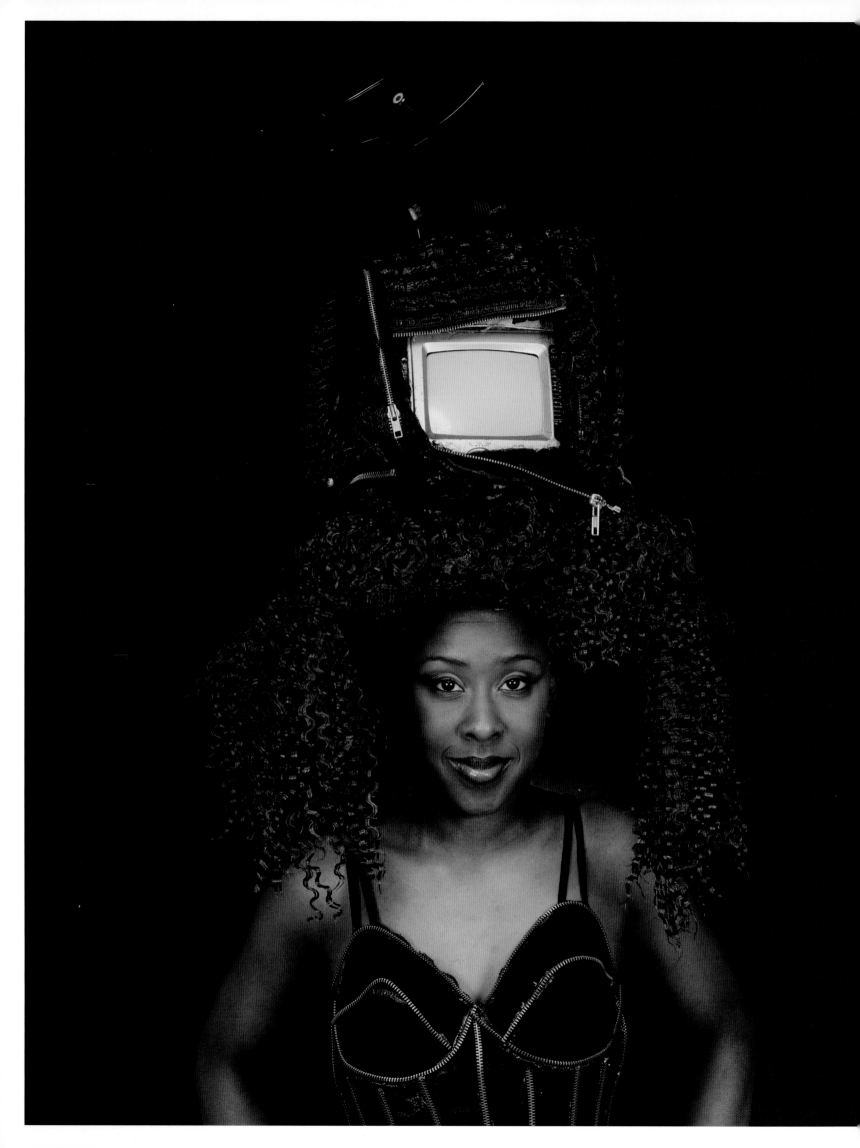

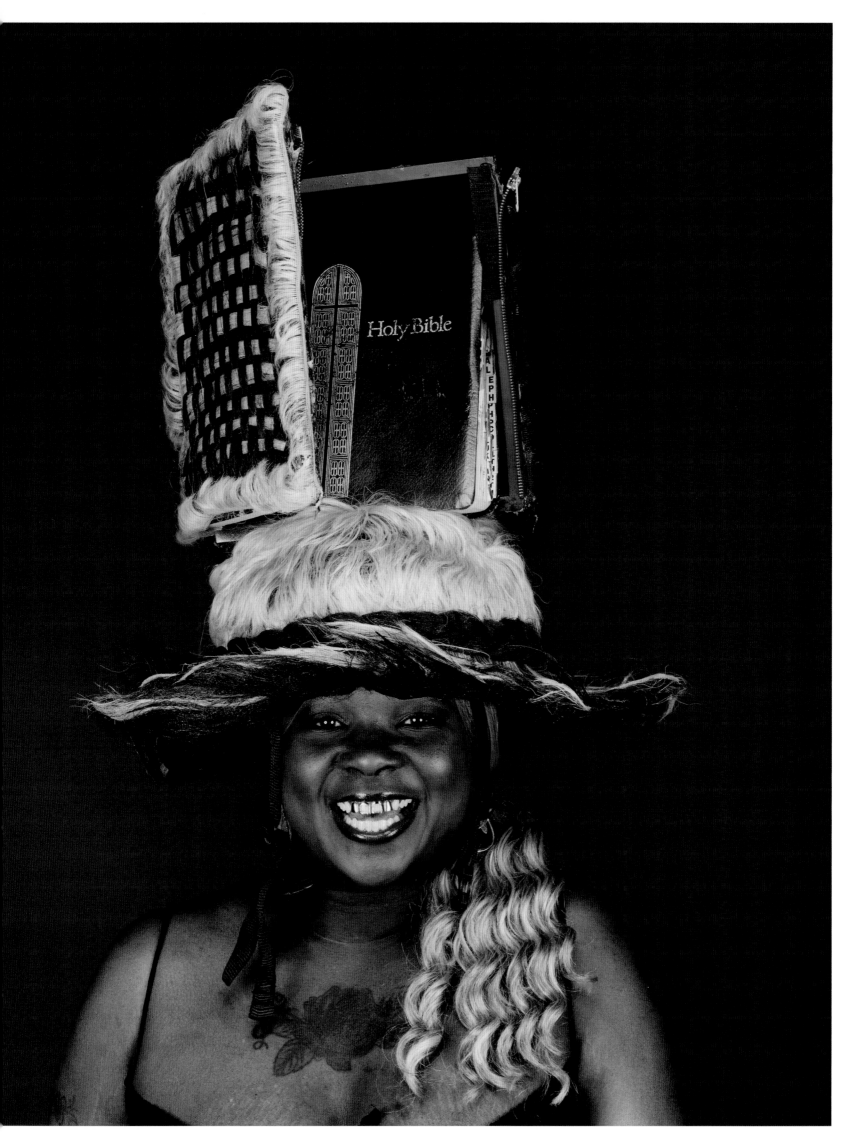

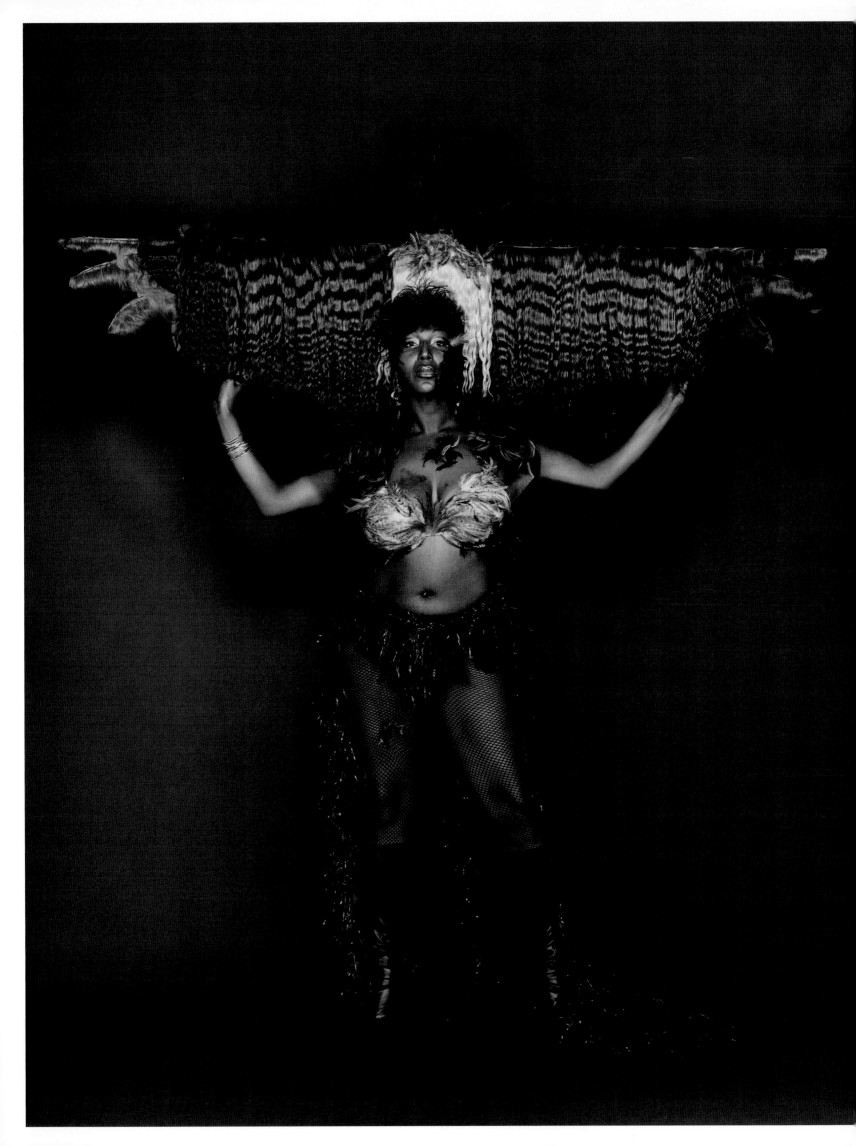

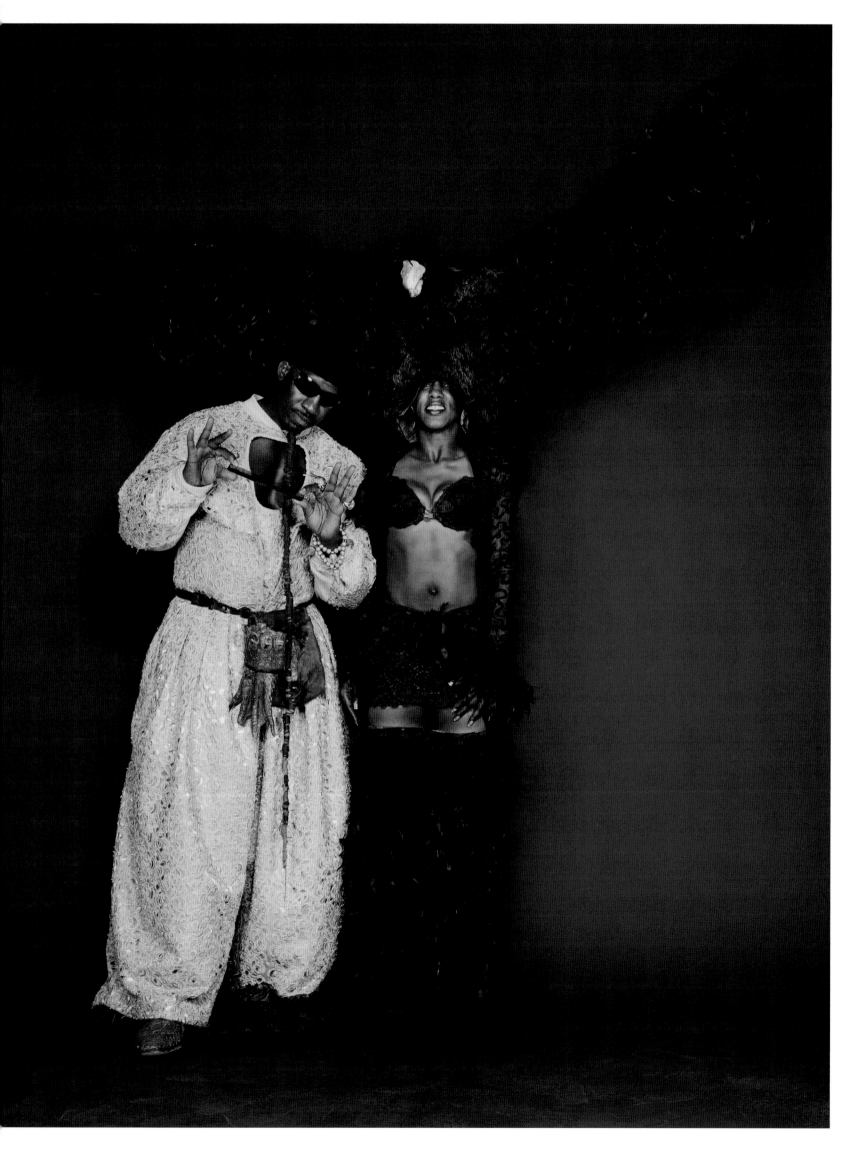

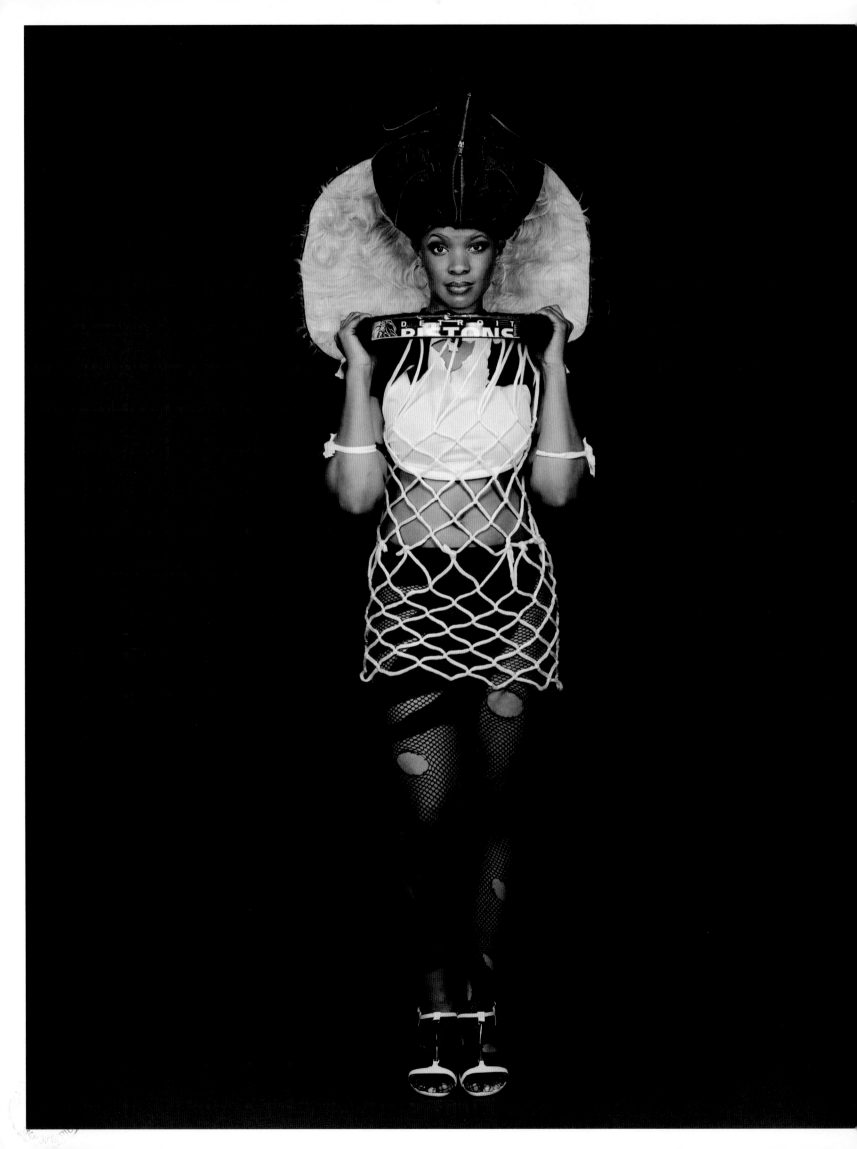

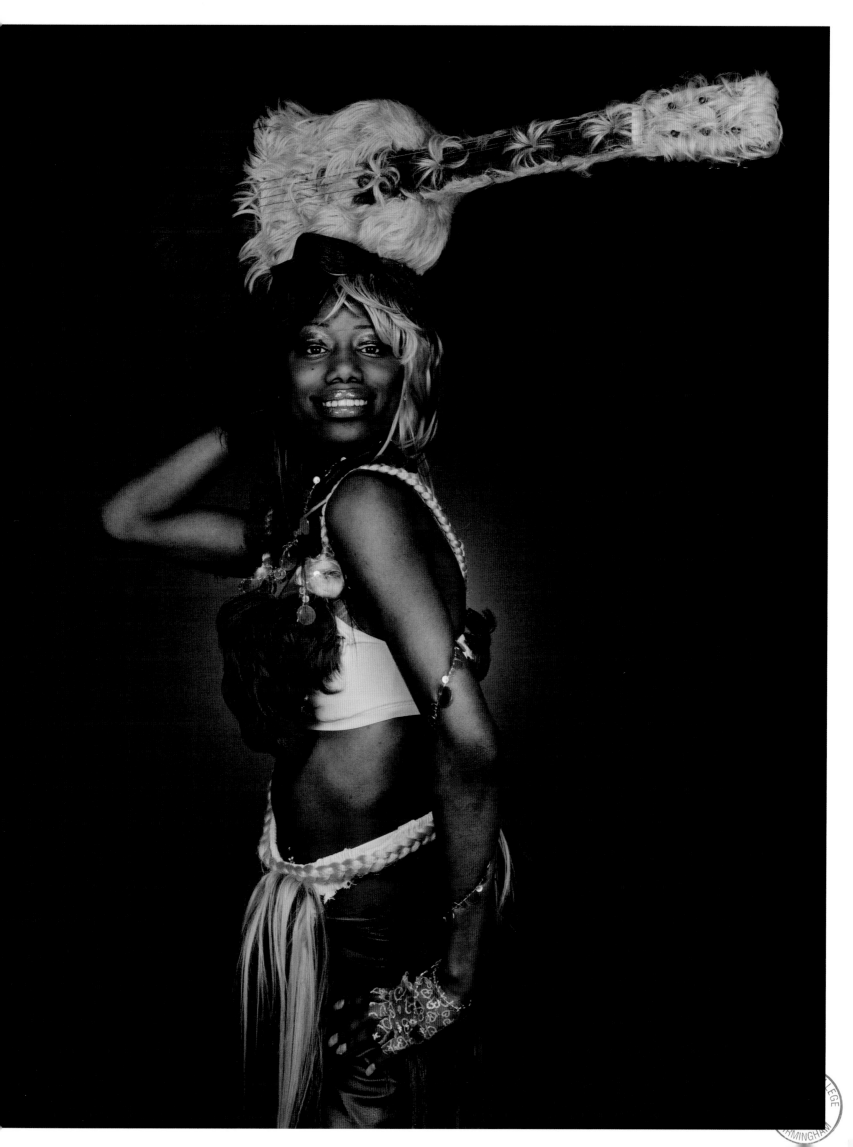

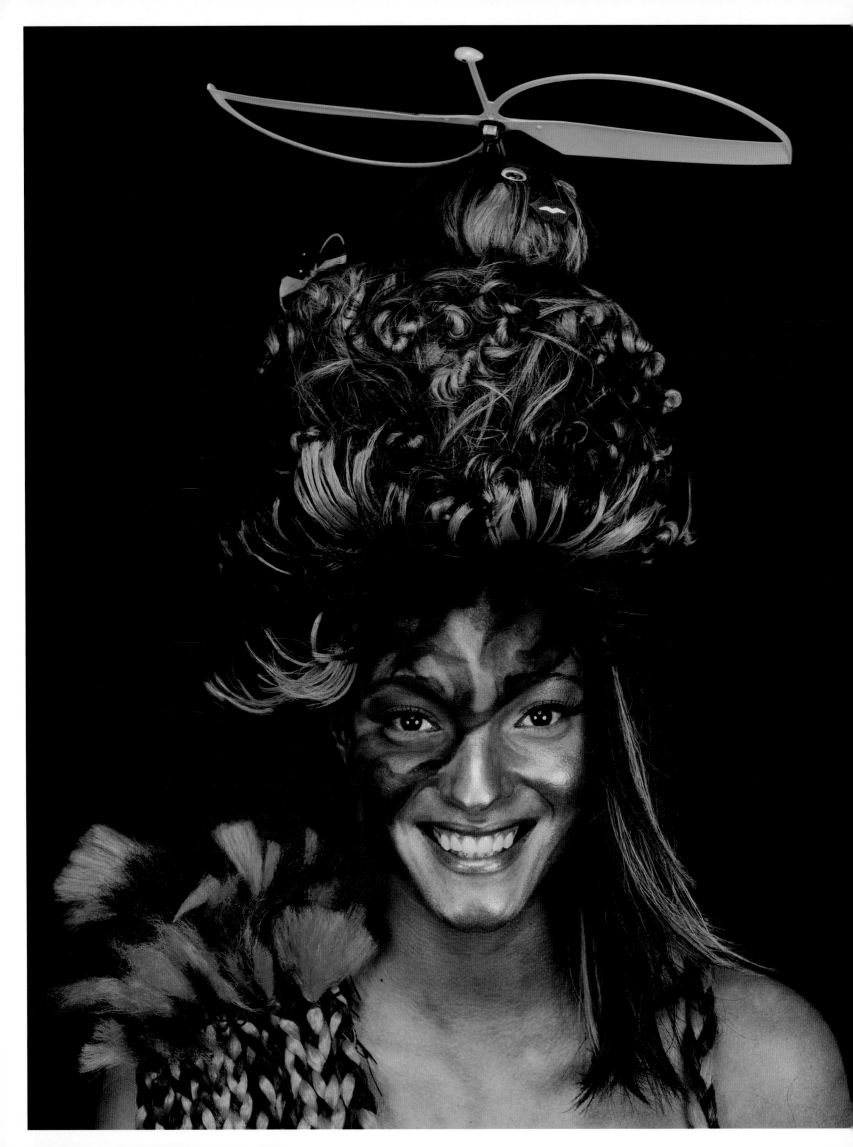

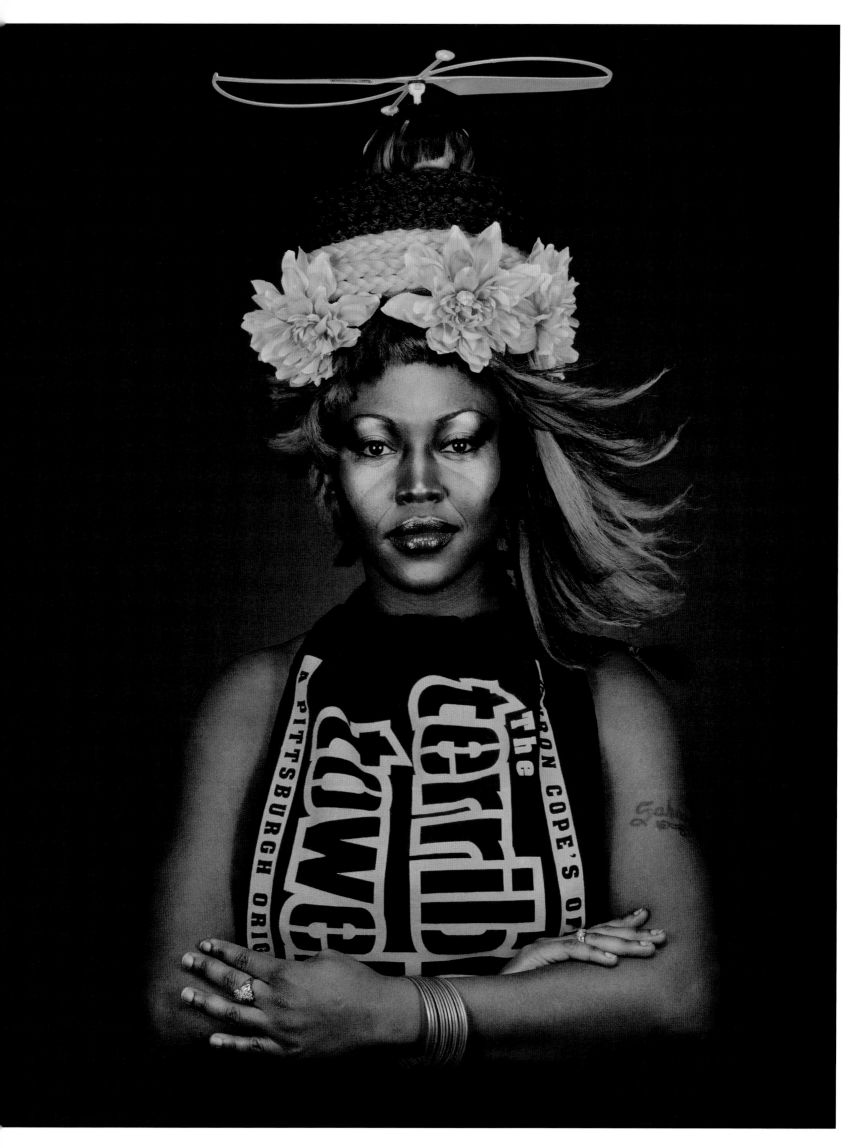

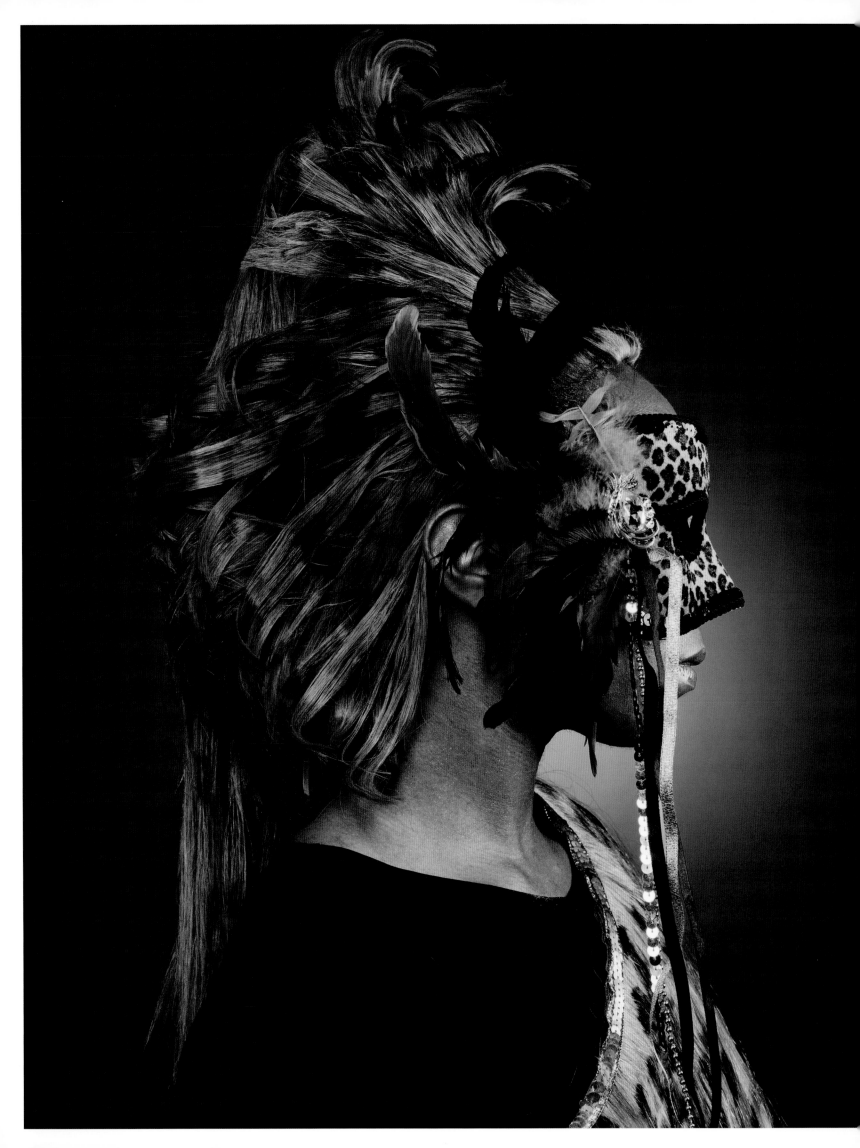

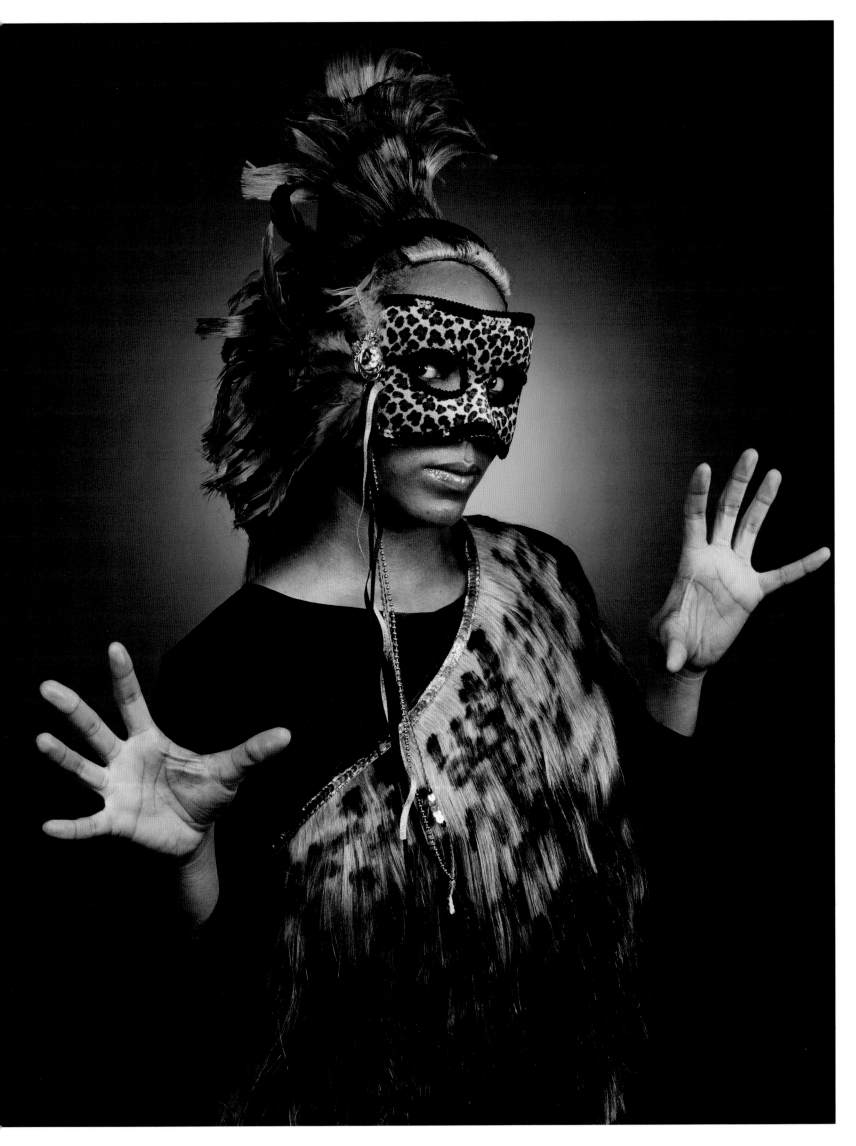

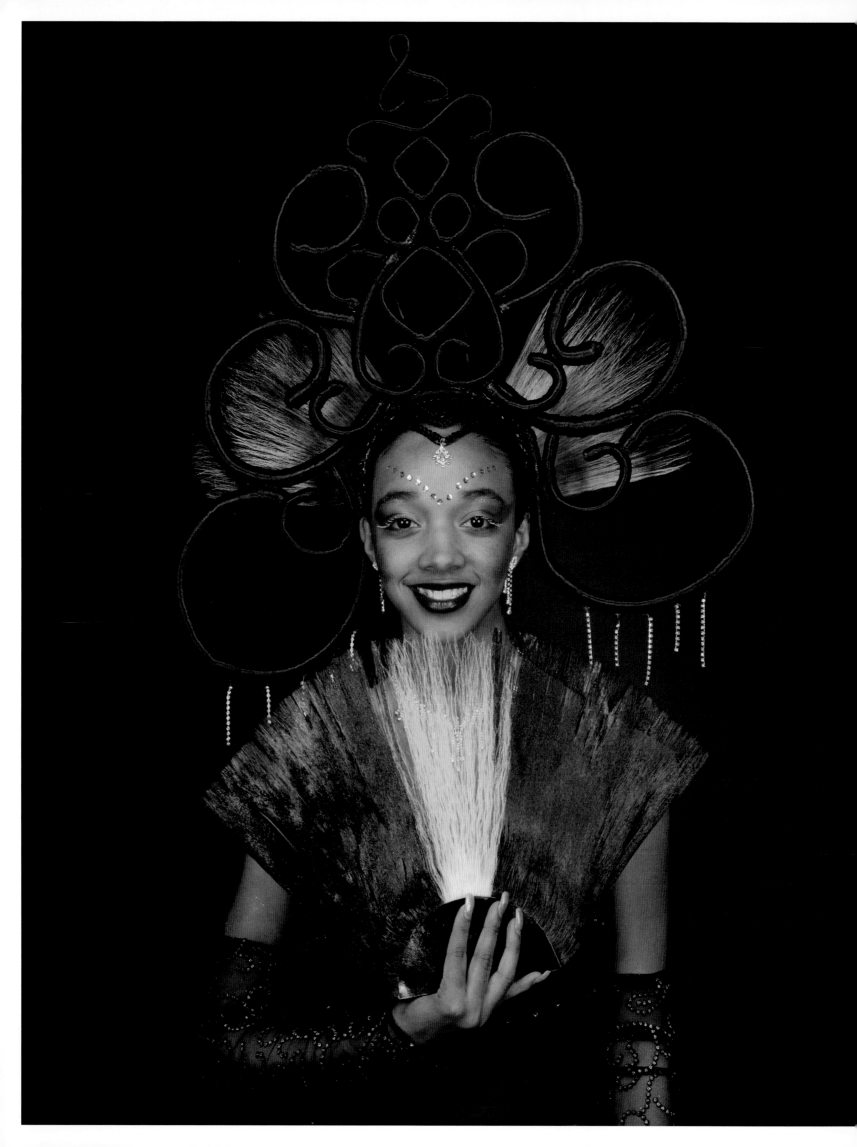

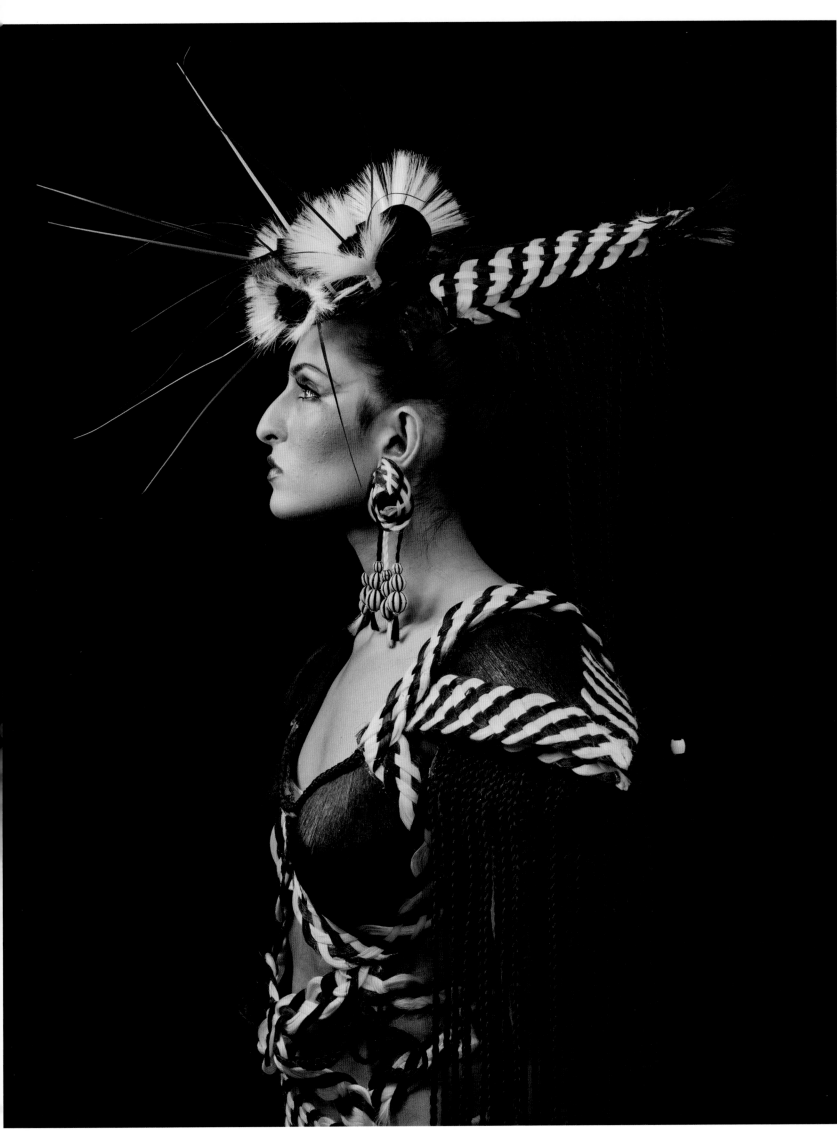

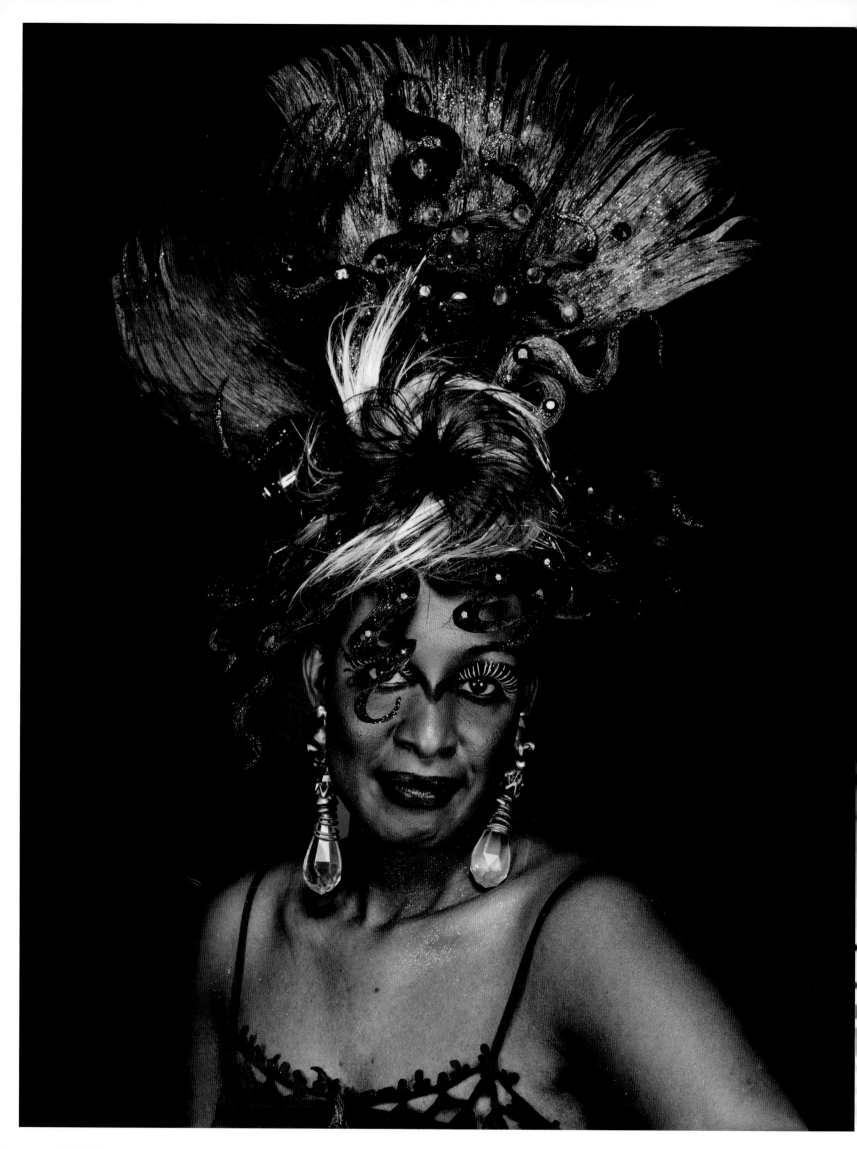

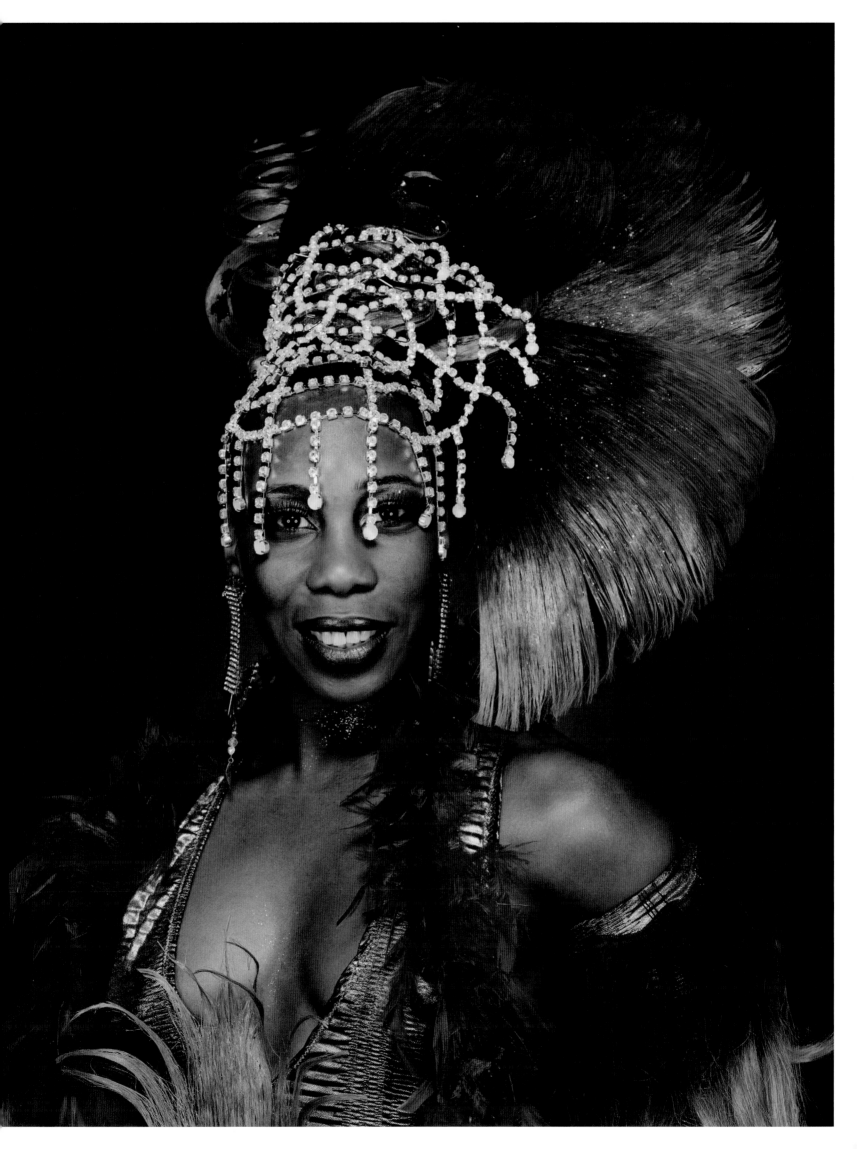

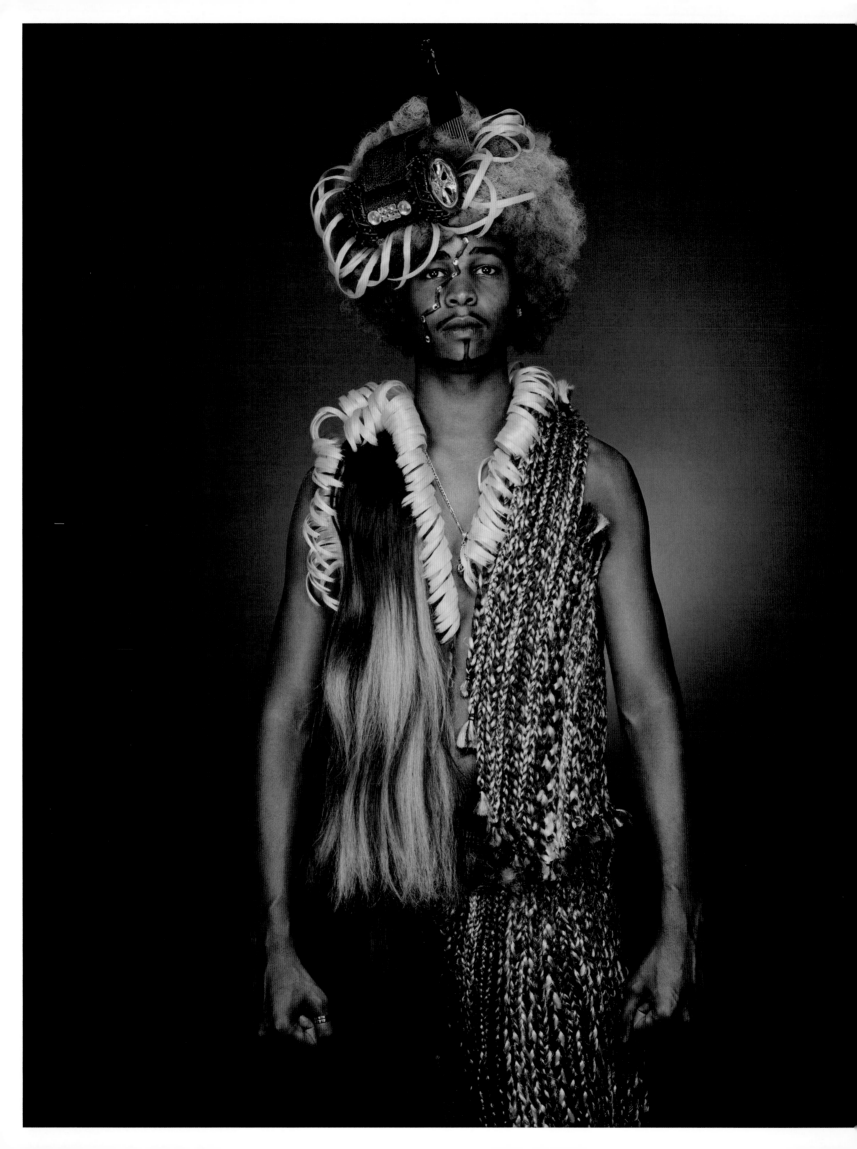

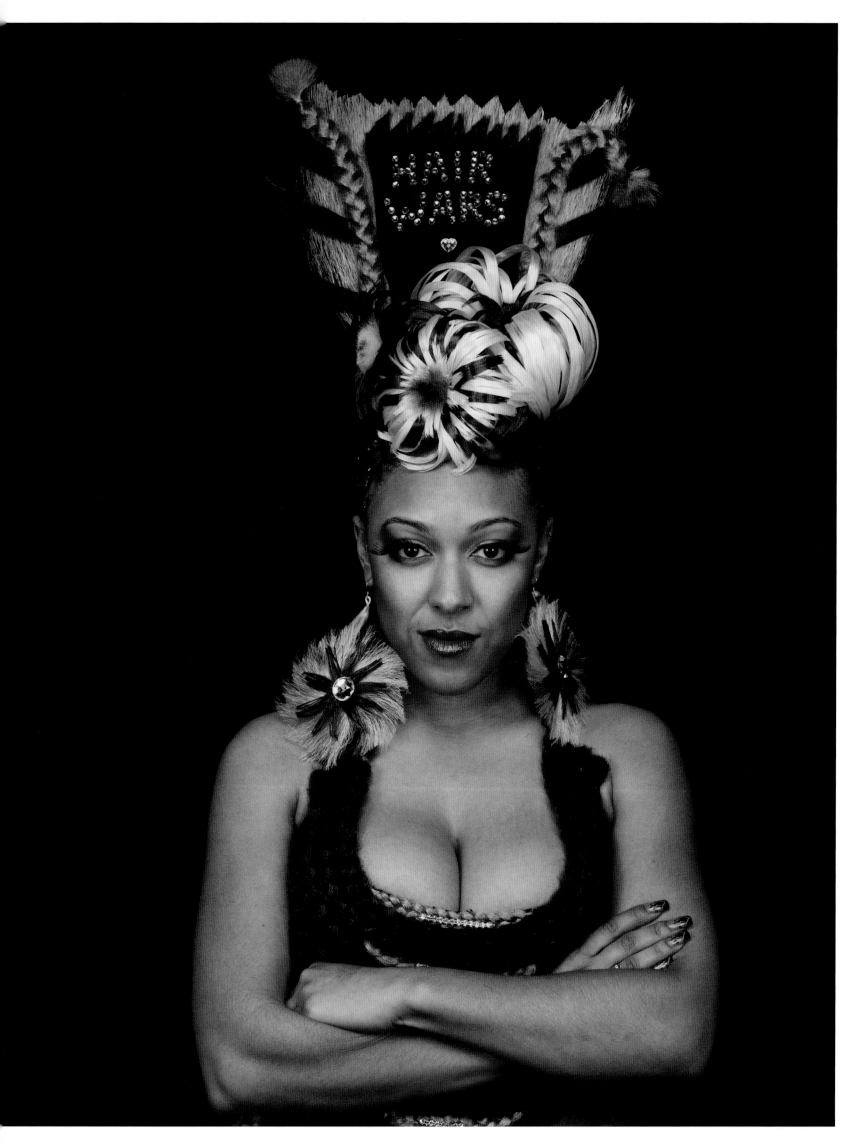

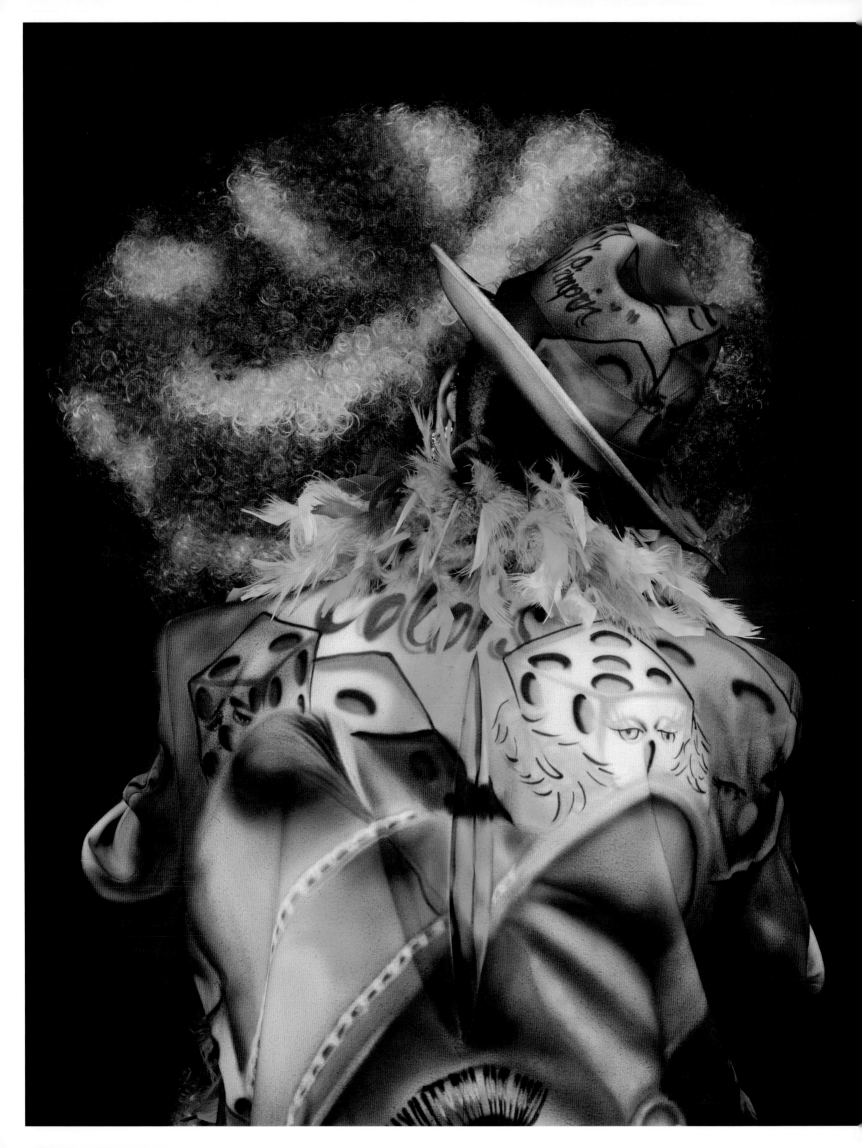

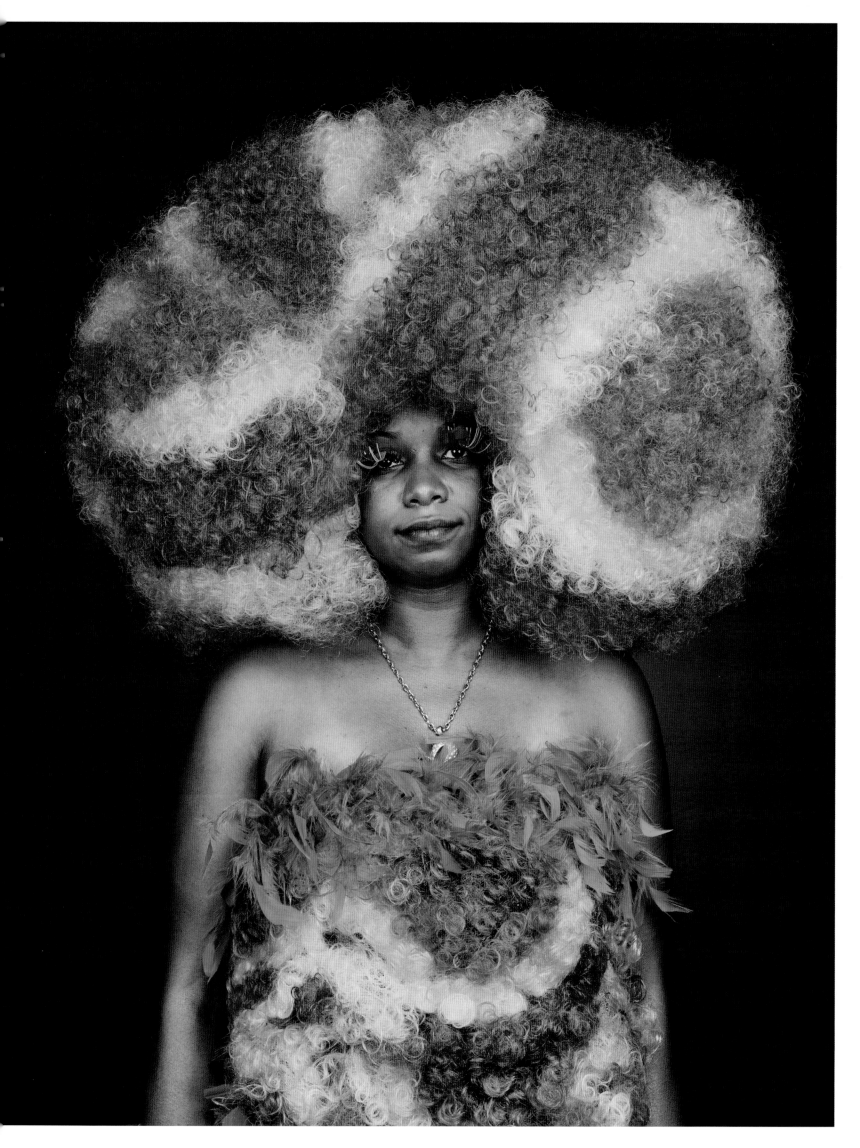

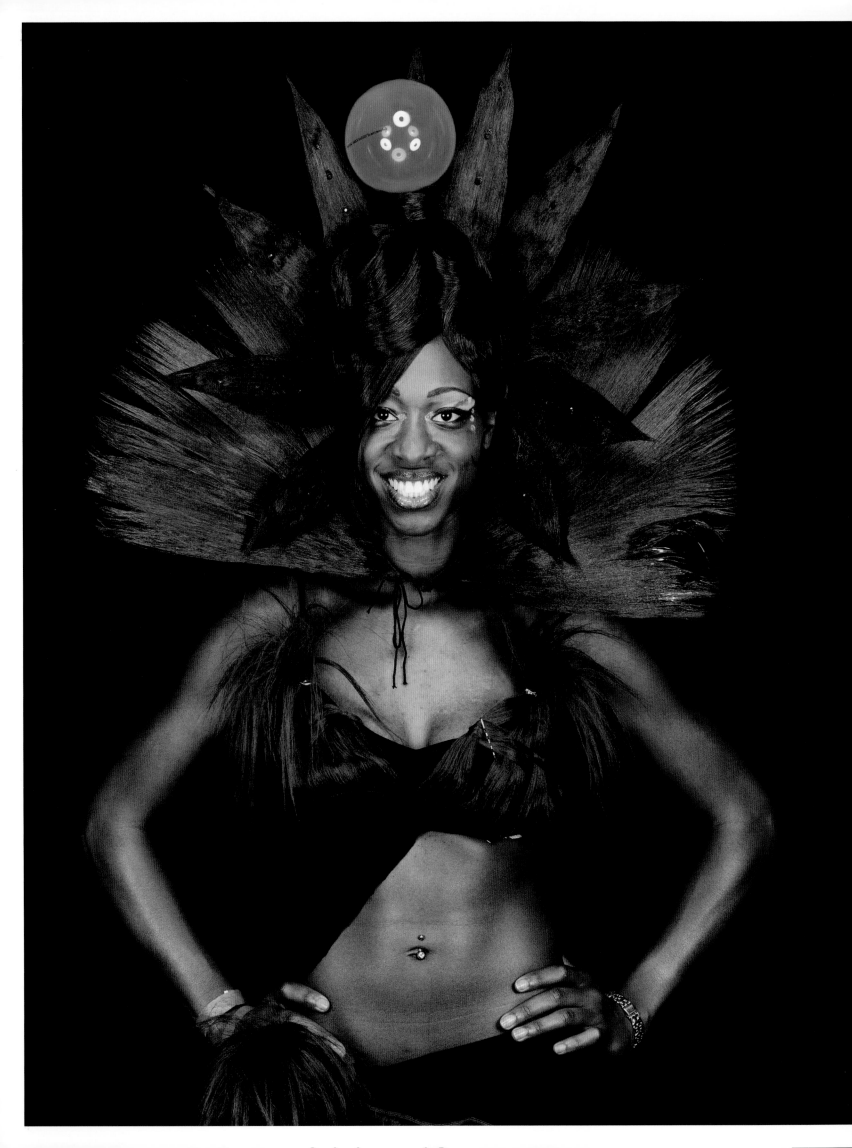

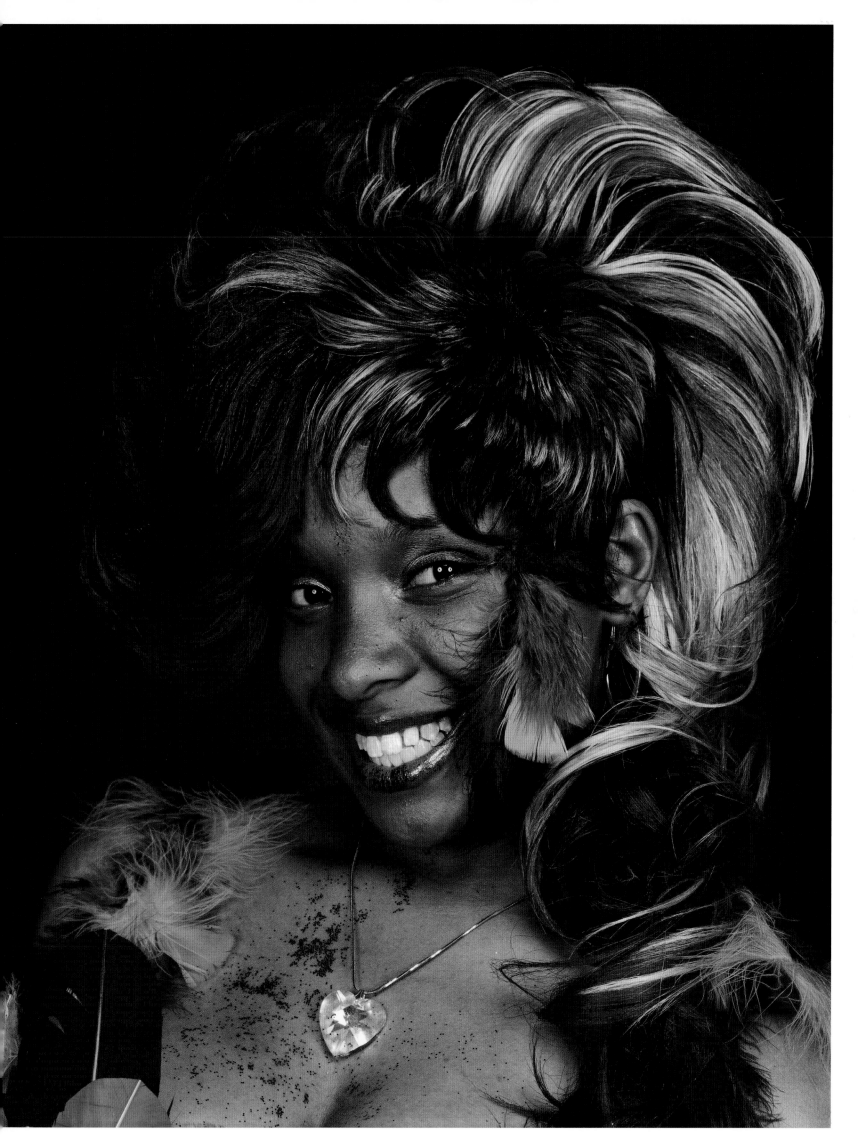

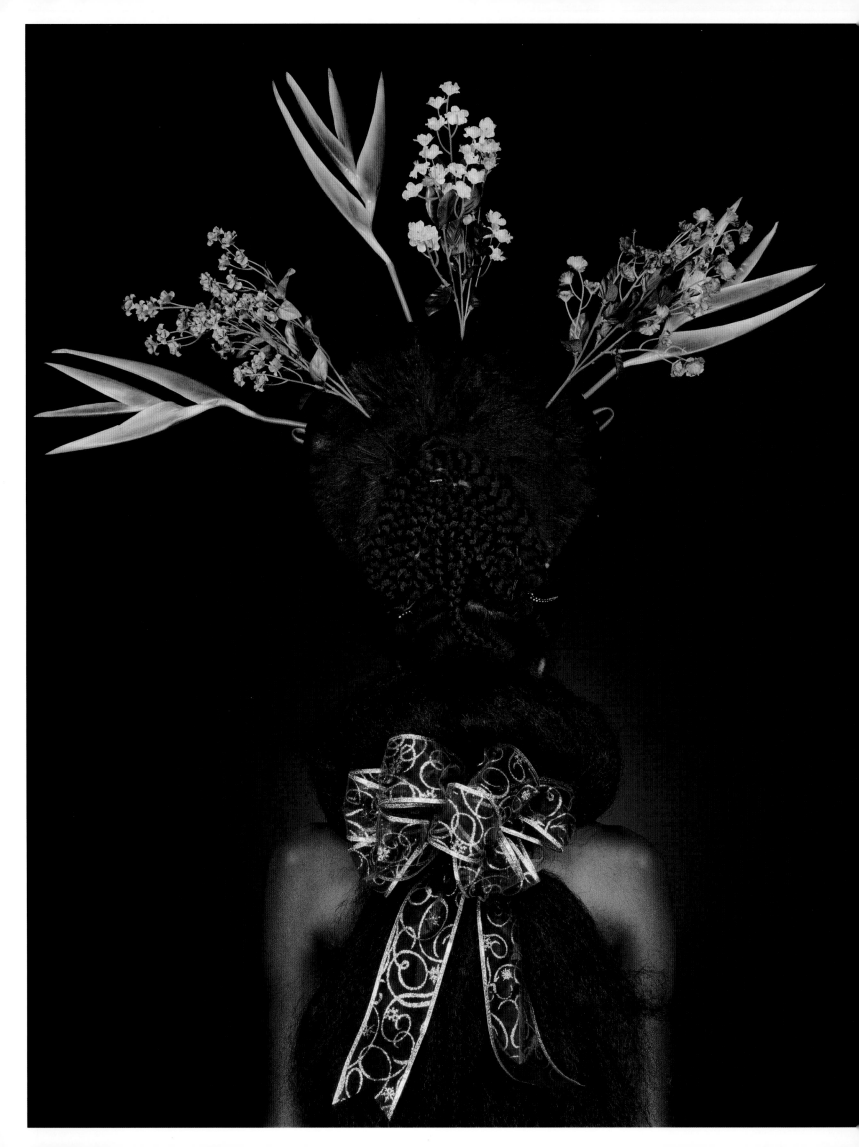

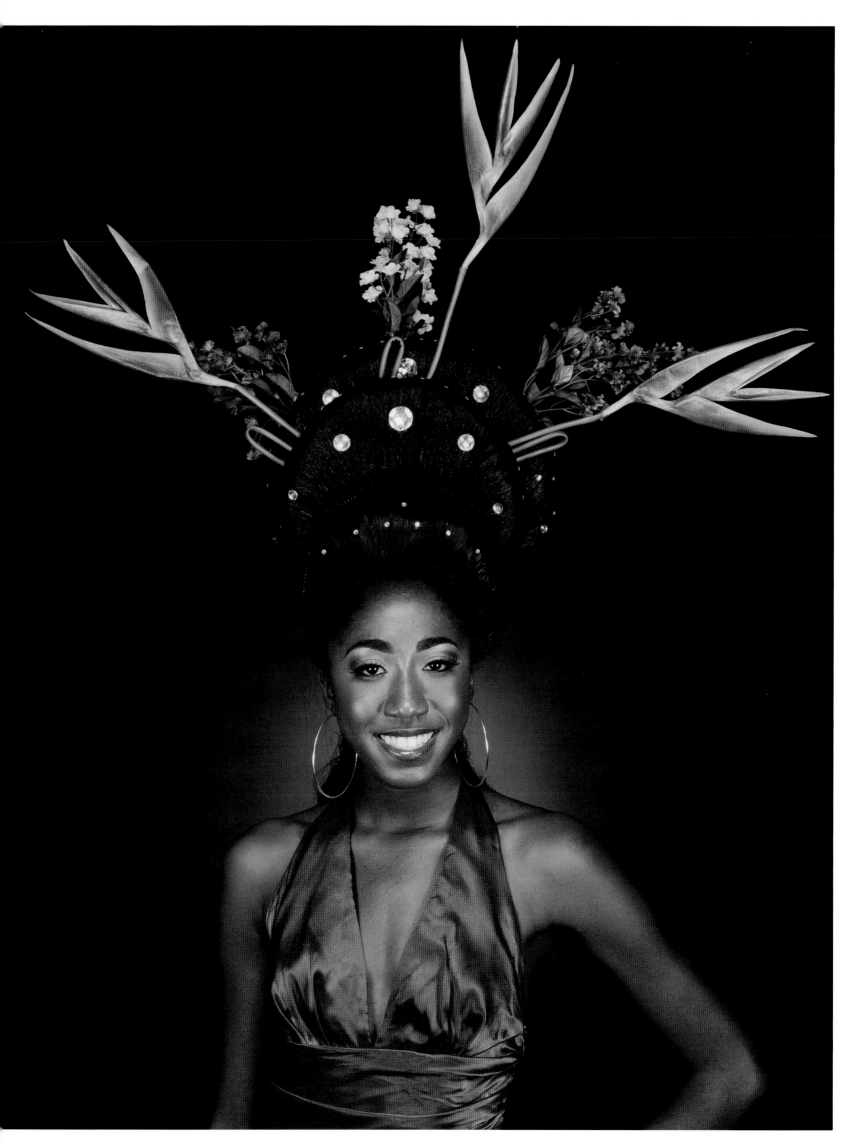

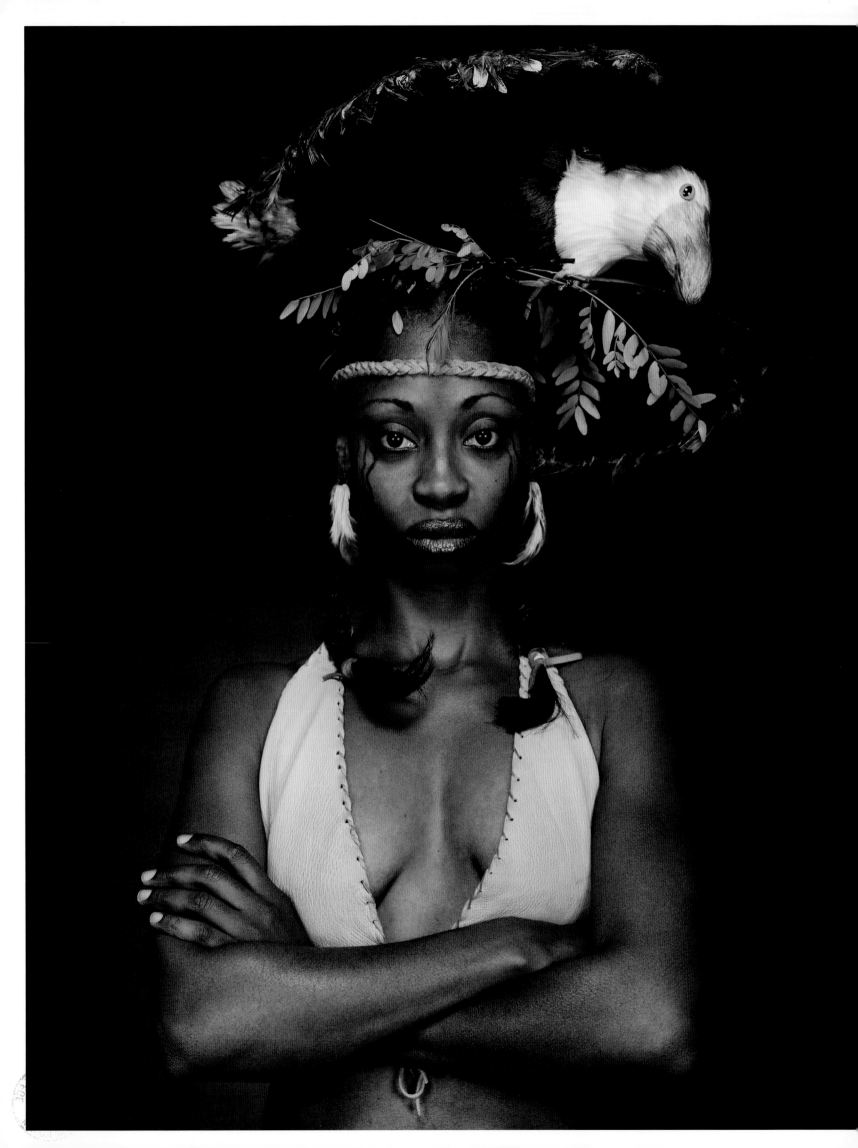

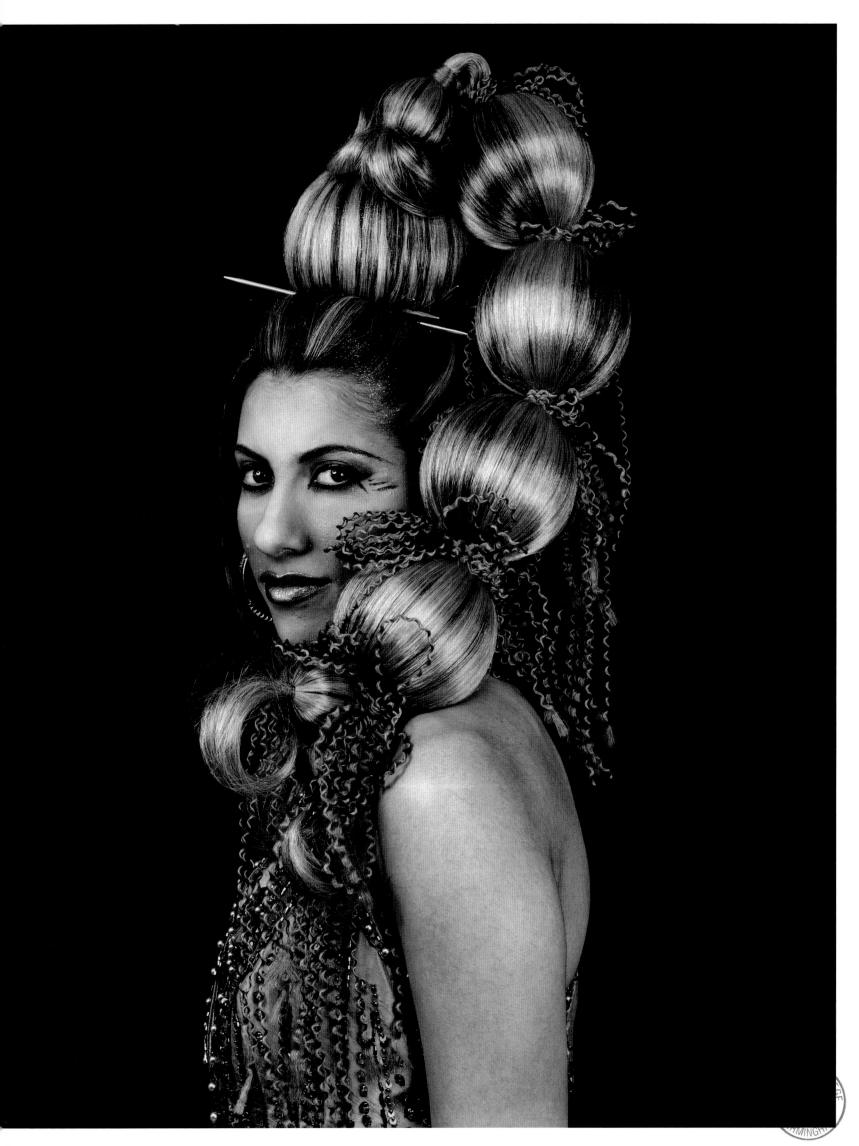

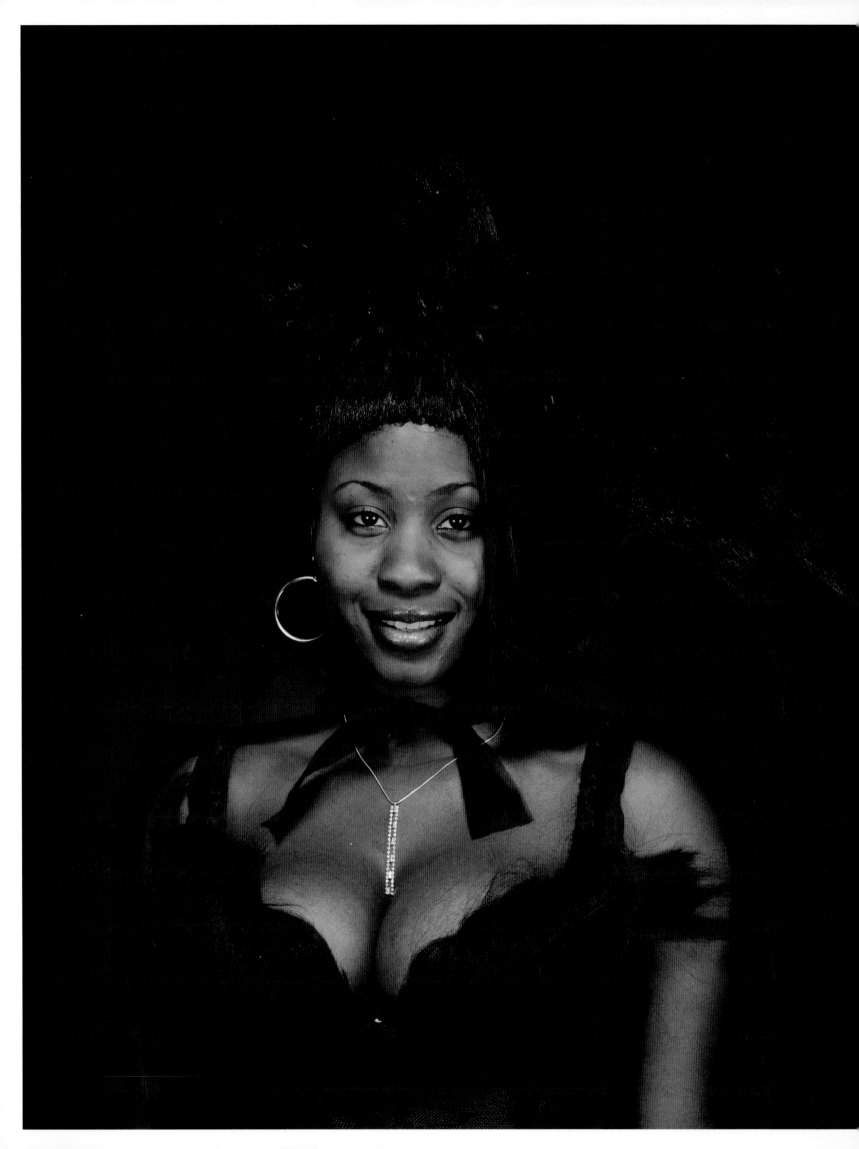

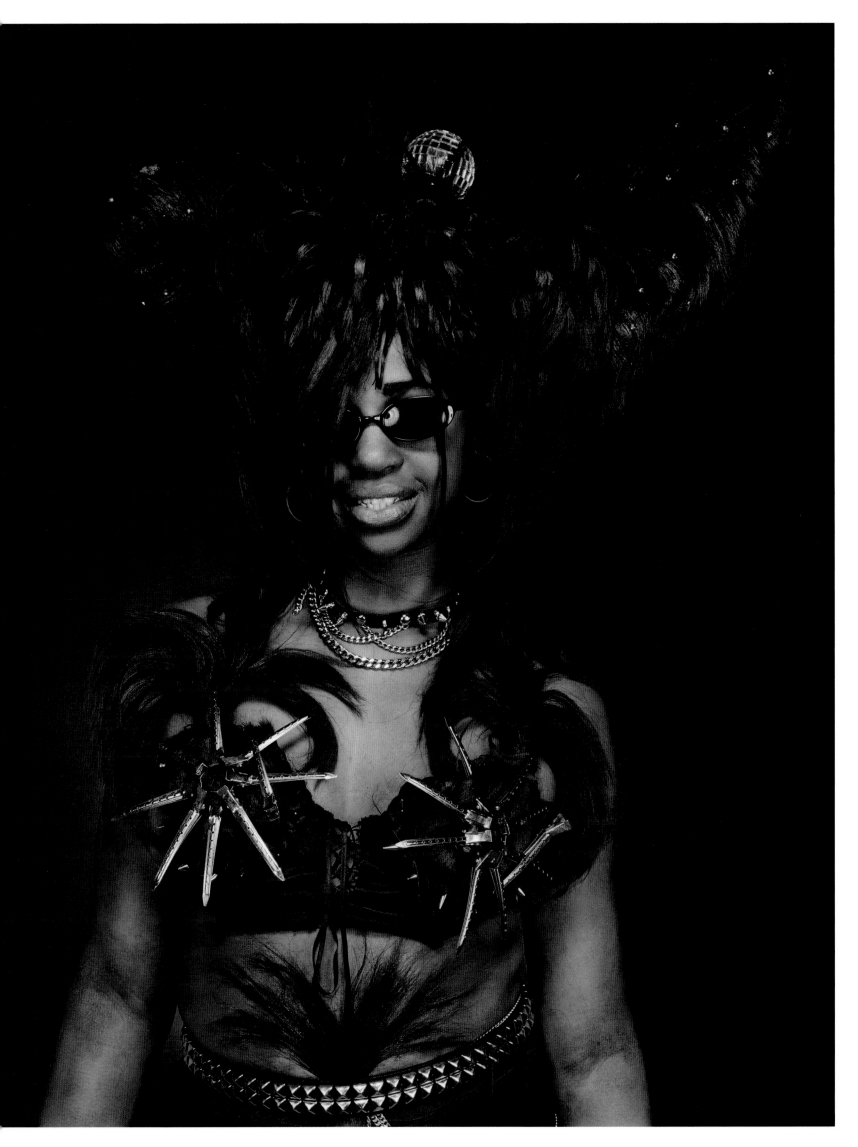

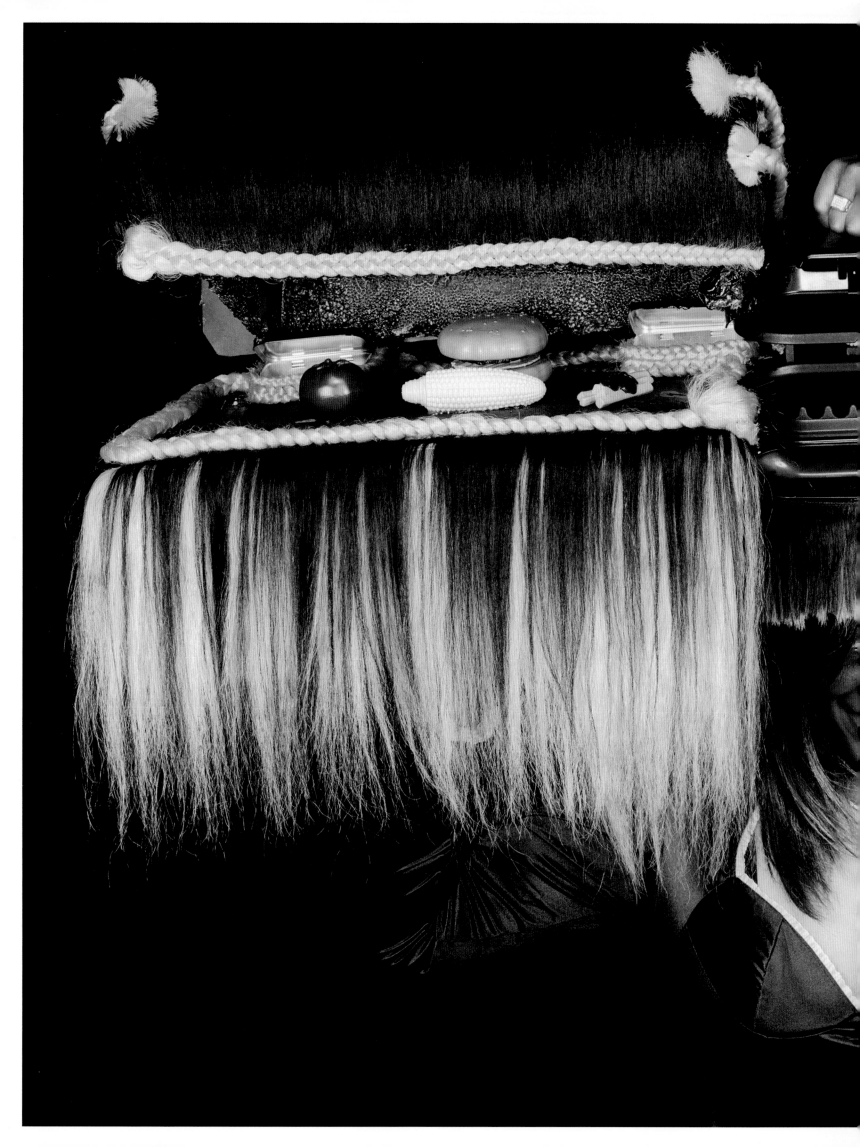

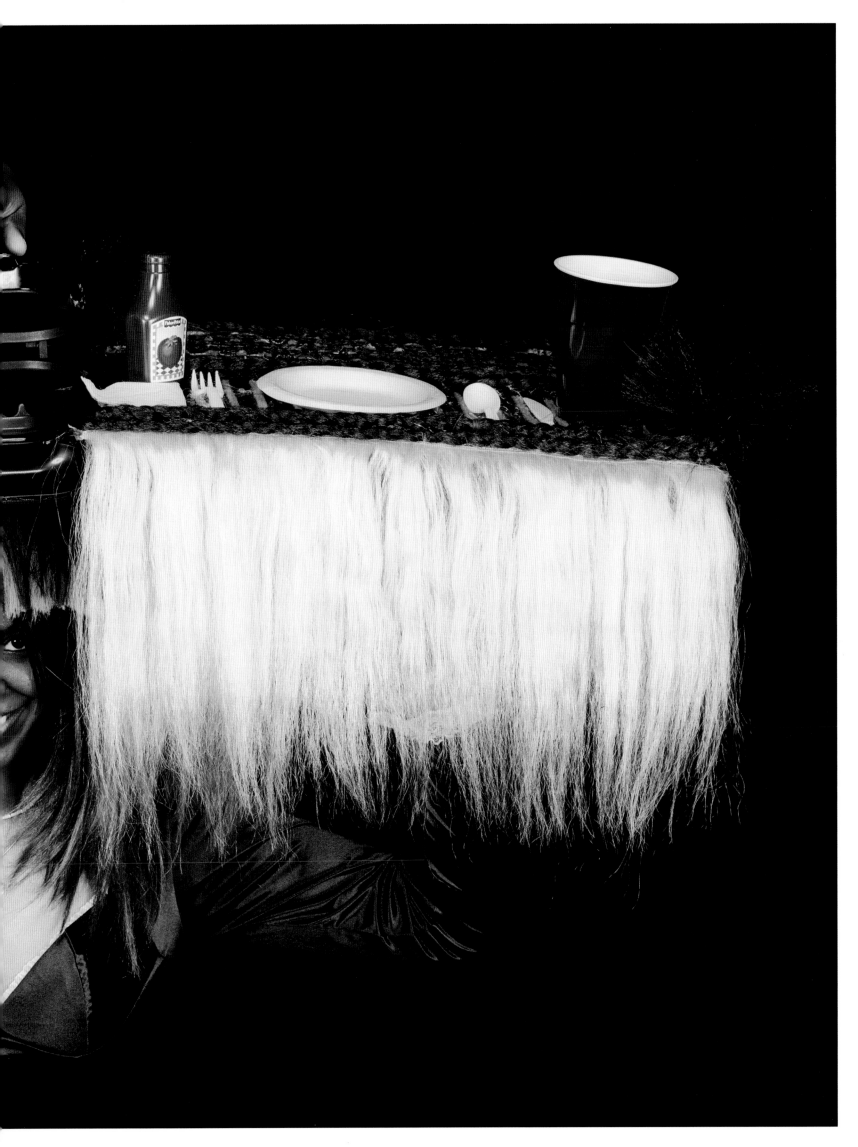

Stylist: Mr. Little

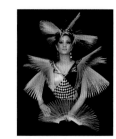

Stylist: Raphael

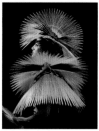

Stylist: Raphael

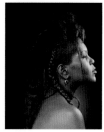

Stylist: Princess P. Ditti

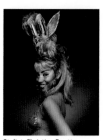

Stylist: Christina Beatty

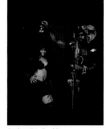

Stylist: Big Bad D

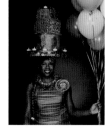

Stylist: Big Bad D

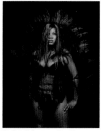

Stylist: Infamous Lisa B

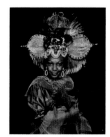

Stylist: Infamous Lisa B

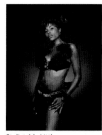

Stylist: Veronica Forbes

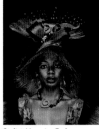

Stylist: Veronica Forbes

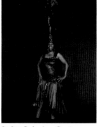

Stylist: Stephanie Moyé

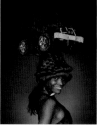

Stylist: Ruby Jean Davis

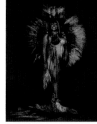

Stylist: Little Willie

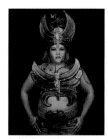

Stylist: Mr. Little

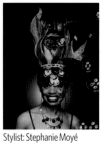

Stylist: Stephanie Moyé

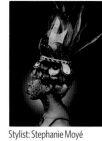

Stylist: Stephanie Moyé

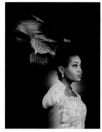

Stylist: Charlie Maehongbey

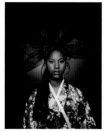

Stylist: Kevin Whitfield

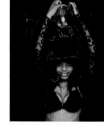

Stylist: Steven Noss

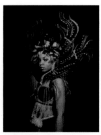

Stylist: Steven Noss

Stylist: Celeste Toomer

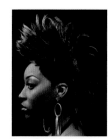

Stylist: Celeste Toomer

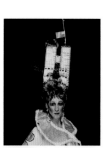

Stylist: Veronica Forbes

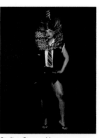

Stylist: Steven Noss

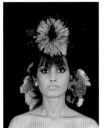

Stylist: Raphael

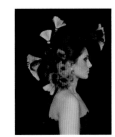

Stylist: Raphael

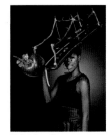

Stylist: Kevin Carter

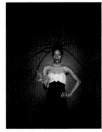

Stylist: Dave Ray

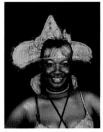

Stylist: Country Girl

Stylist: Country Girl

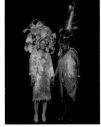

Stylist: Mz. Jadé

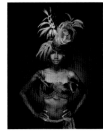

Stylist: Ruby Jean Davis

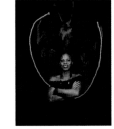

Stylist: Steven Noss

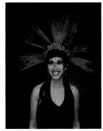

Stylist: Stephanie Moyé

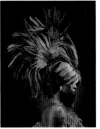

Stylist: Ms. 'Color Me' Vic

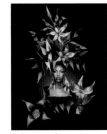

Stylist: Kevin Carter

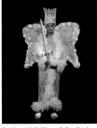

Stylist: Ali D'Shua & Big Dickie

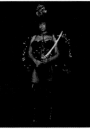

Stylist: Ali D'Shua & Big Dickie

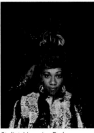

Stylist: Veronica Forbes

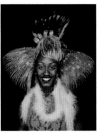

Stylist: Veronica Forbes

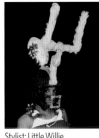

Stylist: Little Willie

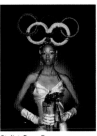

Stylist: Dave Ray

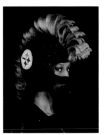

Stylist: Little Willie

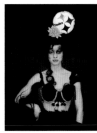

Stylist: Steven Noss

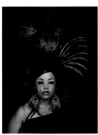

Stylist: Celeste Toomer

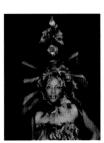

Stylist: Mr. Little

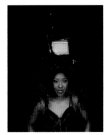

Stylist: Little Willie

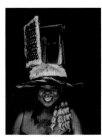

Stylist: Little Willie

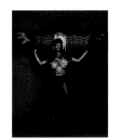

Stylist: Wishbone

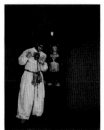
Stylist: Big Bad D

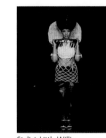
Stylist: Little Willie

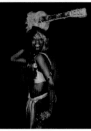
Stylist: Little Willie

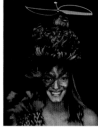
Stylist: Steven Noss

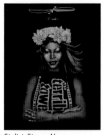
Stylist: Steven Noss

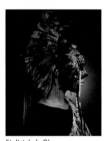
Stylist: Lola Oloye

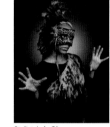
Stylist: Lola Oloye

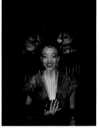
Stylist: Stephanie Moyé

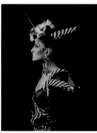
Stylist: Raphael

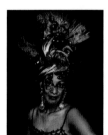
Stylist: Veronica Forbes

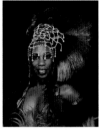
Stylist: Veronica Forbes

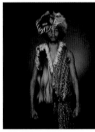
Stylist: Steven Noss

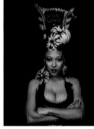
Stylist: Terry Boden

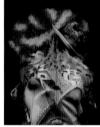
Stylist: Ms. 'Color Me' Vic

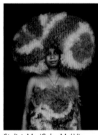
Stylist: Ms. 'Color Me' Vic

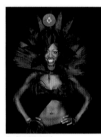
Stylist: Mr. Little

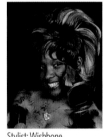
Stylist: Wishbone

Stylist: Dave Ray

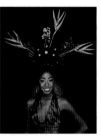
Stylist: Dave Ray

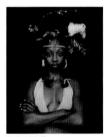
Stylist: Muffen

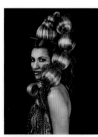
Stylist: Raphael

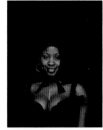
Stylist: Mr. Little

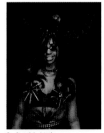
Stylist: Mr. Little

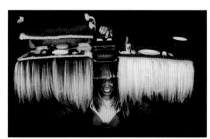
Stylist: Ali D'Shua & Big Dickie

Acknowledgements

We would like to thank our families for all their support. David would like to thank: Jennifer Kilberg for her ability to edit a book over brunch; David Humphries for creating a forum for the most expressive hairstyles this world has ever seen; Joan Hernandez for his hard work and indecipherable mutterings; Ted Keller for his late-night design sessions and deep knowledge of mail order Texas BBQ; Ryan Speth for his infinite wisdom of CMYK; Allen Young for his Detroit hair underworld expertise; Krystallynne Gonzalez for taking care of everything that needed to be taken care of; Las Brisas, Sammy's Roumanian Steakhouse, Yama Sushi, and the soul food restaurant in Bert's Warehouse for nourishing us along the way; Shannon Greer, Chris Dougherty, and Armin Harris. Johanna would like to thank: Anouche Wise for invaluable input and editing; Martina Lundborg for enduring love and friendship; Clara Young for bearing with my Continental English; Rebecca Voight for unfailing loyalty and encouragement; Ed Filipowski for continuing support and trust; Brett Littman for always coming through; Tony Valentine for opening my eyes to good design; and Karen Steinberg for helping me see what I don't need. We would both like to thank the hairstylists for their dedication and creativity, Karl Lipsky for giving us the best seats at Tanglewood, and, of course, Rocky Lenander the mechanical dog.

Please visit www.hairwarsustour.com.

Bio

David Yellen was born 1972 in Queens. He graduated from SUNY Purchase in 1997 with a BFA in photography. His work has been featured in periodicals such as *Time, Life, People,* British *Esquire,* and *WWE* magazine. In 2004 his first book, *Too Fast For Love,* was published by powerHouse Books. He lives and works in New York City.

Johanna Lenander was born in Örebro, Sweden. She graduated from the Department of Journalism, Media and Communication (JMK) at Stockholm University in 1999. Her work has appeared in *New York, T: The New York Times Style Magazine, I.D.,* and *Surface.* She lives and works in New York City.

Hair Wars

Published in the United States by powerHouse Books,
a division of powerHouse Cultural Entertainment, Inc.
37 Main Street, Brooklyn, NY 11201-1021
telephone 212 604 9074, fax 212 366 5247
e-mail: hairwars@powerHouseBooks.com
website: www.powerHouseBooks.com

First edition, 2007

Library of Congress Cataloging-in-Publication Data:

Yellen, David, 1972-
 Hair Wars / photographs by David Yellen ; introduction and interviews
by Johanna Lenander. -- 1st ed.
 p. cm.
 ISBN 978-1-57687-399-1
 1. Portrait photography. 2. Photography of women. 3. Hairwork--
Pictorial works. 4. Hairdressing--United States--Pictorial works. 5.
Hairdressing of African Americans--Pictorial works. 6. Hair Wars. I.
Lenander, Johanna. II. Title.
 TR681.W6Y455 2007
 779'.93915--dc22
 2007060148

Hardcover ISBN 978-1-57687-399-1

Printing and binding by Midas Printing, Inc., China

Book design by Ted Keller

A complete catalog of powerHouse Books and Limited Editions is available upon request; please call, write, or hit the catwalk on our website.

10 9 8 7 6 5 4 3 2 1

Printed and bound in China